The Dance of Śiva

THE DANCE OF ŚIVA.

Cosmic Dance of Naṭarājā. Brahmanical bronze. South Indian. 12th Century,
Madras Museum

The Dance of Śiva

ESSAYS ON INDIAN ART AND CULTURE

by

ANANDA K. COOMARASWAMY

*With a Foreword by
Romain Rolland*

Dover Publications, Inc., New York

Published in Canada by General Publishing Company, Ltd., 30 Lesmill Road, Don Mills, Toronto, Ontario.

Published in the United Kingdom by Constable and Company, Ltd., 10 Orange Street, London WC2H 7EG.

This Dover edition, first published in 1985, is an unabridged republication of the work first published by Simpkin, Marshall, Hamilton, Kent & Co., London, in 1924 under the title *The Dance of Śiva: Fourteen Indian Essays*. Some of the essays had originally been published in earlier versions in the *Burlington Magazine*, the *Athenaeum*, the *Modern Review*, the *Musical Quarterly*, the *Sociological Review* and the *Modern School Magazine*. The position of some of the plates has been altered slightly in this edition, but nothing has been omitted.

Manufactured in the United States of America
Dover Publications, Inc., 31 East 2nd Street, Mineola, N.Y. 11501

Library of Congress Cataloging in Publication Data

Coomaraswamy, Ananda Kentish, 1877–1947.
 The dance of Śiva.

 Reprint. Originally published: New York : Sunwise Turn, 1924.
 1. India—Civilization—Addresses, essays, lectures. 2. Art, Indic—Addresses, essays, lectures. I. Title.
DS423.C6 1985 954 84-25910
ISBN 0-486-24817-8

CONTENTS

LIST OF PLATES

FOREWORD

There are a number of us in Europe for whom European civilisation no longer suffices—dissatisfied children of the spirit of the West, who feel ourselves cramped in our old abode, and who, without depreciating the subtlety, the brilliance, the heroic energy of a philosophy which conquered and ruled the world for more than two thousand years, nevertheless have had to confess its insufficiencies and its limited arrogance. We few look towards Asia!

Asia, the great land of which Europe is but a peninsula, the advance guard of the army, the prow of the heavy ship, laden with a thousand wisdoms . . . from her have always come to us our gods and our ideas. But, in the course of the many circuits made by our peoples who followed the track of the sun, losing contact with our native East, we have deformed, for our own ends of violent and limited action, the universality of her great thoughts.

And now the Western races find themselves trapped deep in a blind alley, and are savagely crushing each other out of existence. Let us snatch our souls from the bloody rout! Let us strive to win back to the great crossways whence flow out to the four points of the sky the streams of human genius. Let us climb back to the high plains of Asia!

It is true that Europe has never scorned the roads of Asia when the business in hand was pillage or extortion, or exploitation of the material riches of her countries under the banner of Christ or of Civilisation. But what benefit has she drawn from Asia's spiritual wealth? That has lain buried in collections and in archæological museums. A few brilliant tourists, members of Academies, have nibbled at its crumbs, but the spiritual life of Europe has derived no benefit from it.

Who, amid the disorder in which the chaotic conscience of the West is struggling, has sought whether the forty-century-old civilisations of India and China had not answers to offer to our griefs, models, it may be, for our aspirations? The Germans, with their more exacting and unhappy vitality, have been the first to ask of Asia that food which their starved spirit can no longer find in Europe; and the disasters of these last years

have precipitated this moral evolution, arising out of the dis-
illusionment of political action and the exaltation of the interior
life. A few noble pioneers, like Count Kayserling, have popu-
larised the wisdom of Asia. And certain of Germany's purest
poets, as Hermann Hesse, have so far fallen under the spell of
Eastern thought as to subside into silence among the souls of
the artist-sages of the Celestial Empire.

France, although similar currents have begun to make them-
selves felt within her, and although certain little-known Frenchmen
are counted among the pioneers of the Re-Awakening of Asia—
has held back from this movement of fruitful sympathy and curi-
osity. Nowhere in Europe have Tagore's recent journey and his
appeal for communal work in European-Asiatic culture been
heeded less. A wall of self-satisfied indifference separates this
country from the life of the rest of the world. Not long ago the
fiery Björnson made a justifiable reproach against France on this
count. But he was unjust in not recognising the ceaseless efforts
of a small number of Frenchmen to open a breach in the wall.
And even that little group, led by the staunch Bazalgette—the
brotherly friend, in Whitman's meaning, of all that is human—
bears splendid testimony. Let us widen the breach! And through
the opening may the message of India make itself heard in France!

Ananda Coomaraswamy is one of those great Hindus who,
nourished like Tagore on the culture of Europe and of Asia, and
justifiably proud of their splendid civilisation, have conceived the
task of working for the union of Eastern and Western thought
for the good of humanity. The spectacle of the recent war, which
has rendered manifest the signs of the approaching ruin of the
whole fabric of European life, has shown them the urgency of
their mission. Even while the harmonious voice of Tagore is
inviting us to collaborate in his International University of San-
tiniketan, Coomaraswamy raises his cry of alarm. He says to
us: " Save Asia! Her idealism is in danger. If you do not save
her, beware lest great Nemesis turn back on you, by the hand of
Asia, the imperialism of wealth and of violence with which you
will have armed her. The degradation of Asia will be the cause
of your ruin. In her uplift lies your safety."

But Europe in her arrogance does not admit that she can have
need of Asia, whom for centuries she has trampled under foot,
without once the suspicion stirring that she was playing the part
of Alaric on the ruins of Rome. But Rome has vanquished the

conquering barbarians, as Greece has vanquished Rome, as India and China will finally vanquish Europe—a victory to the soul.

The purpose of Coomaraswamy's book is to show the power of this soul, to show all the riches that it holds stored up, with which to ennoble and render happy the human race. In a series of Essays, which are apparently detached, but all of which spring from the same central thought and converge into one design, the vast and tranquil metaphysic of India is unfolded; her conception of the universe, her social organisation, perfect in its day and still capable of adaptation to the demands of modern times; the solution which she offers for the feminist problem, for the problems of the family, of love, of marriage; and lastly, the magnificent revelation of her art. The whole vast soul of India proclaims from end to end of its crowded and well-ordered edifice the same domination of a sovereign synthesis.

There is no negation. All is harmonised. All the forces of life are grouped like a forest, whose thousand waving arms are led by Nataraja, the master of the Dance. Everything has its place, every being has its function, and all take part in the divine concert, their different voices, and their very dissonances, creating, in the phrase of Heraclitus, a most beautiful harmony. Whereas in the West, cold, hard logic isolates the unusual, shutting it off from the rest of life into a definite and distinct compartment of the spirit, India, ever mindful of the natural differences in souls and in philosophies, endeavours to blend them into each other, so as to re-create in its fullest perfection the complete unity. The matching of opposites produces the true rhythm of life. Spiritual purity may not shrink from allying itself with sensual joy, and to the most licensed sexualism may be joined the highest wisdom. (The amazing Sahaja is an extreme example, a paradoxical challenge to forces opposed and mated.)

In the masterpieces of art we see beauty wedded to science or to religion, for the harvest of the intensely lived life is invariably garnered from the intermingling of many different seeds. And always, from the depths of millions of eyes, we meet the look of the One. Tagore has sung this thought in deathless lines :

> " I shall find hidden Thy infinite joy
> In every splendour of smell and vision and sound;
> Even while a thousand fetters still bind me to the wheel
> I shall taste Thy infinite liberty."

Of course, this entire fabric of Indian life stands solidly on faith, that is to say (as can be said of all faiths), on a slender and

emotional hypothesis. But amid all the beliefs of Europe, and of Asia, that of the Indian Brahmins seems to me infinitely the most alluring. I do not at all despise the others. The ecstatic intellectualism of the primitive Buddhist, or the radiant serenity of the void inhaled in Lao-Tse, are infinitely dear to me; but I find in them only rare, exceptional moments, only the dizzying peaks of the spiritual life. And the reason why I love the Brahmin more than the other schools of Asiatic thought is because it seems to me to contain them all. Greater than all European philosophies, it is even capable of adjusting itself to the vast hypotheses of modern science. Our Chrisian religions have tried in vain, when there was no other choice open to them, to adapt themselves to the progress of science; but one would think, indeed, that they have difficulty in forgetting that heaven of Hipparchus and Ptolemy which they saw above them in their infancy.

But after having allowed myself to be swept away by the powerful rhythm of Brahmin thought, along the curve of life, with its movement of alternating ascent and return, I come back to my own century, and while finding therein the immense projections of a new cosmogony, offspring of the genius of Einstein, or deriving freely from his discoveries, I yet do not feel that I enter a strange land. For, in the journey of the spirit across stellar space, even to the deeps of the planetary void, amid the Islands of the cosmos, the nebular spirals, the countless Milky Ways, and through the millions of creations which sweep along down Space-and-Time, that endless, limitless arc, the rays of whose suns, revolving eternally, could light up phantom, insubstantial worlds, I yet can hear resounding still the cosmic symphony of all these planets which forever succeed each other, are extinguished and once more illumined, with their living souls, their humanities, their gods— according to the law of the eternal To Become, the Brahmin Samsara—I hear Siva dancing, dancing in the heart of the world, in my own heart.

I do not suggest that Europeans should embrace an Asiatic faith, I would merely invite them to taste the delight of this rhythmic philosophy, this deep, slow breath of thought. From it they would learn those virtues which above all others the soul of Europe (and of America!)* needs to-day: tranquillity, patience, manly hope, unruffled joy, " like a lamp in a windless place, that does not flicker."†

* Since, of course, all I have written here about Europe applies equally to those European races which have peopled the New World.
† Bhagavad Gitâ.

The Western world, abandoning itself utterly to its search of individual and social happiness, maims and disfigures life by the very frenzy of its haste, and kills in the shell the happiness which it pursues. Like a runaway horse who from between his blinkers sees only the blinding road before him, the average European cannot see beyond the boundaries of his individual life, or of the life of his class, of his country, or of his party. Within that narrow pale he imprisons of his own will the realisation of the human ideal. At all costs he must be assured that he will see it, with his own eyes, or (supreme sacrifice which he must needs concede to the slow movement of human progress!) that his children at least will harvest its fruits. Hence these eternal and tumultuous hopes, lent out on short credit and inevitably to be lost, hence these dreams of Picrocholes, these social Paradises realised on earth, with maxim guns and ruthless edicts, hence this short-sighted hurrying, this violence. And as deception must of necessity follow, the enthusiasts think that all is lost; and their brief hour of feverish exaltation gives way to a long term of morbid depression.

In the great philosophy of Brahma, such violent turns of the scale are quite unknown. It does not expect that the world will be suddenly and miraculously transformed by a war or a revolution, or an act of God. It embraces vast stretches of time, cycles of human ages, whose successive lives gravitate in concentric circles, and travel ever slowly towards the centre, the Place of Deliverance—already attained in certain of the souls of the Prophets. Such a philosophy knows no discouragement; it is never impatient. It knows that there is time. The disasters of the journey bring forth neither anger nor defeat. Error for it is not sin but only youth. The full cycle of Time must be accomplished. It watches the turn of the wheel and it waits. And its vision, penetrating far beyond the shifting horizons of good and evil, judges clearly and calmly the stream of passing souls— gentle with the frailties of the weak, stern only with the strong. For this proud philosophy demands most of those who are capable of most; and its whole conception of the hierarchy of castes, which at first sight seems so scornfully aristocratic, is based on this lofty principle (diametrically opposed to that of the self-seeking democracies of the West), that the higher we climb, less become our rights, greater our obligations! . . . In fine, everyone, however low his status, shall climb higher, everyone knows that, sooner or later, in the normal unfolding of his lives,

he will be able to attain to the culminating point on the curve, whence, along the way of Return, the soul will escape from Time and its vicissitudes.

Thus the infinite diversity of souls and of desires is brought into accord with the eternal rhythm which holds them in the one great current which travels on to Unity.

But it is not intended that this stately fabric of the soul should cast over Europe the golden shadow of its dome. No, there is no wish that Europe should become Asia! But she must not try to make Asia become Europe! She must learn to respect this colossal personality to which she herself is complementary. Without seeking (oh, vain dreams!) to restore a fictitious life to the forms of the past, may these two worlds of human beings, allying their distinctive spirits, build up by their union the road of the future.

This is the wish which Ananda Coomaraswamy expresses at the conclusion of this book, setting against the nationalism of Young India the high idealism of Asia :

" Nationalism does not suffice for the great idealists of Young India. Patriotism is but a local interest. . . . Great souls have greater destinies to fulfil. Life, not merely the life of India, demands our great devotion. The happiness of the human race is of more import to us than any party triumph. The chosen people of the future can be no nation, no race, but an aristocracy of the whole world, in whom the vigour of European action will be united to the serenity of Asiatic thought! . . ." *

We take within our own, this hand which India extends to us. Our cause is one : the saving of human unity and its full accord. Europe, Asia, our strengths are different. Let us unite them for the accomplishment of a common task, for the achievement of human genius. Teach us to understand all things, Asia, teach us your knowledge of life! And learn of us action, achievement!

ROMAIN ROLLAND.

* I have taken the liberty of joining together in this sentence two sentences from the essays : Intellectual Brotherhood and Young India.

The Dance of Śiva

WHAT HAS INDIA CONTRIBUTED TO HUMAN WELFARE?[1]

Each race contributes something essential to the world's civilization in the course of its own self-expression and self-realization. The character built up in solving its own problems, in the experience of its own misfortunes, is itself a gift which each offers to the world. The essential contribution of India, then, is simply her Indianness; her great humiliation would be to substitute or to have substituted for this own character (*svabhāva*) a cosmopolitan veneer, for then indeed she must come before the world empty-handed.

If now we ask what is most distinctive in this essential contribution, we must first make it clear that there cannot be anything absolutely unique in the experience of any race. Its peculiarities will be chiefly a matter of selection and emphasis, certainly not a difference in specific humanity. If we regard the world as a family of nations, then we shall best understand the position of India by recognizing in her the elder, who no longer, it is true, possesses the virility and enterprise of youth, but has passed through many experiences and solved many problems which younger races have hardly yet recognized. The heart and essence of the Indian experience is to be found in a constant intuition of the unity of all life, and the instinctive and ineradicable conviction that the recognition of this unity is the highest good and the uttermost freedom. All that India can offer to the world proceeds from her philosophy. This philosophy is not, indeed, unknown to others—it is equally the gospel of Jesus and of Blake, Lao Tze, and Rūmī—but nowhere else has it been made the essential basis of sociology and education.

Every race must solve its own problems, and those of its own day. I do not suggest that the ancient Indian solution of the special Indian problems, though its lessons may be many and valuable, can be directly applied to modern conditions. What I do suggest is that the Hindus grasped more firmly than others the fundamental meaning and purpose of life, and more deliber-

[1] First published in the 'Athenæum,' London, 1915.

ately than others organized society with a view to the attainment
of the fruit of life; and this organization was designed, not for
the advantage of a single class, but, to use a modern formula, to
take from each according to his capacity, and to give to each
according to his needs. How far the *rishis* succeeded in this
aim may be a matter of opinion. We must not judge of Indian
society, especially Indian society in its present moment of decay,
as if it actually realized the Brahmanical social ideas; yet even
with all its imperfections Hindu society as it survives will appear
to many to be superior to any form of social organization attained
on a large scale anywhere else, and infinitely superior to the social
order which we know as "modern civilization." But even if it
were impossible to maintain this view—and a majority of Euro-
peans and of English-educated Indians certainly believe to the
contrary—what nevertheless remains as the most conspicuous
special character of the Indian culture, and its greatest signifiance
for the modern world, is the evidence of a constant effort to
understand the meaning and the ultimate purpose of life, and a
purposive organization of society in harmony with that order,
and with a view to the attainment of the purpose.[1] The Brah-
manical idea is an Indian "City of the gods"—as *devanāgarī,* the
name of the Sanskrit script, suggests. The building of that
city anew is the constant task of civilization; and though the
details of our plans may change, and the contours of our building,
we may learn from India to build on the foundations of the
religion of Eternity.

Where the Indian mind differs most from the average mind of
modern Europe is in its view of the value of philosophy. In
Europe and America the study of philosophy is regarded as an

[1] Lest I should seem to exaggerate the importance which Hindus attach
to *Adhyātmā-vidyā,* the Science of the Self, I quote from the '*Bhagavad
Gītā,*' ix. 2: " It is the kingly science, the royal secret, sacred surpassingly.
It supplies the only sanction and support to righteousness, and its benefits
may be seen even with the eyes of the flesh as bringing peace and perma-
nence of happiness to men"; and from Manu, xii. 100: "Only he who
knows the Vedaśāstra, only he deserves to be the Leader of Armies, the
Wielder of the Rod of Law, the King of Men, the Suzerain and Overlord
of Kings."

The reader who desires to follow up the subject of this essay is strongly
recommended to the work of Bhagavan Das, '*The Science of Social
Organization,*' London and Benares, 1910.

end in itself, and as such it seems of but little importance to the ordinary man. In India, on the contrary, philosophy is not regarded primarily as a mental gymnastic, but rather, and with deep religious conviction, as our salvation (*moksha*) from the ignorance (*avidyā*) which for ever hides from our eyes the vision of reality. Philosophy is the key to the map of life, by which are set forth the meaning of life and the means of attaining its goal. It is no wonder, then, that the Indians have pursued the study of philosophy with enthusiasm, for these are matters that concern all.

There is a fundamental difference between the Brahman and the modern view of politics. The modern politician considers that idealism in politics is unpractical; time enough, he thinks, to deal with social misfortunes when they arise. The same outlook may be recognized in the fact that modern medicine lays greater stress on cure than on prevention, *i. e.*, endeavours to protect against unnatural conditions rather than to change the social environment. The Western sociologist is apt to say: "The teachings of religion and philosophy may or may not be true, but in any case they have no significance for the practical reformer." The Brahmans, on the contrary, considered all activity not directed in accordance with a consistent theory of the meaning and purpose of life as supremely unpractical.

Only one condition permits us to excuse the indifference of the European individual to philosophy; it is that the struggle to exist leaves him no time for reflection. Philosophy can only be known to those who are alike disinterested and free from care; and Europeans are not thus free, whatever their political status. Where modern Industrialism prevails, the Brahman, Kshattriya, and Śūdra alike are exploited by the Vaishya,[1] and where in this way commerce settles on every tree there must be felt continual anxiety about a bare subsistence; the victim of Industry must confine his thoughts to the subject of to-morrow's food for himself and his family; the mere Will to Life takes precedence of the Will to Power. If at the same time it is decided that every man's voice is to count equally in the councils of the nation, it follows naturally that the voice of those who think must be

[1] Brahman, Kshattriya, Vaishya, Śūdra—the four primary types of Brahmanical sociology, *viz.*, philosopher and educator, administrator and soldier, tradesman and herdsman, craftsman and labourer.

drowned by that of those who do not think and have no leisure. This position leaves all classes alike at the mercy of unscrupulous individual exploitation, for all political effort lacking a philosophical basis becomes merely opportunist. The problem of modern Europe is to discover her own aristocracy and to learn to obey its will.

It is just this problem which India long since solved for herself in her own way. Indian philosophy is essentially the creation of the two upper classes of society, the Brahmans and the Kshattriyas. To the latter are due most of its forward movements; to the former its elaboration, systematization, mythical representation, and application. The Brahmans possessed not merely the genius for organization, but also the power to enforce their will; for, whatever may be the failings of individuals, the Brahmans as a class are men whom other Hindus have always agreed to reverence, and still regard with the highest respect and affection. The secret of their power is manifold; but it is above all in the nature of their appointed *dharma,* of study, teaching, and renunciation.

Of Buddhism I shall not speak at great length, but rather in parenthesis; for the Buddhists never directly attempted to organize human society, thinking that, rather than concern himself with polity, the wise man should leave the dark state of life in the world to follow the bright state of the mendicant.[1] Buddhist doctrine is a medicine solely directed to save the individual from burning, not in a future hell, but in the present fire of his own thirst. It assumes that to escape from the eternal recurrence is not merely the *summum bonum,* but the whole purpose of life; he is the wisest who devotes himself immediately to this end; he the most loving who devotes himself to the enlightenment of others.

Buddhism has nevertheless deep and lasting effects on Indian state-craft. For just as the Brahman philosopher advised and guided his royal patrons, so did the Buddhist ascetics. The sentiment of friendliness (*metteya*), through its effect upon individual character, reacted upon social theory.

It is difficult to separate what is Buddhist from what is Indian generally; but we may fairly take the statemanship of the great

[1] *Dhammapada,* 87; also the *Jātakamālā* of Ārya Śūra, xix, 27.

Buddhist Emperor Aśoka as an example of the effect of Buddhist teaching upon character and policy. His famous edicts very well illustrate the little accepted truth that "in the Orient, from ancient times, national government has been based on benevolence, and directed to securing the welfare and happiness of the people."[1] One of the most significant of the edicts deals with "True Conquest." Previous to his acceptance of the Buddhist *dharma* Aśoka had conquered the neighbouring kingdom of the Kalingas, and added their territory to his own; but now, says the edict, His Majesty feels "remorse for having conquered the Kalingas, because the conquest of a country previously unconquered involves the slaughter, death, and carrying away captive of the people. That is a matter of profound sorrow and regret to His Sacred Majesty . . . His Sacred Majesty desires that all animate beings should have security, self-control, peace of mind, and joyousness.... My sons and grandsons, who may be, should not regard it as their duty to conquer a new conquest. If perchance they become engaged in a conquest by arms, they should take pleasure in patience and gentleness, and regard as (the only true) conquest, the conquest won by piety. That avails both for this world and the next."

In another edict "His Sacred and Gracious Majesty the King does reverence to men of all sects, whether ascetics or householders." Elsewhere he announces the establishment of hospitals, and the appointment of officials "to consider the case where a man has a large family, has been smitten by calamity, or is advanced in years"; he orders that animals should not be killed for his table; he commands that shade and fruit trees should be planted by the high roads; and he exhorts all men to "strive hard." He quotes the Buddhist saying, "All men are my children." The annals of India, and especially of Ceylon, can show us other Buddhist kings of the same temper. But it will be seen that such effects of Buddhist teaching have their further consequences mainly through benevolent despotism, and the moral order established by one wise king may be destroyed by his successors. Buddhism, so far as I know, never attempted to

[1] Viscount Torio in *The Japan Daily Mail*, November 19th-20th, 1890. The whole essay, of which a good part is quoted in Lafcadio Hearn's *' Glimpses of Unfamiliar Japan,'* is a searching criticism of Western polity, regarded from the standpoint of a modern Buddhist.

formulate a constitution or to determine the social order. Just this, however, the Brahmans attempted in many ways, and to a great extent achieved, and it is mainly their application of religious philosophy to the problems of sociology which forms the subject of the present discussion.

The Kshattriya-Brahman solution of the ultimate problems of life is given in the early Upanishads.[1] It is a form of absolute (according to Śankarāchārya) or modified (according to Rāmānuja) Monism. Filled with enthusiasm for this doctrine of the Unity or Interdependence of all life, the Brahman-Utopists set themselves to found a social order upon the basis provided. In the great epics[2] they represented the desired social order as having actually existed in a golden past, and they put into the mouths of the epic heroes not only their actual philosophy, but the theory of its practical application—this, above all, in the long discourses of the dying Bhīshma. The heroes themselves they made ideal types of character for the guidance of all subsequent generations; for the education of India has been accomplished deliberately through hero-worship. In the 'Dharmaśāstra' of Manu[3] and the 'Arthaśāstra'[4] of Chānakya—perhaps the most remarkable sociological documents the world possesses—they set forth the picture of the ideal society, defined from the standpoint of law. By these and other means they accomplished what has not yet been effected in any other country in making religious philosophy the essential and intelligible basis of popular culture and national polity.

[1] Deussen, *The Philosophy of the Upanishads,* translated by A. S. Geden, London, 1906.

[2] The 'Mahābhārata' and 'The Rāmāyaṇa.' These can be studied in the prose translations by P. C. Ray and M. N. Dutt, published in Calcutta.

[3] This most important document is best expounded by Bhagavan Das, *The Science of Social Organization,* London and Benares, 1910; also translated in full in the "Sacred Books of the East," vol. xxv. "Herein," says Manu (i. 107, 118), "are declared the good and evil results of various deeds, and herein are expounded the eternal principles of all the four types of human beings, of many lands, nations, tribes, and families, and also the ways of evil men."

[4] N. N. Law, *Studies in Ancient Hindu Polity,* London, 1914. The following precept may serve as an example of the text: that the king who has acquired new territory "should follow the people in their faith, with which they celebrate their national, religious, and congregational festivals and amusements."

What, then, is the Brahman view of life? To answer this at length, to expound the Science of the Self (*Adhyātmā-vidyā*), which is the religion and philosophy of India, would require considerable space. We have already indicated that this science recognizes the unity of all life—one source, one essence, and one goal—and regards the realization of this unity as the highest good, bliss, salvation, freedom, the final purpose of life. This is for Hindu thinkers eternal life; not an eternity in time, but the recognition here and now of All Things in the Self and the Self in All. "More than all else," says Kabīr, who may be said to speak for India, "do I cherish at heart that love which makes me to live a limitless life *in this world*." This inseparable unity of the material and spiritual world is made the foundation of the Indian culture, and determines the whole character of her social ideals.

How, then, could the Brahmans tolerate the practical diversity of life, how provide for the fact that a majority of individuals are guided by selfish aims, how could they deal with the problem of evil? They had found the Religion of Eternity (*Nirguṇa Vidyā*); what of the Religion of Time (*Saguṇa Vidyā*)?

This is the critical point of religious sociology, when it remains to be seen whether the older idealist (it is old souls that are idealistic, the young are short-sighted) can remember his youth, and can make provision for the interest and activities of spiritual immaturity. To fail here is to divide the church from the everyday life, and to create the misleading distinction of sacred and profane; to succeed is to illuminate daily life with the light of heaven.

The life or lives of man may be regarded as constituting a curve—an arc of time-experience subtended by the duration of the individual Will to Life. The outward movement on this curve—Evolution, the Path of Pursuit—the *Pravṛitti Mārga*—is characterized by self-assertion. The inward movement—Involution, the Path of Return—the *Nivṛitti Mārga*—is characterized by increasing Self-realization.[1] The religion of men on the outward

[1] It is a common convention of Indianists to print the world "self" in lower case when the ego (*jīvātman*) is intended, and with a capital when the higher self, the divine nature (*paramātman*), is referred to. Spiritual freedom—the true goal—is the release of the self from the ego concept.

path is the Religion of Time; the religion of those who return is the Religion of Eternity. If we consider life as one whole, certainly Self-realization must be regarded as its essential purpose from the beginning; all our forgetting is but that we may remember the more vividly. But though it is true that in most men the two phases of experience interpenetrate, we shall best understand the soul of man—drawn as it is in the two opposite, or seeming opposite, directions of Affirmation and Denial, Will and Will-surrender—by separate consideration of the outward and the inward tendencies. Brahmans avoid the theological use of the terms "good" and "evil," and prefer to speak of "knowledge" and "ignorance" (*vidyā* and *avidyā*), and of the three qualities of *sattva, rajas,* and *tamas.* As knowledge increases, so much the more will a man of his own motion, and not from any sense of duty, tend to return, and his character and actions will be more purely *sāttvic.* But we need not on that account condemn the self-assertion of the ignorant as sin; for could Self-realization be where self-assertion had never been? It is not sin, but youth, and to forbid the satisfaction of the thirst of youth is not a cure; rather, as we realize more clearly every day *desires suppressed breed pestilence.* The Brahmans therefore, notwithstanding the austere rule appointed for themselves, held that an ideal human society must provide for the enjoyment of all pleasures by those who wish for them; they would say, perhaps, that those who have risen above the mere gratification of the senses, and beyond a life of mere pleasure, however refined, are just those who have already tasted pleasure to the full.

For reasons of this kind it was held that the acquisition of wealth (*artha*) and the enjoyment of sense-pleasure (*kāma*), subject to such law (*dharma*[1]) as may protect the weak against the strong, are the legitimate preoccupations of those on the outward path. This is the stage attained by modern Western society, of which the norm is competition regulated by ethical restraint. Beyond this stage no society can progress unless it is subjected to the creative will of those who have passed beyond the stage of most extreme egoism, whether we call them heroes,

[1] *Dharma* is that morality by which a given social order is protected. "It is by *Dharma* that civilization is maintained" (*Matsya Purāna,* cxlv. 27). *Dharma* may also be translated as social norm, moral law, order, duty, righteousness, or as religion, mainly in its exoteric aspects.

guardians, Brahmans, Samurai, or simply men of genius.

Puritanism consists in a desire to impose the natural asceticism of age upon the young, and this position is largely founded on the untenable theories of an absolute ethic and an only true theology. The opposite extreme is illustrated in industrial society, which accepts the principles of competition and self-assertion as a matter of course, while it denies the value of philosophy and discipline. Brahman sociology, just because of its philosophical basis, avoided both errors in adopting the theory of *sva-dharma*, the "own-morality" appropriate to the individual according to his social and spiritual status, and the doctrine of the many forms of Īśvara, which is so clumsily interpreted by the missionaries as polytheistic. However much the Brahmans held Self-realization to be the end of life, the *summum bonum*, they saw very clearly that it would be illogical to impose this aim immediately upon those members of the community who are not yet weary of self-assertion. It is most conspicuously in this understanding tolerance that Brahman sociology surpasses other systems.

At this point we must digress to speak briefly of the doctrine of reincarnation, which is involved in the theory of eternal recurrence. This doctrine is assumed and built upon by Brahman sociologists, and on this account we must clearly understand its practical applications. We must not assume that reincarnation is a superstition which, if it could be definitely refuted (and that is a considerable "if"), would have as a theory no practical value. Even atoms and electrons are but symbols, and do not represent tangible objects like marbles, which we could see if we had large enough microscopes; the practical value of a theory does not depend on its representative character, but on its efficacy in resuming past observation and forecasting future events. The doctrine of reincarnation corresponds to a fact which everyone must have remarked; the varying age of the souls of men, irrespective of the age of the body counted in years. "A man is not an elder because his head is grey" (*Dhammapada*, 260). Sometimes we see an old head on young shoulders. Some men remain irresponsible, self-assertive, uncontrolled, unapt to their last day; others from their youth are serious, self-controlled, talented, and friendly. We must understand the doctrine of reincarnation at any rate as an artistic or mythical representation of these facts. To these facts the Brahmans rightly attached

great importance, for it is this variation of temperament or inheritance which constitutes the natural inequality of men, an inequality that is too often ignored in the theories of Western democracy.

We can now examine the Brahmanical theory a little more closely. An essential factor is to be recognized in the dogma of the rhythmic character of the world-process. This rhythm is determined by the great antithesis of Subject and Object, Self and not-Self, Will and Matter, Unity and Diversity, Love and Hate, and all other "Pairs." The interplay of these opposites constitues the whole of sensational and registrateable existence, the Eternal Becoming (*samsāra*), which is characterized by birth and death, evolution and involution, descent and ascent, *srishṭi* and *samhāra*. Every individual life—mineral, vegetable, animal, human, or personal god—has a beginning and an end, and this creation and destruction, appearance and disappearance, are of the essence of the world-process and equally originate in the past, the present, and the future. According to this view, then, every individual ego (*jīvātman*), or separate expression of the general Will to Life (*ichchhā*, *trishṇa*), must be regarded as having reached a certain stage of its own cycle (*gati*). The same is true of the collective life of a nation, a planet, or a cosmic system. It is further considered that the turning point of this curve is reached in man, and hence the immeasurable value which Hindus (and Buddhists) attach to birth in human form. Before the turning point is reached—to use the language of Christian theology—the natural man prevails; after it is passed, regenerate man. The turning point is not to be regarded as sudden, for the two conditions interpenetrate, and the change of psychological centre of gravity may occupy a succession of lives; or if the turning seems to be a sudden event, it is only in the sense that the fall of a ripe fruit appears sudden.

According to their position on the great curve, that is to say, according to their spiritual age, we can recognize three prominent types of men. There is first the mob, of those who are preoccupied with the thought of I and Mine, whose objective is self-assertion, but are restrained on the one hand by fear of retaliation and of legal or after-death punishment, and on the other by the beginnings of love of family and love of country. These, in the main, are the "Devourers" of Blake, the "Slaves" of Nietzsche. Next there is a smaller, but still large number of thoughtful and

good men whose behaviour is largely determined by a sense of duty, but whose inner life is still the field of conflict between the old Adam and the new man. Men of this type are actuated on the one hand by the love of power and fame, and ambition more or less noble, and on the other by the disinterested love of mankind. But this type is rarely pan-human, and its outlook is often simultaneously unselfish and narrow. In times of great stress, the men of this type reveal their true nature, showing to what extent they have advanced more or less than has appeared. But all these, who have but begun to taste of freedom, must still be guided by rules. Finally, there is the much smaller number of great men—heroes, saviours, saints, and avatars—who have definitely passed the period of greatest stress and have attained peace, or at least have attained to occasional and unmistakeable vision of life as a whole. These are the "Prolific" of Blake, the "Masters" of Nietzsche, the true Brahmans in their own right, and partake of the nature of the Superman and the Bodhisattva. Their activity is determined by their love and wisdom, and not by rules. In the world, but not of it, they are the flower of humanity, our leaders and teachers.

These classes constitute the natural hierarchy of human society. The Brahman sociologists were firmly convinced that in an ideal society, i. e., a society designed deliberately by man for the fulfilment of his own purpose (*purushārtha*),[1] not only must opportunity be allowed to every one for such experience as his spiritual status requires, but also that the best and wisest must rule. It seemed to them impossible that an ideal society should have any other than an aristocratic basis, the aristocracy being at once intellectual and spiritual. Being firm believers in heredity, both of blood and culture, they conceived that it might be possible to constitute an ideal society upon the already existing basis of occupational caste. "If," thought they, "we can determine natural

[1] *Purushārtha*. This is the Brahmanical formula of utility, forming the standard of social ethics. A given activity is useful, and therefore right, if it conduces to the attainment of *dharma, artha, kāma* and *moksha* (function, prosperity, pleasure, and spiritual freedom), or any one or more of these without detriment to any other. Brahmanical utility takes into account the whole man. Industrial sociologists entertain a much narrower view of utility: "It is with utilities that have a price that political economy is mainly concerned" (Nicholson, *Principles of Political Economy*, ed. 2, p. 28).

classes, then let us assign to each its appropriate duties (*sva-dharma*, own norm) and appropriate honour; this will at once facilitate a convenient division of necessary labour, ensure the handing down of hereditary skill in pupillary succession, avoid all possibility of social ambition, and will allow to every individual the experience and activity which he needs and owes." They assumed that by a natural law, the individual ego is always, or nearly always, born into its own befitting environment. If they were wrong on this point, then its remains for others to discover some better way of achieving the same ends. I do not say that this is impossible; but it can hardly be denied that the Brahmanical caste system is the nearest approach that has yet been made towards a society where there shall be no attempt to realise a competitive equality, but where all interests are regarded as identical. To those who admit the variety of age in human souls, this must appear to be the only true communism.

To describe the caste system as an idea or in actual practice would require a whole volume. But we may notice a few of its characteristics. The nature of the difference between a Brahman and a Śūdra is indicated in the view that a Śūdra can do no wrong,[1] a view that must make an immense demand upon the patience of the higher castes, and is the absolute converse of the Western doctrine that the King can do no wrong. These facts are well illustrated in the doctrine of legal punishment, that that of the Vaishya should be twice as heavy as that of the Śūdra, that that of the Kshattriya twice as heavy again, that of the Brahman twice or even four times as heavy again in respect of the same offence; for responsibility rises with intelligence and status. The Śūdra is also free of innumerable forms of self-denial imposed upon the Brahman; he may, for example, indulge in coarse food, the widow may re-marry. It may be observed that it was strongly held that the Śūdra should not by any means outnumber the other castes; if the Śūdras are too many, as befell in ancient Greece, where the slaves outnumbered freemen, the voice of the least wise may prevail by mere weight of numbers.

Modern craftsmen interested in the regulation of machinery will be struck by the fact that the establishment and working of large machines and factories by individuals was reckoned a grievous

[1] Manu, x. 126.

sin; large organizations are only to be carried on in the public interest.[1]

Given the natural classes, one of the good elements of what is now regarded as democracy was provided by making the castes self-governing; thus it was secured that a man should be tried by his peers (whereas, under Industrial Democracy, an artist may be tried by a jury of tradesmen, or a poacher by a bench of squires). Within the caste there existed equality of opportunity for all, and the caste as a body had collective privileges and responsibilities. Society thus organized has much the appearance of what would now be called Guild Socialism.

In a just and healthy society, function should depend upon capacity; and in the normal individual, capacity and inclination are inseparable (this is the 'instinct of workmanship'). We are able accordingly to recognize, in the theory of the Syndicalists, as well as in the caste organization of India, a very nearly ideal combination of duty and pleasure, compulsion and freedom; and the words vocation or *dharma* imply this very identity. Individualism and socialism are united in the concept of function.

The Brahmanical theory has also a far-reaching bearing on the problems of education. "Reading," says the *Garuda Purāna*, "to a man devoid of wisdom, is like a mirror to the blind." The Brahmans attached no value to uncoördinated knowledge or to unearned opinions, but rather regarded these as dangerous tools in the hands of unskilled craftsmen. The greatest stress is laid on the development of character. Proficiency in hereditary aptitudes is assured by pupillary succession within the caste. But

[1] Manu, xi. 63, 64, 66.
A truly progressive society is only possible where there is unity of purpose. How rapidly the social habit can then be changed is well illustrated by the action of many of the Allied Governments in taking control of several departments of industrial production. It is only sad to reflect that it needed a great disaster to compel so simple an act as the limitation of profits. In the same way vast sums are now spent on caring for the welfare of an army of soldiers who would be, and will again be, left to the tender mercies of the labour market in times of peace. If the nation were as united in peace by a determination to make the best of life how much could not be accomplished at a fraction of the cost of war? If a nation can co-operate for self-defence, why not also for self-development?

it is in respect of what we generally understand by higher educa-
tion that the Brahman method differs most from modern ideals;
for it is not even contemplated as desirable that all knowledge
should be made accessible to all. The key to education is to be
found in personality. There should be no teacher for whom
teaching is less than a vocation (none may "sell the Vedas"), and
no teacher should impart his knowledge to a pupil until he finds
the pupil ready to receive it, and the proof of this is to be
found in the asking of the right questions. "As the man who
digs with a spade obtains water, even so an obedient pupil obtains
the knowledge which is in his teacher."[1]

The relative position of man and woman is also very note-
worthy. Perhaps the woman is in general a younger soul, as
Paracelsus puts it, "nearer to the world than man." But there is
no war of words as to which is the superior, which inferior; for
the question of competitive equality is not considered. The Hindu
marriage contemplates identity, and not equality.[2] The pri-
mary motif of marriage is not merely individual satisfaction, but
the achievement of *Purushārta,* the purposes of life, and the
wife is spoken of as *sahadharmachārinī,* "she who coöperates in
the fulfillment of social and religious duties." In the same way
for the community at large, the system of caste is designed rather
to unite than to divide. Men of different castes have more in
common than men of different classes. It is in an Industrial
Democracy, and where a system of secular education prevails,
that groups of men are effectually separated; a Western professor
and a navvy do not understand each other half so well as a
Brahman and a Śūdra. It has been justly remarked that "the
lowest pariah hanging to the skirts of Hindu society is in a
sense as much the disciple of the Brahman ideal as any priest
himself."

It remains to apply what has been said to immediate problems.
I have suggested that India has nothing of more value to offer to
the world than her religious philosophy, and her faith in the
application of philosophy to social problems. A few words may

[1] Manu, ii. 218.
[2] Manu, ix. 45. "The man is not the man alone; he is the man, the
woman, and the progeny. The Sages have declared that the husband is
the same as the wife."

be added on the present crisis[1] and the relationship of East and West. Let us understand first that what we see in India is a co-operative society in a state of decay. Western society has never been so highly organized, but in so far as it was organized, its disintegration has proceeded much further than is yet the case in India. And we may expect that Europe, having sunk into industrial competition first, will be the first to emerge. The seeds of a future co-operation have long been sown, and we can clearly recognize a conscious, and perhaps also an unconscious, effort towards reconstruction.

In the meantime the decay of Asia proceeds, partly of internal necessity, because at the present moment the social change from co-operation to competition is spoken of as progress, and because it seems to promise the ultimate recovery of political power, and partly as the result of destructive exploitation by the Industrialists. Even those European thinkers who may be called the prophets of the new age are content to think of a development taking place in Europe alone. But let it be clearly realized that the modern world is not the ancient world of slow communications; what is done in India or Japan to-day has immediate spiritual and economic results in Europe and America. To say that East is East and West is West is simply to hide one's head in the sand.[2] It will be quite impossible to establish any

[1] I do not mean the present war, as such, but civilization at the parting of the ways.

[2] I should like to point out here that Mr. Lowes Dickinson's return to this position ('An Essay on India, China, and Japan,' and 'Appearances,' both 1914), is very unfortunate. He says the religion of India is the Religion of Eternity, the religion of Europe the Religion of Time, and chooses the latter. These phrases, by the way, are excellent renderings of *Pravṛitti dharma* and *Nivṛitti dharma*. So far as Mr. Dickinson's distinction is true, in so far that is as India suffers from premature *vairāgya*, and Europe from excessive activity, so far each exhibits an excess which each should best be able to correct. But an antithesis of this sort is only conceptually possible, and no race or nation has ever followed either of the religions exclusively. All true civilization is the due adjustment of the two points of view. And just because this balance has been so conspicuously attained in India, one who knows far more of India than Mr. Dickinson remarks that she "may yet be destined to prepare the way for the reconciliation of Christianity with the world, and through the practical identification of the spiritual with the temporal life, to hasten the period of that third step forward in the moral development of human-

higher social order in the West so long as the East remains in-
fatuated with the, to her, entirely novel and fascinating theory of
laissez-faire.

The rapid degradation of Asia is thus an evil portent for the
future of humanity and for the future of that Western social
idealism of which the beginnings are already recognizable. If,
either in ignorance or in contempt of Asia, constructive European
thought omits to seek the co-operation of Eastern philosophers,
there will come a time when Europe will not be able to fight
Industrialism, because this enemy will be entrenched in Asia. It
is not sufficient for the English colonies and America to protect
themselves by immigration laws against cheap Asiatic labour;
that is a merely temporary device, and likely to do more harm
than good, even apart from its injustice. Nor will it be possible
for the European nationalist ideal that every nation should choose
its own form of government, and lead its own life,[1] to be realized,
so long as the European nations have, or desire to have,
possessions in Asia. What has to be secured is the conscious
co-operation of East and West for common ends, not the sub-
jection of either to the other, nor their lasting estrangement. For
if Asia be not with Europe, she will be against her, and there
may arise a terrible conflict, economic, or even armed, between
an idealistic Europe and a materialized Asia.

To put the matter in another way, we do not fully realize the
debt that Europe already owes to Asiatic thought, for the dis-
covery of Asia has hardly begun. And, on the other hand, Europe
has inflicted terrible injuries upon Asia in modern times.[2] I do
not mean to say that the virus of "civilization" would not have
spread through Asia quite apart from any direct European at-
tempts to effect such a result—quite on the contrary; but it can-

ity, when there will be no divisions of race, creed, or class, or nationality
between men, by whatsoever name they may be called, for they will all
be one in the acknowledgment of their common Brotherhood " (Sir George
Birdwood, *Sva,* p. 355).

[1] The ideal of self-determination (*sva-rāj*) for which the Allies claim
to be fighting.

[2] For example—and without the least ill-will—the English in India
who unconsciously created social confusion simply because they could not
understand what they saw, and endeavoured to fit a co-operative structure
into the categories of modern political theory.

not be denied that those who have been the unconscious instruments of the degradation of Asiatic society from the basis of *dharma* to the basis of contract have incurred a debt.

The "clear air" of Asia is not merely a dream of the past. There is idealism, and there are idealists in modern India, even amongst those who have been corrupted by half a century of squalid education. We are not all deceived by the illusion of progress, but, like some of our European colleagues, desire "the coming of better conditions of life, when the whole world will again learn that the object of human life is not to waste it in a feverish anxiety and race after physical objects and comforts, but to use it in developing the mental, moral, and spiritual powers, latent in man." [1] The debt, then, of Europe, can best be paid—and with infinite advantage to herself—by seeking the co-operation of modern Asia in every adventure of the spirit which Europe would essay. It is true that this involves the hard surrender of the old idea that it is the mission of the West to civilize the East; but that somewhat Teutonic and Imperial view of *kultur* is already discredited. What is needed for the common civilization of the world is the recognition of common problems, and to co-operate in their solution. If it be asked what inner riches India brings to aid in the realization of a civilization of the world, then, from the Indian standpoint, the answer must be found in her religions and her philosophy, and her constant application of abstract theory to practical life.

[1] S. C. Basu, *The Daily Practice of the Hindus*, 2nd ed., p. 4.

HINDU VIEW OF ART:
1. HISTORY OF ÆSTHETIC

The earliest Indian art of which we have any information or concerning which we are able to draw reasonably certain inferences, we may designate as Vedic, since we can hardly undertake here the discussion of the perhaps contemporary culture of the early Dravidians. Vedic art was essentially practical. About painting and sculpture we have no knowledge, but the carpenter, metal-worker and potter and weaver efficiently provided for man's material requirements. If their work was decorated, we may be sure that its 'ornament' had often, and perhaps always, a magical and protective significance. The ends of poetry were also practical. The Vedic hymns were designed to persuade the gods to deal generously with men:

> "As birds extend their sheltering wings,
> Spread your protection over us."
>
> (*Rigveda.*)

Much of this poetry is descriptive; it is nature-poetry in the sense that it deals with natural phenomena. Its most poetical quality is its sense of wonder and admiration, but it is not lyrical in any other sense. It has no tragic or reflective elements, except in some of the later hymns, and there is no question of 'æsthetic contemplation,' for the conception of the sympathetic constantly prevails. The poet sometimes comments on his own work, which he compares to a car well-built by a deft craftsman, or to fair and well-woven garments, or to a bride adorned for her lover; and this art it was that made the hymns acceptable to the gods to whom they were addressed. Vedic Æsthetic consisted essentially in the appreciation of skill.

The keynote of the age of the Upanishads (800 B. C.) and Pali Buddhism (500 B. C.) is the search for truth. The ancient hymns had become a long-established institution, taken for granted; ritual was followed solely for the sake of advantage in this world or the next. Meanwhile the deeper foundations

of Indian culture were in process of determination in the mental struggle of the 'dwellers in the forest.' The language of the Upanishads combines austerity with passion, but this passion is the exaltation of mental effort, remote from the common life of men in the world. Only here and there we find glimpses of the later fusion of lyric and religious experience, when, for example, in the *Brihadāraṇyaka Upanishad,* the bliss of ātman-intuition, or the intuition of the Self, is compared with the happiness of earthly lovers in self-forgetting dalliance. In general, the Upanishads are too much preoccupied with deeper speculations to exhibit a conscious art, or to discuss the art of their times; in this age there is no explicit Æsthetic.

When, however, we consider the Indian way of regarding the Vedas as a whole, we shall find implicit in the word '*śruti*' a very important doctrine; that the Veda is eternal, the sacred books are its temporal expression, they have been 'heard.' This is not a theory of 'revelation' in the ordinary sense, since the audition depends on the qualification of the hearer, not on the will and active manifestation of a god. But it is on all fours with the later Hindu view which treats the practice of art as a form of *yoga,* and identifies æsthetic emotion with that felt when the self perceives the Self.

In Pali Buddhism generally, an enthusiasm for the truth, unsurpassed even in the Upanishads, is combined with monastic institutionalism and a rather violent polemic against the joys of the world. Beauty and personal love are not merely evanescent, but are snares to be avoided at all costs; and it is clearly indicated that the Early Buddhist Æsthetic is strictly hedonistic. The indications of this point of view are summed up in the following pages of the *Visuddhi Magga*: "Living beings on account of their love and devotion to the sensations excited by forms and the other objects of sense, give high honour to painters, musicians, perfumers, cooks, elixir-prescribing physicians, and other like persons who furnish us with objects of sense."

In the Upanishads on the one hand, and in the teachings of Buddha on the other, the deepest problems of life were penetrated; the mists of the Vedic dawn had melted in the fire of austerity (*tapas*), and life lay open to man's inspection as a thing of which the secret mechanism was no more mysterious. We can scarcely exaggerate the sense of triumph with which the

doctrines of the Ātman or Self and the gospel of Buddha per-
meated Indian society. The immediate result of the acceptance
of these views appeared in an organized and deliberate endeavour
to create a form of society adapted for the fulfilment of the
purposes of life as seen in the light of the new philosophies. To
the ideal of the saint in retirement was very soon added that of
the man who remains in the world and yet acquires or possesses
the highest wisdom—"It was with works that Janaka and others
came unto adeptship" (*Gītā*, iii. 20). There was now also evolved
the doctrine of union by action (*karma-yoga*) set forth in the
Bhagavad Gītā, as leading even the citizen on the path of sal-
vation. The emergence of a definitely Brahmanical rather than a
Buddhist scheme of life is to be attributed to the fact that the
practical energies of Buddhists were largely absorbed within the
limits of its monasticism; the Buddhists in the main regard Nir-
vāna not merely as the ultimate, but as the sole object of life.
But the Brahmans never forgot that this life is the field alike of
Pursuit and Return. Their scheme of life is set forth at great
length in the Sūtra literature, the *Dharma Śāstras* and the Epics
(in general, 4th—1st centuries B. C.).

This literature yields sufficient material for an elucidation of
the orthodox view of art. But notwithstanding the breadth of
the fourfold plan, we find in this literature the same hedonistic
Æsthetic and puritanical applications as are characteristic of Pali
Buddhism. Thus, Manu forbids the householder to dance or sing
or play on musical instruments, and reckons architects, actors and
singers amongst the unworthy men who should not be invited to
the ceremony of offerings to the dead. Even Chānakya, though
he tolerates musicians and actors, classes them with courtesans.
The hedonistic theory still prevailed. In later times the 'defence'
of any art, such as poetry or drama, was characteristically based
on the fact that it could contribute to the achievement of all or
any of the Four Aims of Life.

, Meanwhile the stimulus of discovered truth led not only to
this austere formulation of a scheme of life (typically in Manu),
but also to the development of *yoga* as a practice for the attain-
ment of the desired end; and in this development an almost equal
part was taken by Brahmans and Buddhists (typically in Patañ-
jali and Nāgārjuna).

We shall digress here, and partially anticipate, to discuss briefly

the important part once played in Indian thought by the concept of Art as Yoga, a subject sufficient in itself for a whole volume. It will be remembered that the purpose of Yoga is mental concentration, carried so far as the overlooking of all distinction between the subject and the object of contemplation; a means of achieving harmony or unity of consciousness.

It was soon recognized that the concentration of the artist was of this very nature; and we find such texts as Śukrāchārya's:

"Let the imager establish images in temples by meditation on the deities who are the objects of his devotion. For the successful achievement of this yoga the lineaments of the image are described in books to be dwelt upon in detail. In no other way, not even by direct and immediate vision of an actual object, is it possible to be so absorbed in contemplation, as thus in the making of images."

The manner in which even the lesser crafts constitute a practice (āchārya) analogous to that of (samprajñātā) yoga is indicated incidentally by Śankarāchārya in the commentary on the *Brahma Sūtra*, 3, 2, 10. The subject of discussion is the distinction of swoon from waking; in swoon the senses no longer perceive their objects. Śankarāchārya remarks, "True, the arrow-maker perceives nothing beyond his work when he is buried in it; but he has nevertheless consciousness and control over his body, both of which are absent in the fainting person." The arrow-maker seems to have afforded, indeed, a proverbial instance of single-minded attention, as we read in the *Bhāgavata Purāṇa.*

"I have learned concentration from the maker of arrows."

A connection between dream and art is recognized in a passage of the *Agni Purāṇa,*[1] where the imager is instructed, on the night before beginning his work, and after ceremonial purification, to pray, "O thou Lord of all the gods, teach me in dreams how to carry out all the work I have in my mind." Here again we see an anticipation of modern views, which associate myth and dream and art as essentially similar and representing the dramatisation of man's innermost hopes and fears.

The practise of visualisation, referred to by Śukrāchārya, is identical in worship and in art. The worshipper recites the

[1] *Agni Purāṇa*, ch. xliii. Cf. Patañjali, *Yoga Sūtra*, 1, 38. For the theory of dreams see also *Katha Upanishad*, v. 8, and *Bṛihadāraṇyaka Upanishad,* iv. 3, 9-14 and 16-18.

dhyāna mantram describing the deity, and forms a corresponding mental picture, and it is then to this imagined form that his prayers are addressed and the offerings are made. The artist follows identical prescriptions, but proceeds to represent the mental picture in a visible and objective form, by drawing or modelling. Thus, to take an example from Buddhist sources:[1]

The artist (*sādhaka, mantrin,* or *yogin,* as he is variously—and significantly—called), after ceremonial purification, is to proceed to a solitary place. There he is to perform the "Sevenfold Office," beginning with the invocation of the hosts of Buddhas and Bodhisattvas, and the offering to them of real or imaginary flowers. Then he must realize in thought the four infinite moods of friendliness, compassion, sympathy, and impartiality. Then he must meditate upon the emptiness (*śūnyatā*) or non-existence of all things, for "by the fire of the idea of the abyss, it is said, there are destroyed beyond recovery the five factors" of ego-consciousness.[2] Then only should he invoke the desired divinity by the utterance of the appropriate seed-word (*bīja*) and should identify himself completely with the divinity to be represented. Then finally on pronouncing the *dhyāna mantram,* in which the attributes are defined, the divinity appears visibly, "like a reflection," or "as in a dream" and this brilliant image is the artist's model.

This ritual is perhaps unduly elaborated, but in essentials it shows a clear understanding of the psychology of the imagination. These essentials are the setting aside the transformations of the thinking principle[3]; self-identification with the object of

[1] Condensed from Foucher, *Iconographie Bouddhique,* 11, 8-11.

[2] Similar views are met with again and again in modern aesthetic. Goethe perceived that he who attains to the vision of beauty is from himself set free: Riciotto Canudo remarks that the secret of all art is self-forgetfulness: and Laurence Binyon that "we too should make ourselves empty, that the great soul of the universe may fill us with its breath (*Ideas of Design in East and West,* Atlantic Monthly, 1913).

[3] Wagner speaks of "an internal sense which becomes clear and active when all the others, directed outward, sleep or dream" (Combarieu, *Music, its Laws and Evolution, p.* 63). That God is the actual theme of all art is suggested by Śankarāchārya in the commentary on the *Brahmā Sūtra,* i, i, 20-21, where he indicates the Brahman as the real theme of secular as well as spiritual songs: and according to Behmen, "It is nought indeed but thine own hearing and willing that do hinder thee, so that thou dost not see and hear God (*Dialogues on the Supersensual Life.*)

the work;[1] and vividness of the final image.[2]

There are abundant literary parallels for this conception of art as yoga. Thus Vālmīki, although he was already familiar with the story of Rāma, before composing his own *Rāmāyaṇa* sought to realize it more profoundly, and "seating himself with his face towards the East, and sipping water according to rule (*i. e.* ceremonial purification), he set himself to yoga-contemplation of his theme. By virtue of his yoga-power he clearly saw before him Rāma, Lakshmaṇa and Sītā, and Daśaratha, together with his wives, in his kingdom laughing, talking, acting and moving as if in real life . . . by yoga-power that righteous one beheld all that had come to pass, and all that was to come to pass in the future, like a nelli fruit[3] on the palm of his hand. And having truly seen all by virtue of his concentration, the generous sage began the setting forth of the history of Rāma."[4]

Notice here particularly that the work of art is completed before the work of transcription or representation is begun.[5] "The mind of the sage," says Chuang Tzu, "being in repose, becomes the mirror of the universe, the speculum of all creation." Croce is entirely correct when he speaks of "the artist, who never makes a stroke with his brush without having previously seen it with his imagination" and remarks that the externalisation of a work of art "implies a vigilant will, which persists in not allowing certain visions, intuitions, or representations to be lost."[6]

[1] Cf. the phrase *"Devam bhutvā, devam yajet"*: to worship the god become the god. That which remains for us object, remains unknown.

[2] "He who does not imagine in stronger and better lineaments," said Blake, "and in stronger and better light than his perishing mortal eye can see, does not imagine at all."

[3] *Phyllanthus emblica*, the round fruit of which is about the size of an ordinary marble. The simile is a common Indian formula for clear insight.

[4] *Rāmāyaṇa*, Bālakāṇḍam.

[5] Cf. Coomaraswamy and Duggirala, *The Mirror of Gesture*, Introduction, p. 3. So Vasubandhu speaks of the poet as seeing the world, like a jujube fruit, lying within the hollow of his hands (*Vāsavadatta*, invocation.) "It seems to me," William Morris wrote, "that no hour of the day passes that the whole world does not show itself to me": and Magnusson records of him, referring to *Sigurd the Volsung* and other poems, that "in each case the subject matter had taken such a clearly definite shape in his mind, as he told me, that it only remained to write it down."

[6] Croce, *Aesthetic*, pp. 162, 168.

It should be understood that yoga ('union') is not merely a mental exercise or a religious discipline, but the most practical preparation for any undertaking whatever. Hanuman, for example, before searching the Aśoka grove for Sītā, "prayed to the gods and ranged the forest in imagination till be found her"; then only did he spring from the walls of Lankā, like an arrow from a bow, and enter the grove in the flesh. Throughout the East, wherever Hindu or Buddhist thought have deeply penetrated, it is firmly believed that all knowledge is directly accessible to the concentred and 'one-pointed' mind, without the direct intervention of the senses. Probably all inventors, artists and mathematicians are more or less aware of this as a matter of personal experience. In the language of psycho-analysis, this concentration preparatory to undertaking a specific task is "the willed introversion of a creative mind, which, retreating before its own problem and inwardly collecting its forces, dips at least for a moment into the source of life, in order there to wrest a little more strength from the mother for the completion of its work," and the result of this reunion is "a fountain of youth and new fertility."[1]

We have spoken so far of yoga, but for the artist this was rather a means than an end. Just as in Mediaeval Europe, so too, and perhaps even more conspicuously in India, the impulse to iconolatry derived from the spirit of adoration—the loving and passionate devotion to a personal divinity, which we know as *bhakti*. Patañjali, in the *Yoga Sūtra*, mentions the Lord only as one amongst other suitable objects of contemplation, and without the use of any image being implied; but the purpose of the lover is precisely to establish a personal relation with the Beloved, and the plastic symbol is created for this end. A purely abstract philosophy or a psychology like that of Early Buddhism does not demand æsthetic expression; it was the spirit of worship which built upon the foundations of Buddhist and Vedantic thought the mansions of Indian religion, which shelter all those whom purely intellectual formulae could not satisfy— the children of this world who will not hurry along the path of Release, and the mystics who find a foretaste of freedom in the love of every cloud in the sky and flower at their feet.

[1] Jung, *Psychology of the Unconscious*, pp. 330, 336.

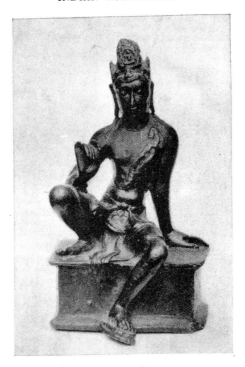

Figure a. Avalokiteśvara Bodhisattva. Buddhist bronze. Ceylon, 8th Century.
Museum of Fine Arts, Boston.

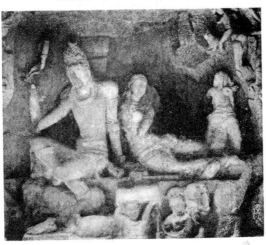

Figure b. Siva and Pārvatī on Mt. Kailāsa. Brahmanical stone sculpture,
Elūra, 8th Century.

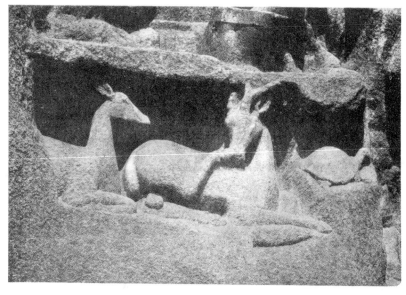

Figure a. Deer, Māmallapuram, 8th Century.

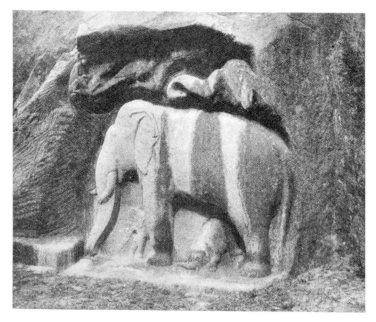

Figure b. Elephants, Māmallapuram, 8th Century.

This was indeed a return to superstition, or at any rate to duality; but what in this world is not a dream and a superstition? —certainly not the atoms of science. And for all those who are not yet idealists there are, as there must be, idols provided. The superstitions of Hinduism, like those of Christianity, accomlished more for the hearts of men than those of modern materialism. It may well be doubted if art and idolatry, idolatry and art, are not inseparable.[1]

Let us observe here that the purpose of the imager was neither self-expression nor the realisation of beauty. He did not choose his own problems, but like the Gothic sculptor, obeyed a hieratic canon.[2] He did not regard his own or his fellows' work from the standpoint of connoisseurship or æstheticism—not, that is to say, from the standpoint of the philosopher, or æsthete, but from that of a pious artisan. To him the theme was all in all, and if there is beauty in his work, this did not arise from æsthetic intention,[3] but from a state of mind which found unconscious expression. In every epoch of great and creative art we observe an identical phenomenon—the artist is preoccupied with his theme. It is only in looking backward, and as philosophers rather than artists—or if we are also artists, a rare combination, then with the philosophic and not the æsthetic side of our minds—that we perceive that the quality of beauty in a work of art is really quite independent of its theme. Then we are apt to forget that beauty has never been reached except through the necessity that was felt to deal with the particular subject. We sit down to paint a beautiful picture, or stand up to dance, and having nothing in us that we feel must be said and said clearly at all costs, we are surprised that the result is insipid and lacks conviction; the subject may be

[1] " The lineaments of images," says Śukrāchārya, "are determined by the relation which subsists between the adorer and the Adored." Cf. the Śaiva invocation "Thou that dost take the forms imagined by thy worshippers."

[2] We cannot assert this too strongly of orthodox or classic (*śāstrīya*) Hindu art. Rajput painting is more romantic, but even there the theme is pre-determined in literature, and the pictures, though they are not illustrations in the representative sense of the word, are pictures for verses just as much as the Ajanṭā paintings or the reliefs of Borobodūr.

[3] " Even the misshapen image of a god," says Śukrāchārya, "is to be preferred to the image of a man, however charming": in full accord with our modern view, that prefers conviction to prettiness.

lovely, the dancer may be ravishing, but the picture and the dance are not *rasavant*. The theory of beauty is a matter for philosophers, and artists strive to demonstrate it at their own risk.

The Indian imager was concerned with his own problem. It is interesting to see the kind of man he was expected to be. According to one of the Śilpa Śāstras "The Śilpan (artificer) should understand the Atharva Veda, the thirty-two Śilpa Śāstras, and the Vedic mantras by which the deities are invoked. He should be one who wears a sacred thread, a necklace of holy beads, and a ring of *kuśa* grass on his finger; delighting in the worship of God, faithful to his wife, avoiding strange women, piously acquiring a knowledge of various sciences, such a one is indeed a craftsman."[1] Elsewhere it is said "the painter must be a good man, no sluggard, not given to anger; holy, learned, self-controlled, devout and charitable, such should be his character."[2] It is added that he should work in solitude, or when another artist is present, never before a layman.

In this connection it is very important to realize that the artisan or artist possessed an assured status in the form of a life contract, or rather an hereditary office. He was trained from childhood as his father's disciple, and followed his father's calling as a matter of course. He was member of a guild, and the guilds were recognized, and protected by the king. The artificer was also protected from competition and undercutting; it is said: "That any other than a Śilpan should build temples, towns, seaports, tanks or wells, is comparable to the sin of murder."[3] This was guild socialism in a non-competitive society.[4]

The earliest impulses of Indian art appears to have been more or less practical and secular, and it is perhaps to this fact that we may partly trace the distrust of art exhibited by the early hedo-

[1] From a Tamil version of a Śilpa Śāstra, quoted by Kearns, Indian Antiquary, vol. v., 1876.

[2] Grünwedel, *Mythologie des Buddhismus*, p. 192. Cf. Cezanne, "I have never permitted anyone to watch me while I work. I refuse to do anything before anyone" (quoted W. H. Wright, *Modern Painting*, p. 152).

[3] Kearns, loc. cit.

[4] The Sociology is discussed more fully in Sir George Birdwood's *Industrial Arts of India*, and *Sva*, and my *Mediaeval Sinhalese Art* and *The Indian Craftsman*.

nists. On the other hand, the dominant motifs governing its evolution from the third century B.C. onwards, and up to the close of the eighteenth century, are devotion (*bhakti*) and reunion (*yoga*). Neither of these is peculiar to India, but they exhibit there a peculiar character which leaves its mark on everything Hindu or Buddhist. Let us now follow these traces in a very summary reference to actual documents.

I have discussed in another chapter the beginnings of Buddhist art.[1] It is in the southern primitives at Amarāvatī and Anurādhapura rather than in the semi-Roman figures of the North-west that we can best observe the development of an art that is distinctively Indian. This is the main stream; and it is these types from which the suave and gracious forms of Gupta sculpture derive, and these in turn became the models of all Buddhist art in China. In India proper, they grow more and more mouvementé, more dramatic and vigorous, in the classic art of Elūra and Elephanta, Māmallapuram and Ceylon, and form the basis of the immense developments of colonial Buddhist and Hindu art in Java and Cambodia. Gupta and classic painting are preserved at Ajaṇṭā.

The tender humanism and the profound nature sympathies which are so conspicuous in the painting of Ajaṇṭā and the sculpture of Māmallapuram are recognizable equally in the work of poets like Aśvaghosha and Ārya Śūra and dramatists like Kālidāsa. Aśvaghosha says of Prince Siddhārtha that one day as he was riding in the country "he saw a piece of land being ploughed, with the path of the plough broken like waves of the water. . . . And regarding the men as they ploughed, their faces soiled by the dust, scorched by the sun, and chafed by the wind, and their cattle bewildered by the burden of drawing, the All-noble One felt the uttermost compassion; and alighting from the back of his horse, he passed slowly over the earth, overcome with sorrow—pondering the birth and destruction proceeding in the world, he grieved." Nor can anything be more poignant than Śānti Deva's expression of his sense of the eternal movement and unsubstantiality of life—"Who is a kinsman, and who a

[1] The beginnings of Hindu art also go back to the second or third century B. C., but apart from a few coins, little or nothing has been preserved of earlier date than the third or fourth century A. D.

friend, and unto whom?" The literature of love is no less remarkable. We recognize here, just as in the painting and sculpture, what is eternal in all art, and universal—impassioned vision based on understanding, correlated with cloudless thought and devoid of sentimentality. There is every reason to believe too that this was the time of highest attainment in music. Lastly, this was a time of progress in the field of pure science, especially mathematics and astronomy. From the fourth to the end of the eighth century we must regard as the golden age of Indian civilization. This was the period of Wei and T'ang in China; Eastern Asia represented then to all intents and purposes the civilization of the world.

After the ninth or tenth century there is a general, though certainly not universal, decline in orthodox art, of which the formulae were rapidly stereotyped in their main outlines, and rendered florid in their detail. Classical Sanskrit literature also came to an end in a forest of elaborate embroidery. But great forces (sometimes grouped under the designation of the Pauranic Renaissance) had long been at work preparing the way for the emergence of the old cults of Śiva and Vishnu in forms which gave renewed inspiration to art—sculpture and poetry in the South, and poetry and painting in the North. In these devotional faiths was completed the cycle of Indian spiritual evolution from pure philosophy to pure mysticism, from knowledge to love. The inner and outer life were finally unified—a development entirely analogous to that of Zen Buddhism in the Far East. The transparency of life so clearly expressed in the paintings of Ajantā is indicated with a renewed emphasis—above all in the Rādhā-Krishna cults—and in all the Northern Vaishnava poetry and painting—the tradition in which Rabindranath Tagore is the latest singer, and of which the theory is plainly set forth in his song:

Not my way of salvation, to surrender the world!
Rather for me the taste of Infinite Freedom
While yet I am bound by a thousand bonds to the wheel . . .
In each glory of sound and sight and scent
I shall find Thy infinite joy abiding:
My passion shall burn as the flame of salvation,
The flower of my love shall become the ripe fruit of devotion.

PLATE III

INDIAN PAINTING.

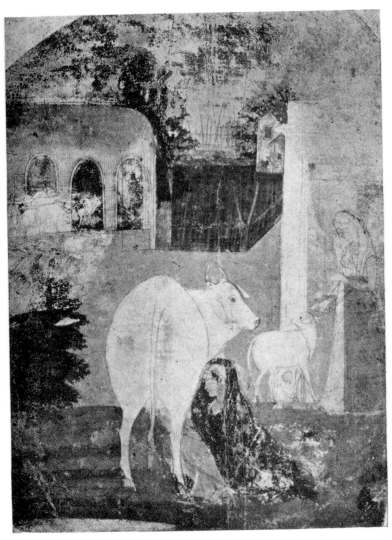

Krishna disguised as a milkmaid. Rajput Painting, 17th Century. Museum of
Fine Arts, Boston.

But such a theory is now rather a survival of all that was universal in Indian religion, rather than a new point of departure. The current Æsthetic of 'educated' India—a product of a wide miscomprehension of Western culture and a general surrender to Noncomformist ethics—is again realistic and hedonistic, and perhaps for the first time illustrative, personal, and sentimental.

HINDU VIEW OF ART:
II. THEORY OF BEAUTY

We have so far discussed the Hindu view of art mainly from the internal evidence of the art itself. There remains, what is more exactly pertinent to the title of these chapters, to discuss the Hindu Æsthetic as it is expressly formulated and elaborated in the abundant Sanskrit and Hindī literature on Poetics and the Drama. We shall find that general conclusions are reached which are applicable, not only to literature, but to all arts alike.

The discussion begins with the Defence of Poesy. This is summed up in the statement that it may contribute to the achievement of all or any of the Four Ends of Life. A single word rightly employed and understood is compared to the 'cow of plenty,' yielding every treasure; and the same poem that is of material advantage to one, may be of spiritual advantage to another or upon another occasion.

The question follows: What is the essential element in poetry? According to some authors this consists in style or figures, or in suggestion (*vyañjanā*, to which we shall recur in discussing the varieties of poetry). But the greater writers refute these views and are agreed that the one essential element in poetry[2] is what they term *Rasa*, or Flavour. With this term, which is the equivalent of Beauty or Æsthetic Emotion[3] in the strict sense of the philosopher, must be considered the derivative adjective *rasavant*

[1] Especially Viśvanātha in the *Sāhitya Darpaṇa*, ca. 1450 A. D. (trans. Bibliotheca Indica, Ballantyne). Also in the *Agni Purāṇa*, and the *Vyakti Viveka.*

[2] As remarked by W. Rothenstein, "What is written upon a single work should enable people to apply clear principles to all works they may meet with" (*Two Drawings by Hok'sai,* 1910). Also Benedetto Croce, "laws relating to special branches are not conceivable" (*Aesthetic,* p. 350).

[3] Such words as *saundarya* and *rūpa* should be translated as *loveliness* or *charm.*

No one suggests that metre makes poetry. This error was hardly to be expected in a country where even the dryest treatises on law and logic are composed in metre. Metrical poetry is *padya kāvya,* prose poetry is *gadya kāvya,* but it is *rasa* that makes them poetry.

'having rasa,' applied to a work of art, and the derivative substantive *rasika,* one who enjoys rasa, a connoisseur or lover, and finally *rasāsvādana,* the tasting of rasa, i. e., æsthetic contemplation.

A whole literature is devoted to the discussion of rasa and the conditions of its experience. The theory, as we have remarked, is worked out in relation to poetry and drama, especially the classic drama of Kālidāsa and others. When we consider that these plays are essentially secular in subject and sensuous in expression, the position arrived at regarding its significance will seem all the more remarkable.

Aesthetic emotion—rasa—is said to result in the spectator— rasika—though it is not effectively *caused,* through the operation of determinants (*vibhāva*), consequents (*anubhāva*), moods (*bhāva*) and involuntary emotions (*sattvabhāva*).[1] Thus:

DETERMINANTS: the æsthetic problem, plot, theme, etc., viz: the hero and other characters and the circumstances of time and place. In the terminology of Croce these are the "physical stimulants to æsthetic reproduction."

CONSEQUENTS: deliberate manifestations of feeling, as gestures, etc.

MOODS: transient moods (thirty-three in number) induced in the characters by pleasure and pain, e. g., joy, agitation, impatience, etc. Also the permanent (nine), viz: the Erotic, Heroic, Odious, Furious, Terrible, Pathetic, Wondrous and Peaceful.

INVOLUNTARY EMOTIONS: emotional states originating in the inner nature; involuntary expressions of emotion such as horripilation, trembling, etc. (eight in all).

In order that a work may be able to evoke rasa one[2] of the permanent moods must form a master-motif to which all other expressions of emotion are subordinate.[3] That is to say, the first essential of a rasavant work is unity—

As a king to his subjects, as a guru to his disciples,
Even so the master-motif is lord of all other motifs.[4]

[1] Dhanamjaya, *Daśarūpa,* iv. 1.
[2] Or any two rasas combined.
[3] *Daśarūpa,* iv, 46.
[4] Bharata, *Nātya Śāstra,* 7, 8.

If, on the contrary, a transient emotion is made the motif of the whole work, this "extended development of a transient emotion tends to the absence of rasa,"[1] or as we should now say, the work becomes sentimental. Pretty art which emphasizes passing feelings and personal emotion is neither beautiful nor true: it tells us of meeting again in heaven, it confuses time and eternity, loveliness and beauty, partiality and love.

Let us remark in passing that while the nine permanent moods correspond to an identical classification of rasas or flavours as nine in number, the rasa of which we speak here is an absolute, and distinct from any one of these. The 'nine rasas 'are no more than the various colourings of one experience, and are arbitrary terms of rhetoric used only for convenience in classification: just as we speak of poetry categorically as lyric, epic, dramatic, etc., without implying that poetry is anything but poetry. Rasa is tasted—beauty is felt—only by empathy, 'einfühlung' (sādhāra-ana) ; that is to say by entering into, feeling, the permanent motif; but it is not the same as the permanent motif itself, for, from this point of view, it matters not with which of the permanent motifs we have to do.

It is just here that we see how far Hindu Aesthetic had now departed from its once practical and hedonistic character: the Daśarūpa declares plainly that Beauty is absolutely independent of the sympathetic—"Delightful or disgusting, exalted or lowly, cruel or kindly, obscure or refined, (actual) or imaginary, there is no subject that cannot evoke rasa in man."

Of course, a work of art may and often does afford us at the same time pleasure in a sensuous or moral way, but this sort of pleasure is derived directly from its material qualities, such as tone or texture, assonance, etc., or the ethical peculiarity of its theme, and not from its æsthetic qualities: the æsthetic experience is independent of this, and may even, as Dhanamjaya says, be derived in spite of sensuous or moral displeasure.

Incidentally we may observe that the *fear* of art which prevails

[1] *Daśarūpa*, iv. 45.

Blake, too, says that "Knowledge of Ideal Beauty is not to be acquired. It is born with us." And as P'u Sung-ling remarks: "Each interprets in his own way the music of heaven; and whether it be discord or not, depends upon antecedent causes" (Giles, *Strange Stories from a Chinese Studio*, p. xvii).

amongst Puritans arises partly from the failure to recognize that æsthetic experience does not depend on pleasure or pain at all: and when this is not the immediate difficulty, then from the distrust of any experience which is "beyond good and evil" and so devoid of a definitely *moral* purpose.

The tasting of rasa—the vision of beauty—is enjoyed, says Viśvanātha, "only by those who are competent thereto": and he quotes Dharmadatta to the effect that "those devoid of imagination, in the theatre, are but as the wood-work, the walls, and the stones." It is a matter of common experience that it is possible for a man to devote a whole life time to the study of art, without having once experienced æsthetic emotion: "historical research" as Croce expresses it, "directed to illumine a work of art by placing us in a position to judge it, does not alone suffice to bring it to birth in our spirit," for "pictures, poetry, and every work of art produce no effect save on souls prepared to receive them." Viśvanātha comments very pertinently on this fact when he says that "even some of the most eager students of poetry are seen not to have a right perception of rasa." The capacity and genius necessary for appreciation are partly native ('ancient') and partly cultivated ('contemporary'): but cultivation alone is useless, and if the poet is born, so too is the rasika, and criticism is akin to genius.

Indian theory is very clear that instruction is not the purpose of art. On this point Dhanamjaya is sufficiently sarcastic:

"As for any simple man of little intelligence," he writes, "who says that from dramas, which distil joy, the gain is knowledge only, as in the case of history and the like (mere statement, narrative, or illustration)—homage to him, for he has averted his face from what is delightful."[1]

The spectator's appreciation of beauty depends on the effort of his own imagination, "just as in the case of children playing with clay elephants."[2] Thus, technical elaboration (realism) in art is not by itself the cause of rasa: as remarked by Rabindra-

[1] *Daśarūpa*, 1, 6.
[2] *Daśarūpa*, 1V. 50. Cf. Goethe, "He who would work for the stage . . . should leave Nature in her proper place and take careful heed not to have recourse to anything but what may be performed by children with puppets upon boards and laths, together with sheets of cardboard and linen"—quoted in 'The Mask,' Vol. v. p. 3.

nath Tagore "in our country, those of the audience who are appreciative, are content to perfect the song in their own mind by the force of their own feeling."[1] This is not very different from what is said by Śukrāchārya with reference to images: "the defects of images are constantly destroyed by the power of the virtue of the worshipper who has his heart always set on God." If this attitude seems to us dangerously uncritical, that is to say dangerous to art, or rather to accomplishment, let us remember that it prevailed everywhere in all periods of great creative activity: and that the decline of art has always followed the decline of love and faith.

Tolerance of an imperfect work of art may arise in two ways: the one *uncritical*, powerfully swayed by the sympathetic, and too easily satisfied with a very inadequate correspondence between content and form, the other *creative*, very little swayed by considerations of charm, and able by force of true imagination to complete the correspondence of content and form which is not achieved or not preserved in the original. Uncritical tolerance is content with prettiness or edification, and recoils from beauty that is 'difficult': creative tolerance is indifferent to prettiness or edification, and is able from a mere suggestion, such as an awkward 'primitive' or a broken fragment, to create or recreate a perfect experience.

"Also, "the permanent motif becomes rasa through the rasika's own capacity for being delighted—not from the character of the hero to be imitated, nor because the work aims at the production of æsthetic emotion."[2] How many works which have "aimed at the production of æsthetic emotion," that is to say, which were intended to be beautiful, have failed of their purpose!

The degrees of excellence in poetry are discussed in the *Kāvya Prakāśa* and the *Sāhitya Darpaṇa*. The best is where there is a deeper significance than that of the literal sense. In minor poetry the sense overpowers the suggestion. In inferior poetry, significantly described as 'variegated' or 'romantic' (*chitra*), the only artistic quality consists in the ornamentation of the literal sense, which conveys no suggestion beyond its face meaning. Thus narrative and descriptive verse take a low place, just as portraiture does in plastic art: and, indeed, the *Sāhitya Darpaṇa*

[1] *Jīban-smṛiti*, pp. 134-5.
[2] *Daśarūpa*, iv., 47.

excludes the last kind of poetry altogether. It is to be observed that the kind of suggestion meant is something more than implication or *double entendre:* in the first case we have to do with mere abbreviation, comparable with the use of the words *et cetera,* in the second we have a mere play on words. What is understood to be suggested is one of the nine rasas.

It is worth noting that we have here a departure from, and I think, an improvement on Croce's definition *'expression is art.'* A mere statement, however completely expressive, such as: "The man walks," or $(a+b)^2 = a^2+2ab+b^2$, is not art. Poetry is indeed a kind of sentence[1]: but what kind of sentence?" A sentence ensouled by rasa,[2] i. e., in which one of the nine rasas is implied or suggested: and the savouring of this flavour, *rasāsvādana,* through empathy, by those possessing the necessary sensibility is the condition of beauty.

What then are *rasa* and *rasāsvādana,* beauty and æsthetic emotion? The nature of this experience is discussed by Viśvanātha in the *Sāhitya Darpaṇa*[3]: "It is pure, indivisible, self-manifested, compounded equally of joy and consciousness, free of admixture with any other perception, the very twin brother of mystic experience (*Brahmāsvādana sahodaraḥ*), and the very life of it is supersensuous (*lokottara*) wonder."[4] Further, "It is enjoyed by those who are competent thereto, in identity,[5] just as the form of God is itself the joy with which it is recognized."

For that very reason it cannot be an object of knowledge, its perception being indivisible from its very existence. Apart from perception it does not exist. It is not on that account to be regarded as eternal in time or as interrupted: it is timeless. It is again, supersensuous, hyperphysical (*alaukika*), and the only proof of its reality is to be found in experience.[6]

Religion and art are thus names for one and the same experi-

[1] The likeness of aesthetic to linguistic is indicated in *Daśarūpa,* iv. 46.

[2] *Vākyam rasātmakam vācakam—Sāhitya Darpaṇa,* 3.

[3] vv. 33, 51, 53, 54.

[4] Wonder is defined as a kind of expanding of the mind in 'admiration.'

[5] The expression *rasāsvādana* is fictitious, because rasāsvādana is rasa, and *vice versa.* In aesthetic contemplation, as in perfect worship, there is identity of subject and object, cause and effect.

[6] The rasika is therefore unable to convince the Philistine by argument: he can but say, Taste and see that it is good—for *I know* in what I have believed.

ence—an intuition of reality and of identity. This is not, of course, exclusively a Hindu view: it has been expounded by many others, such as the Neo-platonists, Hsieh Ho, Goethe, Blake, Schopenhauer and Schiller. Nor is it refuted by Croce. It has been recently restated as follows:

"In those moments of exaltation that art can give, it is easy to believe that we have been possessed by an emotion that comes from the world of reality. Those who take this view will have to say that there is in all things the stuff out of which art is made —reality. The peculiarity of the artist would seem to be that he possesses the power of surely and frequently seizing reality (generally behind pure form), and the power of expressing his sense of it, in pure form always!"[1]

Here pure form means form not clogged with unæsthetic matter such as associations.

It will be seen that this view is monistic: the doctrine of the universal presence of reality is that of the immanence of the Absolute. It is inconsistent with a view of the world as absolute *māyā*, or utterly unreal, but it implies that through the false world of everyday experience may be seen by those of penetrating vision (artists, lovers and philosophers) glimpses of the real substrate. This world is the formless as we perceive it, the unknowable as we know it.

Precisely as love is reality experienced by the lover, and truth is reality as experienced by the philosopher, so beauty is reality as experienced by the artist: and these are three phases of the Absolute. But it is only through the objective work of art that the artist is able to communicate his experience, and for this purpose any theme proper to himself will serve, since the Absolute is manifested equally in the little and the great, animate and inanimate, good and evil.

We have seen that the world of Beauty, like the Absolute, cannot be known objectively. Can we then reach this world by rejecting objects, by a deliberate purification of art from all associations? We have already seen, however, that the mere intention to create beauty is not sufficient: there must exist an object of devotion. Without a point of departure there can be no flight and no attainment: here also "one does not attain to perfection

[1] Clive Bell, *Art*, p. 54.

by mere renunciation."[2] We can no more achieve Beauty than we can find Release by turning our backs on the world: we cannot find our way by a mere denial of things, but only in learning to see those things as they really are, infinite or beautiful. The artist reveals this beauty wherever the mind attaches itself: and the mind attaches itself, not directly to the Absolute, but to objects of choice.

Thus we return to the earth. If we supposed we should find the object of search elsewhere, we were mistaken. The two worlds, of spirit and matter, Purusha and Prakṛiti, are one: and this is as clear to the artist as it is to the lover or the philosopher. Those Philistines to whom it is not so apparent, we should speak of as materialists or as nihilists—exclusive monists, to whom the report of the senses is either all in all, or nothing at all. The theory of rasa set forth according to Viśvanātha and other æstheticians, belongs to totalistic monism; it marches with the Vedānta. In a country like India, where thought is typically consistent with itself, this is no more than we had a right to expect.

[2] *Bhagavad Gītā*, III, 14.

THAT BEAUTY IS A STATE

It is very generally held that natural objects such as human beings, animals or landscapes, and artificial objects such as factories, textiles or works of intentional art, can be classified as beautiful or ugly. And yet no general principle of classification has ever been found: and that which seems to be beautiful to one is described as ugly by another. In the words of Plato "Everyone chooses his love out of the objects of beauty according to his own taste."

To take, for example, the human type: every race, and to some extent every individual, has an unique ideal. Nor can we hope for a final agreement: we cannot expect the European to prefer the Mongolian features, nor the Mongolian the European. Of course, it is very easy for each to maintain the absolute value of his own taste and to speak of other types as ugly; just as the hero of chivalry maintains by force of arms that his own beloved is far more beautiful than any other. In like manner the various sects maintain the absolute value of their own ethics. But it is clear that such claims are nothing more than statements of prejudice, for who is to decide which racial ideal or which morality is "best"? It is a little too easy to decide that our own is best; we are at the most entitled to believe it the best for us. This relativity is nowhere better suggested than in the classic saying attributed to Majñūn, when it was pointed out to him that the world at large regarded his Lailā as far from beautiful. "To see the beauty of Lailā," he said, "requires the eyes of Majñūn."

It is the same with works of art. Different artists are inspired by different objects; what is attractive and stimulating to one is depressing and unattractive to another, and the choice also varies from race to race and epoch to epoch. As to the appreciation of such works, it is the same; for men in general admire only such works as by education or temperament they are predisposed to admire. To enter into the spirit of an unfamiliar art demands a greater effort than most are willing to make. The classic scholar starts convinced that the art of Greece has never been equalled or surpassed, and never will be; there are many who think, like Michelangelo, that because Italian painting is good, therefore

good painting is Italian. There are many who never yet felt the beauty of Egyptian sculpture or Chinese or Indian painting or music: that they have also the hardihood to deny their beauty, however, proves nothing.

It is also possible to forget that certain works are beautiful: the eighteenth century had thus forgotten the beauty of Gothic sculpture and primitive Italian painting, and the memory of their beauty was only restored by a great effort in the course of the nineteenth. There may also exist natural objects or works of art which humanity only very slowly learns to regard as in any way beautiful; the western æsthetic appreciation of desert and mountain scenery, for example, is no older than the nineteenth century; and it is notorious that artists of the highest rank are often not understood till long after their death. So that the more we consider the variety of human election, the more we must admit the relativity of taste.

And yet there remain philosophers firmly convinced that an absolute Beauty (rasa)[1] exists, just as others maintain the conceptions of absolute Goodness and absolute Truth. The lovers of God identify these absolutes with Him (or It) and maintain that He can only be known as perfect Beauty, Love and Truth. It is also widely held that the true critic (rasika) is able to decide which works of art are beautiful (rasavant) and which are not; or in simpler words, to distinguish works of genuine art from those that have no claim to be so described. At the same time we must admit the relativity of taste, and the fact that all gods (devas and Īśvaras) are modelled after the likeness of men.

It remains, then, to resolve the seeming contradictions. This is only to be accomplished by the use of more exact terminology. So far have I spoken of 'beauty' without defining my meaning, and have used one word to express a multiplicity of ideas. But we do not mean the same thing when we speak of a beautiful girl and a beautiful poem; it will be still more obvious that we mean two different things, if we speak of beautiful weather and a beautiful picture. In point of fact, the conception of beauty and the adjective "beautiful" belong exclusively to æsthetic and should only be used in æsthetic judgment. We seldom make any such judgments when we speak of natural objects as beautiful; we gen-

[1] Rasa, rasavant and rasika are the principal terms of Indian æsthetics, explained in the preceding chapter.

erally mean that such objects as we call beautiful are congenial
to us, practically or ethically. Too often we pretend to judge a
work of art in the same way, calling it beautiful if it represents
some form or activity of which we heartily approve, or if it
attracts us by the tenderness or gaiety of its colour, the sweet-
ness of its sounds or the charm of its movement. But when we
thus pass judgment on the dance in accordance with our sympa-
thetic attitude towards the dancer's charm or skill, or the mean-
ing of the dance, we ought not to use the language of pure
æsthetic. Only when we judge a work of art æsthetically may
we speak of the presence or absence of beauty, we may call the
work *rasavant* or otherwise; but when we judge it from the
standpoint of activity, practical or ethical, we ought to use a
corresponding terminology, calling the picture, song or actor
"lovely," that is to say lovable, or otherwise, the action "noble,"
the colour "brilliant," the gesture "graceful," or otherwise, and
so forth. And it will be seen that in doing this we are not really
judging the work of art as such, but only the material and the
separate parts of which it is made, the activities they represent,
or the feelings they express.

Of course, when we come to choose such works of art to live
with, there is no reason why we should not allow the sympathetic
and ethical considerations to influence our judgment. Why should
the ascetic invite annoyance by hanging in his cell some repre-
sentation of the nude, or the general select a lullaby to be per-
formed upon the eve of battle? When every ascetic and every
soldier has become an artist there will be no more need for works
of art: in the meanwhile ethical selection of some kind is allow-
able and necessary. But in this selection we must clearly under-
stand what we are doing, if we would avoid an infinity of error,
culminating in that type of sentimentality which regards the
useful, the stimulating and the moral elements in works of art as
the essential. We ought not to forget that he who plays the
villain of the piece may be a greater artist than he who plays the
hero. For beauty—in the profound words of Millet—does not
arise from the subject of a work of art, but from the necessity
that has been felt of representing that subject.

We should only speak of a work of art as good or bad with
reference to its æsthetic quality; only the subject and the material
of the work are entangled in relativity. In other words, to say

Ajaṇṭā fresco : right, Bodhisattva ; left, coronation. Buddhist Painting of
6th or 7th Century.

PLATE V
INDIAN ARCHITECTURE AND SCULPTURE.

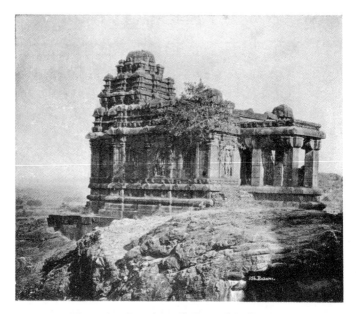

Figure a. Temple at Bādāmī, 8th Century.

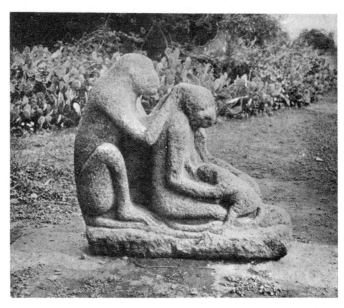

Figure b. Monkey family. Stone sculpture. Māmallapuram, 8th Century.

that a work of art is more or less beautiful, or *rasavant*, is to define the extent to which it is a work of art, rather than a mere illustration. However important the element of sympathetic magic in such a work may be, however important its practical applications, it is not in these that its beauty consists.

What, then, is Beauty, what is *rasa*, what is it that entitles us to speak of divers works as beautiful or *rasavant?* What is this sole quality which the most dissimilar works of art possess in common? Let us recall the history of a work of art. There is (1) an æsthetic intuition on the part of the original artist,—the poet or creator; then (2) the internal expression of this intuition, —the true creation or vision of beauty, (3) the indication of this by external signs (language) for the purpose of communication, —the technical activity; and finally, (4) the resulting stimulation of the critic or *rasika* to reproduction of the original intuition, or of some approximation to it.

The source of the original intuition may, as we have seen, be any aspect of life whatsoever. To one creator the scales of a fish suggest a rhythmical design, another is moved by certain land-scapes, a third elects to speak of hovels, a fourth to sing of palaces, a fifth may express the idea that all things are enlinked, enlaced and enamoured in terms of the General Dance, or he may express the same idea equally vividly by saying that "not a sparrow falls to the ground without our Father's knowledge." Every artist discovers beauty, and every critic finds it again when he tastes of the same experience through the medium of the external signs. But where is this beauty? We have seen that it cannot be said to exist in certain things and not in others. It may then be claimed that beauty exists everywhere; and this I do not deny, though I prefer the clearer statement that it may be discovered anywhere. If it could be said to exist everywhere in a material and intrinsic sense, we could pursue it with our cameras and scales, after the fashion of the experimental psychologists: but if we did so, we should only achieve a certain acquaintance with average taste—we should not discover a means of distinguishing forms that are beautiful from forms that are ugly. Beauty can never thus be measured, for it does not exist apart from the artist himself, and the *rasika* who enters into his experience.[1]

[1] Cf. "The secret of art lies in the artist himself"—Kuo Jo Hsū, (12th century), quoted in *The Kokka,* No. 244.

All architecture is what you do to it when you look upon it.
Did you think it was in the white or grey stone? or the lines of the
　　arches and cornices?
All music is what awakes in you when you are reminded of it by the
　　instruments,
It is not the violins and the cornets . . . nor the score of the baritone
　　singer
It is nearer and further than they.[1]

When every sympathetic consideration has been excluded, how-
ever, there still remains a pragmatic value in the classification
of works of art as beautiful or ugly.　But what precisely do we
mean by these designations as applied to objects?　In the works
called beautiful we recognize a correspondence of theme and ex-
pression, content and form: while in those called ugly we find
the content and form at variance.　In time and space, however,
the correspondence never amounts to an identity: it is our own
activity, in the presence of the work of art, which completes the
ideal relation, and it is in this sense that beauty is what we "do
to" a work of art rather than a quality present in the object.
With reference to the object, then "more" or "less" beautiful
will imply a greater or less correspondence between content and
form, and this is all that we can say of the object as such: or
in other words, art is good that is good of its kind.　In the
stricter sense of completed internal æsthetic activity, however,
beauty is absolute and cannot have degrees.

The vision of beauty is spontaneous, in just the same sense
as the inward light of the lover (*bhākta*).　It is a state of grace
that cannot be achieved by deliberate effort; though perhaps we
can remove hindrances to its manifestation, for there are many
witnesses that the secret of all art is to be found in self-forget-
fulness.[2]　And we know that this state of grace is not achieved
in the pursuit of pleasure; the hedonists have their reward, but
they are in bondage to loveliness, while the artist is free in
beauty.

It is further to be observed that when we speak seriously of
works of art as beautiful, meaning that they are truly works of
art, valued as such apart from subject, association, or technical
charm, we still speak elliptically.　We mean that the external

[1] Walt Whitman.
[2] E. G. Riciotto Canudo: "It is certain that the secret of all art . . .
lies in the faculty of self-oblivion"—(*Music as a Religion of the Future*).

signs—poems, pictures, dances, and so forth—are effective reminders. We may say that they possess significant form. But this can only mean that they possess that kind of form which reminds us of beauty, and awakens in us æsthetic emotion. The nearest explanation of significant form should be *such form as exhibits the inner relations of things;* or, after Hsieh Ho, "which reveals the rhythm of the spirit in the gestures of living things." All such works as possess significant form are linguistic; and, if we remember this, we shall not fall into the error of those who advocate the use of language for language's sake, nor shall we confuse the significant forms, or their logical meaning or moral value, with the beauty of which they remind us.

Let us insist, however, that the concept of beauty has originated with the philosopher, not with the artist: *he* has been ever concerned with saying clearly what had to be said. In all ages of creation the artist has been in love with his particular subject—when it is not so, we see that his work is not 'felt'—he has never set out to achieve the Beautiful, in the strict æsthetic sense, and to have this aim is to invite disaster, as one who should seek to fly without wings.

It is not to the artist that one should say the subject is immaterial: that is for the philosopher to say to the philistine who dislikes a work of art for no other reason than that he dislikes it.

The true critic (*rasika*) perceives the beauty of which the artist has exhibited the signs. It is not necessary that the critic should appreciate the artist's meaning—every work of art is a *kāmadhenu,* yielding many meanings—for he knows without reasoning whether or not the work is beautiful, before the mind begins to question what it is "about." Hindu writers say that the capacity to feel beauty (to taste *rasa*) cannot be acquired by study, but is the reward of merit gained in a past life; for many good men and would-be historians of art have never perceived it. The poet is born, not made; but so also is the *rasika*, whose genius differs in degree, not in kind, from that of the original artist. In western phraseology we should express this by saying that experience can only be bought by experience; opinions must be earned. We gain and feel nothing merely when we take it on authority that any particular works are beautiful. It is far better to be honest, and to admit that perhaps we cannot see their beauty. A day may come when we shall be better prepared.

The critic, as soon as he becomes an exponent, has to prove his case; and he cannot do this by any process of argument, but only by creating a new work of art, the criticism. His audience, catching the gleam at second-hand—but still the same gleam, for there is only one—has then the opportunity to approach the original work a second time, more reverently.

When I say that works of art are reminders, and the activity of the critic is one of reproduction, I suggest that the vision of even the original artist may be rather a discovery than a creation. If beauty awaits discovery everywhere, that is to say that it waits upon our recollection (in the sūfī sense and in Wordsworth's) : in æsthetic contemplation as in love and knowledge, we momentarily recover the unity of our being released from individuality.

There are no degrees of beauty; the most complex and the simplest expression remind us of one and the same state. The sonata cannot be more beautiful than the simplest lyric, nor the painting than the drawing, merely because of their greater elaboration. Civilized art is not more beautiful than savage art, merely because of its possibly more attractive *ethos*. A mathematical analogy is found if we consider large and small circles; these differ only in their content, not in their circularity. In the same way, there cannot be any continuous progress in art. Immediately a given intuition has attained to perfectly clear expression, it remains only to multiply and repeat this expression. This repetition may be desirable for many reasons, but it almost invariably involves a gradual decadence, because we soon begin to take the experience for granted. The vitality of a tradition persists only so long as it is fed by intensity of imagination. What we mean by creative art, however, has no necessary connection with novelty of subject, though that is not excluded. Creative art is art that reveals beauty where we should have otherwise overlooked it, or more clearly than we have yet received. Beauty is sometimes overlooked just because certain expressions have become what we call "hackneyed"; then the creative artist dealing with the same subject restores our memory. The artist is challenged to reveal the beauty of all experiences, new and old.

Many have rightly insisted that the beauty of a work of art is independent of its subject, and truly, the humility of art, which finds its inspiration everywhere, is identical with the humility of Love, which regards alike a dog and a Brahman—and of

Science, to which the lowest form is as significant as the highest. And this is possible, because it is one and the same undivided all. "If a beauteous form we view, 'Tis His reflection shining through."

It will now be seen in what sense we are justified in speaking of Absolute Beauty, and in identifying this beauty with God. We do not imply by this that God (who is without parts) has a lovely form which can be the object of knowledge; but that in so far as we see and feel beauty, we see and are one with Him. That God is the first artist does not mean that He created forms, which might not have been lovely had the hand of the potter slipped: but that every natural object is an immediate realization of His being. This creative activity is comparable with æsthetic expression in its non-volitional character; no element of choice enters into that world of imagination and eternity, but there is always perfect identity of intuition-expression, soul and body. The human artist who discovers beauty here or there is the ideal *guru* of Kabīr, who "reveals the Supreme Spirit wherever the mind attaches itself."

BUDDHIST PRIMITIVES

The Early Buddhist view of art is strictly hedonistic. Just as little as Early Buddhism dreamed of an expression of its characteristic ideas through poetry, drama, or music, so little was it imagined that the arts of sculpture and painting could be anything but worldly in their purpose and effect. The arts were looked upon as physical luxuries, and loveliness as a snare. "Beauty is nothing to me," says the *Dasa Dhamma Sutta*, "neither the beauty of the body nor that that comes of dress." The Brethren were forbidden to allow the figures of men and women to be painted on monastery walls, and were permitted only representations of wreaths and creepers.[1] The psychological foundation of this attitude is nowhere more clearly revealed than in a passage of the *Visuddhi Magga*, where we find that painters, musicians, perfumers, cooks, and elixir-prescribing physicians are all classed together as purveyors of sensuous luxuries, whom others honour "on account of love and devotion to the sensations excited by forms and other objects of sense." This is the characteristic Hīnayāna position throughout, and it is, of course, conspicuous also in the Jaina system, and in certain phases of Brahmanical thought, particularly in the period contemporary with early Buddhism.

It is only in the third and second centuries B. C. that we find the Buddhists patronizing craftsmen and employing art for edifying ends. From what has just been said, however, it will be well understood that there had not at this time come into being any truly Buddhist or Brahmanical idealistic art; and thus "Early Buddist" art was necessarily the popular Brahmanical art and animistic art of the day, adapted to Buddhist requirements. The only exception to this rule is that special phase of Early Buddhist art which is represented by the capital of the Aśoka columns, of which the forms are not merely non-Buddhist, but of extra-Indian origin.[2]

The Indian non-Buddhist art that we have evidence of in the age

[1] *Cullavagga,* vi, 3, 2.
[2] *Viśvakarmā,* 80, 81.

PLATE VI

BUDDHIST PRIMITIVES.

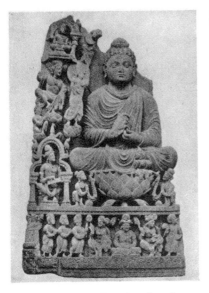

Figure a. Seated Buddha, Gandhāra,
 1st century, A.D.

Figure b. Dryad, Sānchī,
 2nd century, B.C.

Figure c. Lay worshippers at a Buddha Shrine. Amarī/atī, 2nd century, A.D.

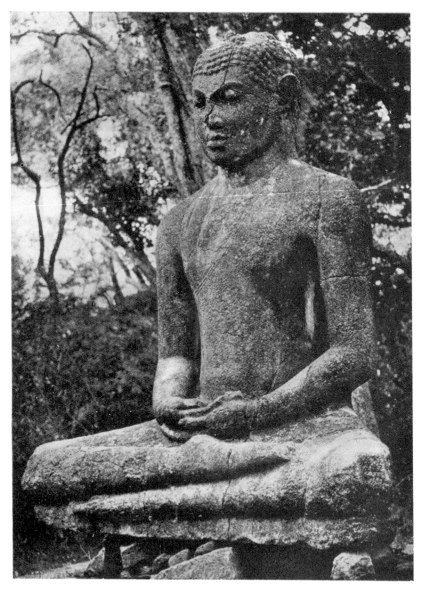

Buddha in Samādhi. Stone sculpture, Ceylon, 2nd century, A.D.

of Aśoka and in the period immediately following Aśoka, is chiefly concerned with the cult of nature-spirits—the Earth Goddess, the Nāgas or Serpent kings of the waters, and the Yaksha kings who rule the Four Quarters. The Maurya types are represented by the well-known free-standing female figure at Besnagar,[1] and the Parkham figure[2] now in the Mathurā Museum. The early Buddhist art of Sānchī and Bhārhut, probably slightly later, reflects the prevalence of the animistic cults in placing low-relief figures of the Yaksha, guardians of the Four Quarters, as protectors of the entrance gateways.[3] That the nature-spirits should thus act as guardians of Buddhist shrines reflects the essential victory of Buddhism, precisely as the story of the Nāga Muchalinda, who, in the literary tradition, shelters the Buddha during the week of storms.

Besides the Guardians of the Quarters we find at Sānchī figures of beautiful Yakshinīs or dryads, whose function may be partly protective, but is also in large degree honorary and decorative. The Yakshinī figure here reproduced [PLATE VI, B] is typical of all that is best in the art of Sānchī; but in what different world this happy dryad moves from that of the Pāli Suttas, where orthodox Buddhism tries to prove that "as the body when dead is repulsive, so also is it when alive"! Buddhist monasticism—to use the language of Blake—sought consistently to bolt and bar the "Western Gates": but our Sānchī dryad rather seems to say "the soul of sweet delight can never be defiled."

The art of Sānchī is essentially pagan, and this appears not only in its fearless happiness, untinged by puritan misgiving or by mystic intuition, but also in the purely representative and realistic technique. It was in the main a later Mahāyāna and Vaishnava achievement of the Indian lyric spirit to discover that the two worlds of spiritual purity and sensuous delight need not, and perhaps ultimately cannot, be divided.

In any case the Sānchī art is plainly not an expression of Early Buddhist feeling: and so also it is not primitive, but, on the contrary, it is the classic achievement of an old popular art already long practised in less permanent materials. If there is at this

[1] *Viśvakarmā*, 64.

[2] *Viśvakarmā*, 26.

[3] A much later example of the same arrangement is illustrated in *Viśvakarmā*, 75.

time any Buddhist art that can be fairly called primitive, it is only to be recognized in architecture, where the simple forms of the early *stūpas,* and their undecorated railings, and the severe design of the early excavated *chaitya*-halls truly reflect the intellectual and austere enthusiasm of Early Buddhism.

Another part of the art of the Bhārhut railing and the Sānchī gateways is devoted to the illustration of edifying legends, particularly stories of the former lives of the Buddha, and of the last incarnation. The work is delicately executed in low relief—we know from a contemporary inscription that amongst the craftsmen who contributed to the decoration of the Sānchī *toraṇas* were the "ivory-workers of Bhilsā"—and affords us a remarkable record of Indian life, with its characteristic environment, manners and cults set out with evident realism and a wealth of circumstantial detail. But for all their interest these reliefs, too, are essentially illustrations of edifying anecdotes, and only to a limited extent—less, for example, than the similar, but, of course, very much later, illustrations at Borobodūr—directly express the Early Buddhist view of life and death.

There is, however, one respect in which that view is perfectly reflected; in the fact that the figure of the Master himself is nowhere represented. Even in the group of episodes which illustrate the Great Renunciation—Prince Siddhattha's departure from home, riding upon the back of the horse Kanthaka, and attended by the groom Channa—Kanthaka's back is bare, and we see only the figures of the Devas who lift up the feet of the horse lest men should be roused by the sound of his hoofs, while the presence of the Prince is only indicated by the parasol of dominion borne beside the horse. In other compositions the Buddha is represented by symbols such as the Wisdom Tree or the conventionally represented footprints, the "Feet of the Lord" [PLATE VI, c]. It will be realized at once that the absence of the Buddha figure from the world of living men—where, however, there yet remain the traces of his ministry, literally footprints on the sands of time—is a true artistic rendering of the Master's guarded silence respecting the after-death state of those who have attained Nirvāna: "the Perfect One is released from this, that his being should be gauged by the measure of the corporeal world," he is released from "name and form." In the omission of the figure of the Buddha, the Early Buddhist art is truly Budd-

·dhist: for the rest, it is an art about Buddhism, rather than Bud-
dhist art.

Changes were meanwhile proceeding in the material of Bud-
dhist belief. This belief is no longer merely intellectual, but has
undergone an emotional development akin to that which finds
expression in the *bhakti* doctrine of the *Bhagavad Gītā:*

> Even they that be born of sin, even women, traffickers, and serfs,
> if they turn to Me, come to the Supreme Path: be assured, O son
> of Kuntī, that none who is devoted to Me is lost.

Similarly we find, even in so early a text as the *Majjhima
Nikāya* that those who have not yet even entered the Paths, "are
sure of heaven if they have love and faith towards Me." Gradu-
ally the idea of Buddhahood replaces that of Arahatta: the orig-
inal agnosticism is ignored, and the Buddha is endowed with all
the qualities of transcendental godhead as well as with the physical
peculiarities or perfections of the Superman (*mahā-purusha*).
The Buddha thus conceived, together with the Bodhisattvas or
Buddhas-to-be, presently engaged in the active work of salvation,
became the object of a cult and was regarded as approachable
by worship. In all this we see not merely an internal develop-
ment of metaphysics and theology, but also the influence of the
lay community: for a majority of men, and still more the majority
of women, have always been more ready to worship than to know.

At Amarāvatī we still find that the Buddha is represented by
symbols, but it may be clearly seen from the passionate devotion
of those who worship at the symbol-shrines—and many of these
are women, as in the case of the fragment here reproduced in
PLATE VI, c—that the One adored must have been conceived in
others terms than those of a purely intellectual psychological
analysis. Even before the Buddha figure is represented in official
Buddhist art, the Buddha had become an object of adoration, a
very personal god: and it cannot surprise us that the Master's
figure should soon appear wherever Buddhist piety erected shrines
and monuments. We know that images of Hindu gods were
already in use in the second century, B. C., and it is highly probable
that Buddha figures were in similar private use long before they
took their place in a public cult.

Before, however, we speak of the Buddha images, we must
refer to a second phase of religious experience, which plays a

great part alike in the development of Buddhism and Hinduism.
This is the practice of *Yoga,* whereby enlightenment and emanci-
pation are sought to be attained by meditation calculated to
release the individual from empirical consciousness. Even in the
earliest Buddhist praxis it would be difficult to exaggerate the part
which these contemplative exercises play in the spiritual history
of the Brethren, and to a lesser extent of laymen, for while the
most abstract meditations lead to the attainment of Nirvāna and
the station of "No-return," the lesser no less certainly led to
rebirth in the higher heavens. It is just for purposes of medita-
tion that lonely places and roots of trees are so highly praised in
the Buddhist literature, and of this the classic example is that of
the Buddha himself, who reached the final enlightenment while
seated in yogī-fashion at the foot of the Wisdom-tree. The
essence of the method lies in the concentration of thought upon
a single point, carried so far that the duality of subject and
object is resolved into a perfect unity—"when," in the words of
Schelling, "the perceiving self merges in the self-perceived. At
that moment we annihilate time and the duration of time; we are
no longer in time, but time, or rather eternity itself, is in us." A
very beautiful description of the yogī is given as follows in the
Bhagavad Gītā,[1] and as quoted here in a condensed form applies
almost equally to Buddhist and Brahmanical practice, for the
yoga is a praxis rather than a form of sectarian belief:—

> Abiding alone in a secret place, without craving and without pos-
> sessions, he shall take his seat upon a firm seat, neither over-high
> nor over-low, and with the working of the mind and of the senses
> held in check, with body, head and neck maintained in perfect equi-
> poise, looking not round about him, so let him meditate, and thereby
> reach the peace of the Abyss: and the likeness of one such, who
> knows the boundless joy that lies beyond the senses and is grasped
> by intuition, and who swerves not from the truth, is that of a lamp
> in a windless place that does not flicker.

Long before the Buddha image became a cult object, the
familiar form of the seated yogī must have presented itself to
the Indian mind in inseparable association with the idea of a
mental discipline and of the attainment of the highest station of

[1] *Bhagavad Gītā.* vi. 10-21—omitting the theistic elements.

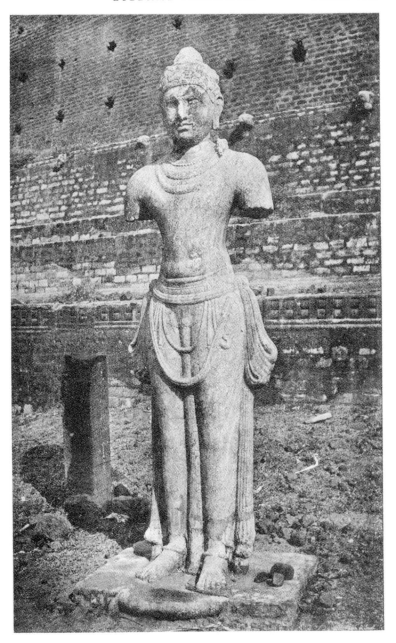

Standing Bodhisattva. Stone sculpture, Ceylon, 2nd century, A.D.

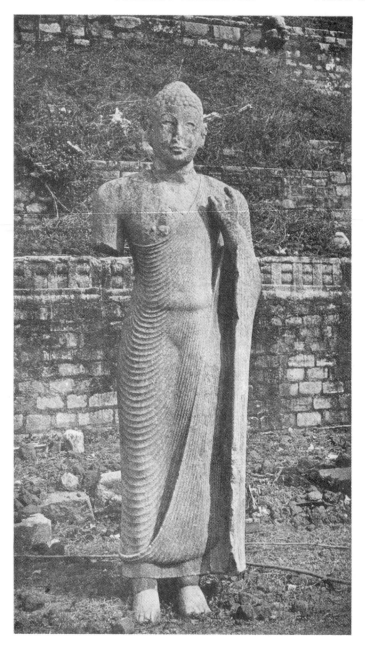

STANDING BUDDHA.
Stone sculpture, Ceylon, 2nd century, A.D.

self-oblivion; and when the development of imagery followed there was no other form which could have been made a universally recognized symbol of Him-who-had-thus-attained.

This figure of the seated Buddha-yogī, with a far deeper content, is as purely monumental art as that of the Egyptian pyramids; and since it represents the greatest ideal which Indian sculpture ever attempted to express, it is well that we find preserved even a few magnificent examples of comparatively early date. Amongst these the colossal figure at Anurādhapura is almost certainly the best [PLATE VII]. The same ancient Buddhist site affords examples of a Bodhisattva, here reproduced on PLATE VIII, and of two standing Buddhas, illustrated in PLATES IX and X, while nearly related to these are the standing figures of Buddhas lately excavated at Amarāvatī, reproduced on PLATE XI. To all these works we may fairly assign the honoured name of primitives, since their massive forms and austere outline are immediately determined by the moral grandeur of the thesis and the suppressed emotion of its realization, without any intrusion of individuality or parade of skill. The fulness of the modelling expresses a high degree of vitality, but does not yet show the conscious elegance and suavity of Gupta types.

We are not in position to precisely date these Buddhist primitives of Anurādhapura and Amarāvatī, but they may not be earlier than the first or second century A. D. and can hardly be later than the third or fourth. In describing these works as primitive, it is not, of course, suggested that they are the earliest or nearly the earliest of Buddha figures extant, nor that all of them are absolutely free from any element of western formulation, but merely that in them the primitive inspiration is better preserved than anywhere else. I have already suggested that the figures of the seated Buddha, if not the standing types, probably came into use as cult objects a good deal earlier, perhaps in the second century B. C.; and if these were generally made in wood or other impermanent materials, this would be in accord with all that we know of the general development of Indian plastic art and architecture. In any case, as M. Foucher points out,[1] the

[1] Foucher (A.), *L'Origine grecque de l'Image du Bouddha,* Paris, 1913. p. 31.

conventional character of the Buddha figure of the Kanishka reliquary

> dénote un art déjà stéréotypé, et . . . suffit pour reporter d'au moins cent ans en arrière et faire par suite remonter au Iᵉʳ siècle *avant* notre ère la création du type plastique du Bienheureux.

The same may be said of the Bodhisattvas. Indra and Brahmā were perhaps the types from which the sculptural representations of Avalokiteśvara and Maitreya were evolved, and Mr. Spooner has recorded his view that this evolution "was an accomplished fact prior to any form of the Gandhāra school with which we are yet familiar," pointing out here too that "the forms of both are stereotyped" already in the earliest examples from Gandhāra.[1]

We have so far left out of account the abundant and well-known Græco-Buddhist art of Gandhāra, dating from the 1st to the 4th century A. D., as well as the school of Mathurā, which in part derives from the older art of Sānchī and Bhārhut, and is partly dependent upon Gandhāra. This omission is not, as M. Foucher would suggest, "par engouement d'esthéticien ou rancune de nationaliste,"[2] but because we are here concerned to discover the sources of inspiration of Buddhist imagery and to learn how this inspiration was first and most fully expressed. That many western formulæ were absorbed into Indian art through Gandhāra does not touch the question of feeling; we must avoid the common error of confusing "Formensprache" with "Geist." It is even easy to exaggerate the importance of the western formulæ, as such, for whatever else in Buddhist art is borrowed, the cross-legged figure seated upon a lotus throne is entirely Indian in form as well as in idea; and besides this seated figure, the standing Buddha and the images of all the Buddhist gods are but of secondary importance.

For several reasons, it seems probable that the actual Gandhāra sculptures are mainly the work of western craftsmen employed by the Gandhāra kings to interpret Buddhist ideas, rather than Indian workmen under western guidance; and if some of the workmen were Indian by birth, they nevertheless did not give expression to Indian feeling. We have the parallel modern

[1] Spooner, D. B. Archaeological Survey of India, Ann. Rep., 1907-8 (1911), p. 144.

[2] Foucher (A.), *loc. cit.,* p. 41.

example of the late Raja Ravi Varma, who, despite the nominally
Indian subject matter of his paintings, entirely fails to reflect the
Indian spirit.

The manner in which the western formulæ have been gradually
Indianized, alike in the northwest and in the school of Mathurā,
and thus, as Professor Oskar Münsterberg remarks, "first de-
veloped under national and Buddhist inspiration into a new and
genuine art,"[1] has been studied in considerable detail by many
scholars; but what is equally or more significant for our enquiry
is the manner in which certain *Indian* formulæ and *Indian* ideas
are misrepresented at Gandhāra, for misrepresentation necessarily
implies the pre-existence of a type to be misinterpreted. The
plainest case is afforded by the Buddha figure seated on a "lotus
throne" (*padmāsana*). In Gandhāra sculpture the seated figure
is uncomfortably and unstably balanced on a lotus flower that is
far too small, and with its pointed petals, like an artichoke,[2] sug-
gests a seat of penance rather than of ease (PLATE VI, A). The
true sense of the *padmāsana* is, of course, to indicate spiritual
purity or divinity, and the symbol is only appropriately combined
with that of the seated yogī, when this function is fulfilled with-
out detracting from the one essential quality of repose. It is
specially emphasized in yoga texts that the seat of the yogī
is to be firm and easy, "*sthira-sukha*," and where this condition is
overlooked, it is impossible to recognize an immediate expression
of the original thesis.

The foregoing argument supports the view already men-
tioned, that the seated Buddha image in the age of
Kanishka was "*déjá stéréotypé*." It takes us, however,
somewhat further, for in connection with the far stronger,
though to archæologists less convincing, æsthetic evidence,
it shows plainly that Gandhāra sculpture is not primitive
Buddhist art. When, then, are we to look for the proto-
type of the seated figure thus "déjá stéréotypé?" Can we
postulate a Roman yogī, seated on a lotus throne, and with hands
in the *dhyāni mudrā*, to set beside the Lateran *Sophocles* of
which the influence is evident in standing images? The sug-
gestion is sufficiently absurd to need no refutation. The seated

[1] A characteristic example may be studied in Vincent Smith, *History
of Fine Art in India and Ceylon*, Plate xxiv.
[2] Münsterberg (O.), *Chinesische Kunstgeschichte*, p. 117, n.

Buddha, as we have already suggested on *á priori* grounds, can only be of Indian origin; and this being so, it will be seen how great an exaggeration is involved in speaking of the "Greek Origin of *the* Image of Buddha."

It has been sufficient for our purpose to explain in what senses Gandhāra sculpture cannot be regarded as primitive and autochthonous Buddhist art; it has not been necessary to emphasize also how little the smug and complacent features of the Gandhāra Buddhas and Bodhisattvas, and their listless and effeminate gestures, reflect the intellectual vigour or the devotional passion of Buddhist thought. For the benefit of M. Foucher, however, and of other scholars who may suppose, with him, that Mr. Havell, Professor Münsterberg, and I, have cared more for Indian art than for art, I may point out that our estimate of Gandhāra sculpture as of small æsthetic significance must not be taken as evidence of any prejudice against the art of Europe; it simply indicates concurrence in the view that "in the long sands and flats of Roman realism the stream of Greek inspiration is lost for ever." To admire Gandhāra art, as art, is not a compliment to the greatness of the Greeks, but only shows how far that greatness has been misunderstood. If it is possible for a European critic to write of the mosaics of the Galla Placidia at Ravenna that they are "still coarsely classical," and that "there is a nasty, woolly realism about the sheep, and about the good shepherd more than a suspicion of the stodgy, Græco-Roman Apollo,"[1] then surely we may criticize the sculptures of Gandhāra in the same terms without incurring charges of bad faith.

To resume: Early Buddhist art is popular, sensuous and animistic Indian art adapted to the purposes of the illustration of Buddhist anecdote and the decoration of Buddhist monuments; Gandhāra art is mixed, and misinterpreted equally both eastern and western formulæ, which must be older than itself, while it is not Buddhist in expression; the earliest Indian primitives of Buddhist art properly so-called are probably lost. In northern India the absence of primitives is partly to be accounted for by the fact that Buddhist inspiration was there absorbed, not in direct creation, but in adapting Græco-Roman motifs to its own spiritual ends. In southern India and Ceylon the same energy

[1] Bell (Clive), *Art,* p. 128.

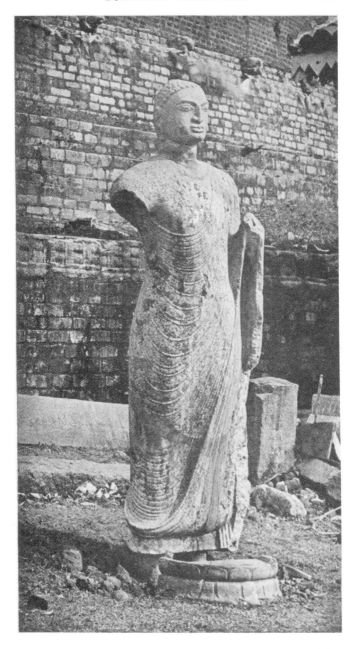

Standing Buddha. Stone sculpture, Ceylon, 2nd century, A.D.

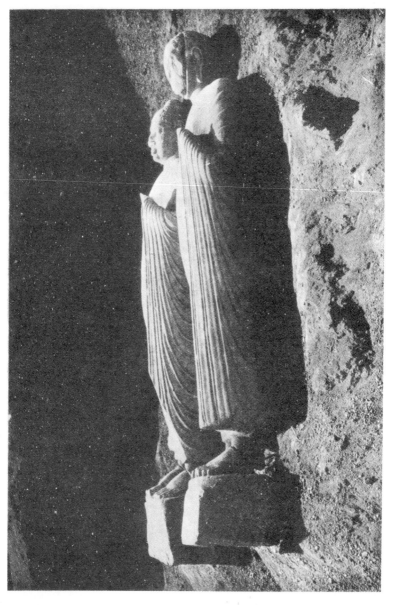

Standing images of Buddha. Stone sculpture, 2nd century, A.D. Amarāvatī.

working in greater isolation found a more direct expression; and though the earliest masterpieces may be lost, there are still preserved at Anurādhapura and Amarāvatī magnificent works, which we may fairly speak of as Buddhist primitives.[1]

[1] Early Buddhist art in China and Japan is also "primitive" in the æsthetic sense, precisely as Christian art in Europe preserved its primitive inspiration for six hundred years, because "some new race was always catching the inspiration and feeling and expressing it with primitive sensibility and passion."

THE DANCE OF ŚIVA

"The Lord of Tillai's Court a mystic dance performs;
what's that, my dear?"—*Tiruvāçagam,* XII, 14.

Amongst the greatest of the names of Śiva is Naṭarāja, Lord
of Dancers, or King of Actors. The cosmos is His theatre, there
are many different steps in His repertory, He Himself is actor
and audience—

> When the Actor beateth the drum,
> Everybody cometh to see the show;
> When the Actor collecteth the stage properties
> He abideth alone in His happiness.

How many various dances of Śiva are known to His worship-
pers I cannot say. No doubt the root idea behind all of these
dances is more or less one and the same, the manifestation of
primal rhythmic energy. Śiva is the Eros Protogonos of Lucian,
when he wrote:

"It would seem that dancing came into being at the beginning
of all things, and was brought to light together with Eros, that
ancient one, for we see this primeval dancing clearly set forth in
the choral dance of the constellations, and in the planets and
fixed stars, their interweaving and interchange and orderly har-
mony."

I do not mean to say that the most profound interpretation of
Śiva's dance was present in the minds of those who first danced
in frantic, and perhaps intoxicated energy, in honour of the pre-
Aryan hill-god, afterwards merged in Śiva. A great motif in
religion or art, any great symbol, becomes all things to all men;
age after age it yields to men such treasure as they find in their
own hearts. Whatever the origins of Śiva's dance, it became
in time the clearest image of the *activity* of God which any art
or religion can boast of. Of the various dances of Śiva I shall
only speak of three, one of them alone forming the main subject
of interpretation. The first is an evening dance in the Himā-
layas, with a divine chorus, described as follows in the *Siva
Pradosha Stotra:*

"Placing the Mother of the Three Worlds upon a golden throne, studded with precious gems, Śūlapāṇi dances on the heights of Kailāsa, and all the gods gather round Him:

"Sarasvatī plays on the *vīṇā*, Indra on the flute, Brahmā holds the time-marking cymbals, Lakshmī begins a song, Vishnu plays on a drum, and all the gods stand round about:

"Gandharvas, Yakshas, Patagas, Uragas, Siddhas, Sadhyas, Vidyādharas, Amaras, Apsarases, and all the beings dwelling in the three worlds assemble there to witness the celestial dance and hear the music of the divine choir at the hour of twilight."

This evening dance is also referred to in the invocation preceding the *Kathā Sarit Sāgara*.

In the pictures of this dance, Śiva is two-handed, and the co-operation of the gods is clearly indicated in their position of chorus. There is no prostrate Asura trampled under Śiva's feet. So far as I know, no special interpretations of this dance occur in Śaiva literature.

The second well known dance of Śiva is called the *Tāṇdava*, and belongs to His *tāmasic* aspect as Bhairava or Vīra-bhadra. It is performed in cemeteries and burning grounds, where Śiva, usually in ten-armed form, dances wildly with Devī, accompanied by troops of capering imps. Representations of this dance are common amongst ancient sculptures, as at Elūra, Elephanta, and also Bhuvaneśvara. The *tāṇdava* dance is in origin that of a pre-Aryan divinity, half-god, half-demon, who holds his midnight revels in the burning ground. In later times, this dance in the cremation ground, sometimes of Śiva, sometimes of Devī, is interpreted in Śaiva and Śākta literature in a most touching and profound sense.

Thirdly, we have the Nadānta dance of Naṭarāja before the assembly (*sabhā*) in the golden hall of Chidambaram or Tillai, the centre of the Universe, first revealed to gods and rishis after the submission of the latter in the forest of Tāragam, as related in the *Koyil Purāṇam*. The legend, which has after all, no very close connection with the real meaning of the dance, may be summarised as follows:

In the forest of Tāragam dwelt multitudes of heretical rishis, following of the Mīmāṃsa. Thither proceeded Śiva to confute them, accompanied by Vishnu disguised as a beautiful woman, and Āti-Śeshan. The rishis were at first led to violent dispute

amongst themselves, but their anger was soon directed against Śiva, and they endeavoured to destroy Him by means of incantations. A fierce tiger was created in sacrificial fires, and rushed upon Him; but smiling gently, He seized it and, with the nail of His little finger, stripped off its skin, and wrapped it about Himself like a silken cloth.[1] Undiscouraged by failure, the sages renewed their offerings, and produced a monstrous serpent, which however, Śiva seized and wreathed about His neck like a garland. Then He began to dance; but there rushed upon Him a last monster in the shape of a malignant dwarf, Muyalaka. Upon him the God pressed the tip of His foot, and broke the creature's back, so that it writhed upon the ground; and so, His last foe prostrate, Śiva resumed the dance, witnessed by gods and rishis.

Then Āti Śeshan worshipped Śiva, and prayed above all things for the boon, once more to behold this mystic dance; Śiva promised that he should behold the dance again in sacred Tillai, the centre of the Universe.

This dance of Śiva in Chidambaram or Tillai forms the motif of the South Indian copper images of Śrī Naṭarājā, the Lord of the Dance. These images vary amongst themselves in minor details, but all express one fundamental conception. Before proceeding to enquire what these may be, it will be necessary to describe the image of Śrī Naṭarājā as typically represented. The images then, represent Śiva dancing, having four hands, with braided and jewelled hair of which the lower locks are whirling in the dance. In His hair may be seen a wreathing cobra, a skull, and the mermaid figure of Gangā; upon it rests the crescent moon, and it is crowned with a wreath of Cassia leaves. In His right ear He wears a man's earring, a woman's in the left; He is adorned with necklaces and armlets, a jewelled belt, anklets, bracelets, finger and toe-rings. The chief part of His dress consists of tightly fitting breeches, and He wears also a fluttering scarf and a sacred thread. One right hand holds a drum, the other is uplifted in the sign of do not fear: one left hand holds fire, the other points down upon the demon Muyalaka, a dwarf holding a cobra; the left foot is raised. There is a lotus pedestal, from which springs an encircling glory (*tiruvāsi*), fringed with flame, and touched within by the hands holding drum and fire.

[1] A similar story is elsewhere related about an elephant; and these legends account for the elephant or tiger skin, which Śiva wears.

The images are of all sizes, rarely if ever exceeding four feet in total height.

Even without reliance upon literary references, the interpretation of this dance would not be difficult. Fortunately, however, we have the assistance of a copious contemporary literature, which enables us to fully explain not only the general significance of the dance, but equally, the details of its concrete symbolism. Some of the peculiarities of the Naṭarājā images, of course, belong to the conception of Śiva generally, and not to the dance in particular. Such are the braided locks, as of a yogī: the Cassia garland: the skull of Brahmā: the figure of Gaṇgā, (the Ganges fallen from heaven and lost in Śiva's hair): the cobras: the different earrings, betokening the dual nature of Mahādev, 'whose half is Umā': and the four arms. The drum also is a general attribute of Śiva, belonging to his character of Yogī, though in the dance, it has further a special significance. What then is the meaning of Śiva's Nadānta dance, as understood by Śaivas? Its essential significance is given in texts such as the following:

"Our Lord is the Dancer, who, like the heat latent in firewood, diffuses His power in mind and matter, and makes them dance in their turn."[2]

The dance, in fact, represents His five activites (*Pañcakṛitya*), viz: *Srishṭi* (overlooking, creation, evolution), *Sthiti* (preservation, support), *Samhāra* (destruction, evolution), *Tirobhava* (veiling, embodiment, illusion, and also, giving rest), *Anugraha* (release, salvation, grace). These, separately considered, are the activities of the deities Brahmā, Vishnu, Rudra, Maheśvara and Sadāśiva.

This cosmic activity is the central motif of the dance. Further quotations will illustrate and explain the more detailed symbolisms. *Uṇmai Vilakkam*, verse 36, tells us:

"Creation arises from the drum: protection proceeds from the hand of hope: from fire proceeds destruction: the foot held aloft

[1] Kadavul Māmunivar's *Tiruvātāvurār Purāṇam,* Puttaraivātil, Venracarukkam, stanza 75, translated by Nallasvāmi Pillai, *Sivajñānabodham,* p. 74. This could also be rendered:

 Like heat latent in firewood, he fills all bodies:
 Our Father dances, moving all souls into action, know ye!

Compare Eckhart, "Just as the fire infuses the essence and clearness into the dry wood, so has God done with man."

gives release." It will be observed that the fourth hand points
to this lifted foot, the refuge of the soul.

We have also the following from *Chidambara Mummani Kovai:*

"O my Lord, Thy hand holding the sacred drum has made and
ordered the heavens and earth and other worlds and innumerable
souls. Thy lifted hand protects both the conscious and uncon-
scious order of thy creation. All these worlds are transformed
by Thy hand bearing fire. Thy sacred foot, planted on the
ground, gives an abode to the tired soul struggling in the toils
of causality. It is Thy lifted foot that grants eternal bliss to
those that approach Thee. These Five-Actions are indeed Thy
Handiwork."

The following verses from the *Tirukūttu Darshana* (Vision of
the Sacred Dance), forming the ninth tantra of Tirumūlar's
Tirumantram, expand the central motif further:

"His form is everywhere: all-pervading in His Śiva-Śakti:
Chidambaram is everywhere, everywhere His dance:
As Śiva is all and omnipresent,
Everywhere is Śiva's gracious dance made manifest.
His five-fold dances are temporal and timeless.
His five-fold dances are His Five Activties.
By His grace He performs the five acts,
This is the sacred dance of Umā-Sahāya.
He dances with Water, Fire, Wind and Ether,
Thus our Lord dances ever in the court.
Visible to those who pass over Māyā and Mahāmāyā (illusion
and super-illusion)
Our Lord dances His eternal dance.
The form of the Śakti is all delight—
This united delight is Umā's body:
This form of Śakti arising in time
And uniting the twain is the dance"
His body is Ākāś, the dark cloud therein is Muyalaka,
The eight quarters are His eight arms,
The three lights are His three eyes,
Thus becoming, He dances in our body as the congregation."
This is His dance. Its deepest significance is felt when it is
realised that it takes place within the heart and the self. Every-
where is God: that Everywhere is the heart. Thus also we find
another verse:

"The dancing foot, the sound of the tinkling bells,
The songs that are sung and the varying steps,
The form assumed by our Dancing Gurupara—
Find out these within yourself, then shall your fetters fall away."

To this end, all else but the thought of God must be cast out of the heart, that He alone may abide and dance therein. In *Uṇmai Vilakkam*, we find:

"The silent sages destroying the threefold bond are established where their selves are destroyed. There they behold the sacred and are filled with bliss. This is the dance of the Lord of the assembly, 'whose very form is Grace'."

With this reference to the 'silent sages' compare the beautiful words of Tirumūlar:

"When resting there they (the yogīs who attain the highest place of peace) lose themselves and become idle. . . . Where the idlers dwell is the pure Space. Where the idlers sport is the Light. What the idlers know is Vedānta. What the idlers find is the deep sleep therein."

Śiva is a destroyer and loves the burning ground. But what does He destroy? Not merely the heavens and earth at the close of a world-cycle, but the fetters that bind each separate soul.[1] Where and what is the burning ground? It is not the place where our earthly bodies are cremated, but the hearts of His lovers, laid waste and desolate. The place where the ego is destroyed signifies the state where illusion and deeds are burnt away: that is the crematorium, the burning-ground where Śri Naṭarāja dances, and whence He is named Sudalaiyādi, Dancer of the burning-ground. In this simile, we recognize the historical connection between Śiva's gracious dance as Naṭarāja, and His wild dance as the demon of the cemetery.

This conception of the dance is current also amongst Śāktas, especially in Bengal, where the Mother rather than the Father-aspect of Siva is adored. Kālī is here the dancer, for whose

[1] Cf. Marcel Schwob, *Le Livre de Monelle.*
"This is the teaching: Destroy, destroy, destroy. Destroy within yourself, destroy all around you. Make room for your soul and for other souls. Destroy, because all creation proceeds from destruction For all building up is done with debris, and nothing in the world is new but shapes. But the shapes must be perpetually destroyed . . . Break every cup from which you drink."

entrance the heart must be purified by fire, made empty by renunciation. A Bengali Hymn to Kālī voices this prayer:

> "Because Thou lovest the Burning-ground,
> I have made a Burning-ground of my heart—
> That Thou, Dark One, haunter of the Burning-ground,
> Mayest dance Thy eternal dance.
> Nought else is within my heart, O Mother:
> Day and night blazes the funeral pyre:
> The ashes of the dead, strewn all about,
> I have preserved against Thy coming,
> With death-conquering Mahākāla neath Thy **feet**
> Do Thou enter in, dancing Thy rhythmic dance,
> That I may behold Thee with closed eyes."

Returning to the South, we find that in other Tamil texts the purpose of Śiva's dance is explained. In *Śivajñāna Siddhiyār*, Supaksha, Sūtra V, 5, we find,

"For the purpose of securing both kinds of fruit to the countless souls, our Lord, with actions five, dances His dance." Both kinds of fruit, that is *Iham*, reward in this world, and *Param*, bliss in Mukti.

Again, *Uṇmai Vilakkam*, v. 32, 37, 39 inform us

"The Supreme Intelligence dances in the soul . . . for the purpose of removing our sins. By these means, our Father scatters the darkness of illusion (*māyā*), burns the thread of causality (*karma*), stamps down evil (*mala, āṇava, avidyā*), showers Grace, and lovingly plunges the soul in the ocean of Bliss (*ānanda*). They never see rebirths, who behold this mystic dance."

The conception of the world process as the Lord's pastime or amusement (*līlā*) is also prominent in the Śaiva scriptures. Thus Tirumūlar writes, "The perpetual dance is His play." This spontaneity of Śiva's dance is so clearly expressed in Skryabin's *Poem of Ecstasy* that the extracts following will serve to explain it better than any more formal exposition—what Skryabin wrote is precisely what the Hindu imager moulded:

> "The Spirit (*purusha*) playing,
> The Spirit longing,
> The Spirit with fancy (*yoga-māyā*) creating all,
> Surrenders himself to the bliss (*ānanda*) of love . . .

Amid the flowers of His creation (*prakṛti*), He lingers in a
 kiss. . . .
Blinded by their beauty, He rushes, He frolics, He dances,
 He whirls. . . .
He is all rapture, all bliss, in this play (*līlā*)
Free, divine, in this love struggle.
In the marvellous grandeur of sheer aimlessness,
And in the union of counter-aspirations
In consciousness alone, in love alone,
The Spirit learns the nature (*svabhāva*) of His divine
 being. . . .
' O, my world, my life, my blossoming, my ecstasy!
Your every moment I create
By negation of all forms previously lived through:
I am eternal negation (*neti, neti*). . . .'
Enjoying this dance, choking in this whirlwind,
Into the domain of ecstasy, He takes swift flight.
In this unceasing change (*samsāra, nitya bhava*), in this
 flight, aimless, divine
The Spirit comprehends Himself,
In the power of will, alone, free,
Ever-creating, all-irradiating, all-vivifying,
Divinely playing in the multiplicity of forms, He compre-
 hends Himself. . . .
' I already dwell in thee, O, my world,
Thy dream of me—'twas I coming into existence. . . .
And thou art all—one wave of freedom and bliss. . . .'
By a general conflagration (*mahā-pralaya*) the universe
 (*samsāra*) is embraced
The Spirit is at the height of being, and He feels the tide
 unending
Of the divine power (*śakti*) of free will. He is all-daring:
What menaced, now is excitement,
What terrified, is now delight. . . .
And the universe resounds with the joyful cry I am."[1]

This aspect of Śiva's immanence appears to have given rise to
the objection that he dances as do those who seek to please the
eyes of mortals: but it is answered that in fact He dances to

[1] From the translation by Lydia L. Pimenoff Noble, published in the
Boston Symphony Orchestra Programme, October 29, 1917.

maintain the life of the cosmos and to give release to those who seek Him. Moreover, if we understand even the dances of human dancers rightly, we shall see that they too lead to freedom.[1] But it is nearer the truth to answer that the reason of His dance lies in His own nature, all his gestures are own-nature-born (svabhāva-jaḥ), spontaneous, and purposeless—for His being is beyond the realm of purposes.

In a much more arbitrary way the dance of Śiva is identified with the Pañcākshara, or five syllables of the prayer Śi-va-ya-na-ma, 'Hail to Śiva.' In Uṇmai Vilakkam we are told: "If this beautiful Five-Letters be meditated upon, the soul will reach the land where there is neither light nor darkness, and there Śakti will make it One with Śivam."[1]

Another verse of Uṇmai Vilakkam explains the fiery arch (tiruvāsi): The Pañchākshara and the Dance are identified with the mystic syllable 'Om,' the arch being the kombu or hook of the ideograph of the written symbol: "The arch over Śrī Naṭa-rāja is Omkāra; and the akshara which is never separate from the Omkāra is the contained splendour. This is the Dance of the Lord of Chidambaram."

The Tiru-Arul-Payan however (Ch. ix. 3) explains the tiruvāsi more naturally as representing the dance of Nature, contrasted with Śiva's dance of wisdom.

"The dance of nature proceeds on one side: the dance of enlightenment on the other. Fix your mind in the centre of the latter."

I am indebted to Mr. Nallasvāmi Pillai for a commentary on this:

The first dance is the action of matter—material and individual energy. This is the arch, tiruvāsi, Omkāra, the dance of Kālī. The other is the Dance of Śiva—the akshara inseparable from the Omkāra—called ardhamātra or the fourth letter of the Pra-ṇava—Chaturtam and Turīyam. The first dance is not possible unless Śiva wills it and dances Himself.

The general result of this interpretation of the arch is, then, that it represents matter, nature, Prakṛiti; the contained splen-dour, Śiva dancing within and touching the arch with head, hands and feet, is the universal omnipresent Spirit (Purusha).

[1] See Nandikeśvara, The Mirror of Gesture, translated by Coomara-swamy and Duggirala, p. 11.

Between these stands the individual soul, as *ya* is between *Śi-va* and *na-ma*.

Now to summarize the whole interpretation we find that *The Essential Significance of Śiva's Dance is threefold: First, it is the image of his Rhythmic Play as the Source of all Movement within the Cosmos, which is Represented by the Arch: Secondly, the Purpose of his Dance is to Release the Countless souls of men from the Snare of Illusion: Thirdly the Place of the Dance, Chidambaram, the Centre of the Universe, is within the Heart.*

So far I have refrained from all aesthetic criticism and have endeavoured only to translate the central thought of the conception of Śiva's dance from plastic to verbal expression, without reference to the beauty or imperfection of individual works. But it may not be out of place to call attention to the grandeur of this conception itself as a synthesis of science, religion and art. How amazing the range of thought and sympathy of those rishi-artists who first conceived such a type as this, affording an image of reality, a key to the complex tissue of life, a theory of nature, not merely satisfactory to a single clique or race, nor acceptable to the thinkers of one century only, but universal in its appeal to the philosopher, the lover, and the artist of all ages and all countries. How supremely great in power and grace this dancing image must appear to all those who have striven in plastic forms to give expression to their intuition of Life!

In these days of specialization, we are not accustomed to such a synthesis of thought; but for those who 'saw' such images as this, there could have been no division of life and thought into water-tight compartments. Nor do we always realize, when we criticise the merits of individual works, the full extent of the creative power which, to borrow a musical analogy, could discover a mode so expressive of fundamental rhythms and so profoundly significant and inevitable.

Every part of such an image as this is directly expressive, not of any mere superstition or dogma, but of evident facts. No artist of today, however great, could more exactly or more wisely create an image of that Energy which science must postulate behind all phenomena. If we would reconcile Time with Eternity, we can scarcely do so otherwise than by the conception of alternations of phase extending over vast regions of space and great tracts of time. Especially significant, then, is the phase

alternation implied by the drum, and the fire which 'changes,' not destroys. These are but visual symbols of the theory of the day and night of Brahmā.

In the night of Brahmā, Nature is inert, and cannot dance till Śiva wills it: He rises from His rapture, and dancing sends through inert matter pulsing waves of awakening sound, and lo! matter also dances appearing as a glory round about Him. Dancing, He sustains its manifold phenomena. In the fulness of time, still dancing, he destroys all forms and names by fire and gives new rest. This is poetry; but none the less, science.

It is not strange that the figure of Naṭarāja has commanded the adoration of so many generations past: familiar with all scepticisms, expert in tracing all beliefs to primitive superstitions, explorers of the infinitely great and infinitely small, we are worshippers of Naṭarāja still.

PLATE XII

IMAGES WITH MANY ARMS.

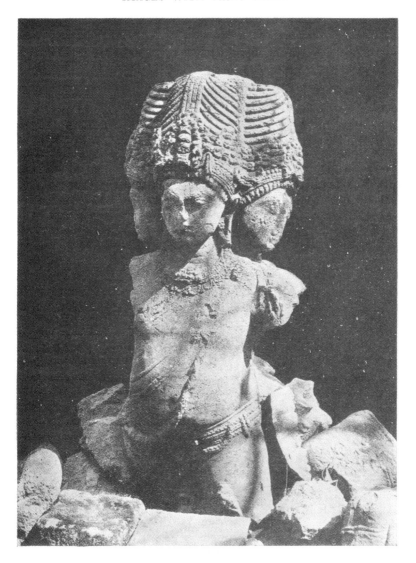

Brahmā. Brahmanical stone sculpture, Elephanta, 8th Century.

INDIAN IMAGES WITH MANY ARMS

Certain writers, speaking of the many-armed images of Indian art, have treated this peculiarity as an unpardonable defect. "After 300 A.D.," says Mr. Vincent Smith, "Indian sculpture properly so-called hardly deserves to be reckoned as art. The figures both of men and animals become stiff and formal, and the idea of power is clumsily expressed by the multiplication of members. The many-headed, many-armed gods and goddesses whose images crowd the walls and roofs of mediæval temples have no pretentions to beauty, and are frequently hideous and grotesque."[1] Mr. Maskell speaks of "these hideous deities with animals' heads and innumerable arms."[2] Sir George Birdwood considers that "the monstrous shapes of the Puranic deities are unsuitable for the higher forms of artistic representation; and this is possibly why sculpture and painting are unknown as fine arts in India."[3] Quotations of this kind could be multiplied, but enough has been given to show that for a certain class of critics there exists the underlying assumption that in Indian art the multiplications of limbs or heads, or addition of any animal attributes, is in itself a very grave defect, and fatal to any claim for merit in the works concerned.

In reply to criticisms of this kind it would be useless to cite examples of Greek art such as the Victory of Samothrace or the head of Hypnos: of Egyptian, such as the figures of Sekhet or other animal divinities: of Byzantine or mediæval angels: or modern works such as some of M. Rodin's. For it is clear that all these, if the critics be consistent, must suffer equal condemnation.

Let me digress at this point to class the critics: for I fear that

[1] *Imperial Gazetteer of India,* 1910, vol. II.
[2] *Ivories,* 1915, p. 332.
[3] *Industrial Arts of India,* 1880, p. 125. If the fine arts were until recently "unknown in India," perhaps this can be explained by the remark of B. H. Baden-Powell, who says that "In a country like this we must not expect to find anything that appeals to mind or deep feeling." For "unknown" to Sir George Birdwood or Mr. Baden-Powell need not imply anything more than "unrecognized."
It is fair to say that Mr. Vincent Smith's opinions have been considerably modified since 1910.

I ought to apologise for putting forward in this chapter what is obvious. The difficulty is one that has been raised exclusively by philologists and historians: in a considerable experience I have never heard these objections raised by artists or by connoisseurs. These notes are dedicated, then, only to the philologist and the historian, and may be neglected by all others.

The condemnations quoted are certainly to be justified if we are to agree to find the final aim of art in representation: then let us seek the most attractive models and carefully copy them.

But this test of verisimilitude has never been anything more than the result of a popular misunderstanding. Let us submit the Indian, Greek or Egyptian figures to recognized standards, and to criticism a little more penetrating than is involved in merely counting heads or arms.

Leonardo says that that figure is most worthy of praise which by its action best expresses the passion that animates it.

Hsieh Ho demands that the work of art should exhibit the fusion of the rhythm of the spirit with the movement of living things.

Mr. Holmes suggests that a work of art must possess in some degree the four qualities of Unity, Vitality, Infinity and Repose.

In other words, a work of art is great in so far as it expresses its own theme in a form at once rhythmic and impassioned: through a definite pattern it must express a motif deeply felt.

From this point of view it would seem that we must take each work of art upon its own merits. To apply the simplest tests just quoted—I wish to speak with the greatest possible simplicity—an image with many arms or heads may be called an inferior work of art, or inartistic, if it lacks any one of the four qualities demanded by Mr. Holmes, or as we may say, if it is not ' felt.' But if it has such qualities, if it is felt, need we further concern ourselves with arithmetic?

The artist does not choose his own problems: he finds in the canon instruction to make such and such images in such and such a fashion—for example, an image of Naṭarāja with four arms (FRONTISPIECE), of Brahmā with four heads, PLATE XII, of Mahisha-mardinī with ten arms, PLATE XIII, or of Gaṇeśa with an elephant's head. Our critics are bold enough to assert that in obeying these instructions he *cannot* create a work of art. It would have been fairer and more moderate to suggest that the

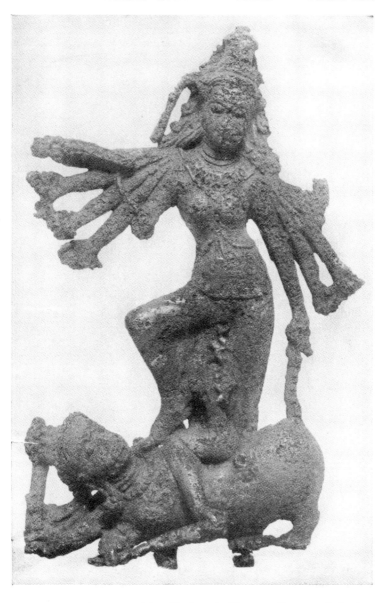

Durgā as Chaṇḍī slaying Mahisha. Brahmanical bronze. Java. 11th Century.

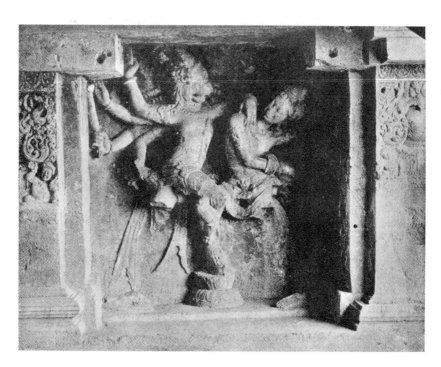

Death of Hiraṇyakasipu. Brahmanical stone sculpture. Elūra,
8th Century.

problems propounded are often very difficult; this would have left open the way to recognize a successful effort, if such could be found. To have overcome the difficulties would then be a proof of artistic capacity—and I suppose it should be the aim of the historian of art to discover such proofs.

The accompanying illustration, PLATE XIII, shows a Javanese figure of Mahisha-mardinī with ten arms, slaying the demon Mahisha. She is here a dread avenging power: yet she is neither cruel nor angry, but rather sad with the sadness of those who are wise, playing an inevitable part, though at heart no more than the spectator of a drama. This entire figure, damaged as it is, shows what tenderness may be expressed, even in tāmasic images. And this peace and tenderness find expression in the movement of the whole figure, and not by any arbitrary means: no part of the whole is at war with any other, and this is what we mean by unity. It would indeed be futile to condemn an image such as this because it has ten arms. Or take the Naṭarāja image of the primal rhythmic energy underlying all phenomenal appearances and activity: here is perpetual movement, perpetually poised—the rhythm of the spirit.

The death of Hiraṇyakaśipu, PLATE XIV, is a work that may be called grotesque. We have long learnt however that this cannot be used as a mere term of abuse. It would be difficult to imagine a more splendid rendering of the well known theme of the impious king who met his death at the hands of the avenging deity in man-lion form. The hand upon the shoulder, the shrinking figure with the mocking smile that has had no time to fade—what could be more terrible? These are figures expressing by their action their animating passions: or if not so, then none have ever been. It would be unkind to contrast a work such as this with the 'truth to nature' of the Laokoon.

In these figures we cannot speak of the many arms as 'additional members' because in a human being they might appear to be such. We have here a work of art which is, or is not a unity. If the work is a unity we can no more speak of added elements, than we can speak of ornament in a work of art as something added to an expression that would not otherwise be beautiful. It is not by addition or removal that we create. Before these works we can only ask, are these, or are they not, clear and impassioned expressions of their subject matter? All unprejudiced

and competent observers would then agree that amongst Indian images there are some of which we can say that they are such adequate expressions, and of others that they are not: but to recognize those and these requires a rather more subtle approach than that involved in the arithmetical process of counting arms or heads.

Certain developments in the most modern art could be quoted in comparison with the Indian complex figures, and, indeed, the method of these is more than modern. Some painters of the present day have sought by many strange devices to create a synthetic and symphonic art representing a continuity of thought or action, and an interpretation of ideas belonging to more than a single phase of personality—an art of interpretation. And if, as we now realise, even the human personality is compound, we should understand that this must be even more true of a cosmic divinity, who is, indeed, able by a division of *upādhis,* to function in many places at one time. To reflect such conceptions in art demands a synthetic rather than a representative language. It might well be claimed, then, that this method adopted sometimes in India, sometimes in Egypt, sometimes in Greece, and still employed, has proved successful from the practical point of view, of pure expression, the getting said what had to be said: and this is after all the sure and safe foundation of art.

These forms remain potentially equally satisfactory, too, whether as philosophers we regard them as purely abstract expressions, or with the artists themselves regard them as realistic presentations of another order of life than our own, deriving from a *deva-loka,* other than the world we are familiar with, but not necessarily unknowable or always invisible. The distinction in any case is slight, for the images equally belong to a world of their own, however we regard them.

The criticism of the philologists ultimately resolves itself into a complaint that the art is not always representative ('true to nature'). I have tried to show that it is true to experience and feeling. But aside from that, whatever in a work of art is ostensibly representative must be judged according to the logic of the world it represents—even if that world be no other than the idea-world of the *sādhanas* and *dhyāna mantrams.* All worlds are idea-worlds of one kind or another, and we should also remember that 'recognition' does not necessarily imply any real knowl-

edge of things in themselves—we do not know that men have really two arms, that is merely an 'intelligible representation.' It is no criticism of a fairy tale to say that in our world we meet no fairies: we should rather, and do actually, condemn on the score of insincerity, a fairy tale which should be so made as to suggest that in the writer's world there were no fairies. It is no criticism of a beast-fable to say that after all animals do not talk English or Sanskrit. Nor is it a criticism of an Indian icon to point out that we know no human beings with more than two arms.

To appreciate any art, moreover, we ought not to concentrate our attention upon its peculiarities—ethical or formal—but should endeavour to *take for granted* whatever the artist takes for granted. No motif appears bizarre to those who have been familiar with it for generations: and in the last analysis it must remain beyond the reach of all others so long as it remains in their eyes primarily bizarre.

If circumstances then compel the philologist and the historian to classify the extant materials for the study of Indian art, their studies will be the more valuable the more strictly they are confined to the archæological point of view. For those should not air their likes and dislikes in Oriental art, who when they speak of art mean mere illustration: for there they will rarely meet with what they seek, and the expression of their disappointment becomes wearisome.

INDIAN MUSIC

Music has been a cultivated art in India for at least three thousand years. The chant is an essential element of Vedic ritual; and the references in later Vedic literature, the scriptures of Buddhism, and the Brahmanical epics show that it was already highly developed as a secular art in centuries preceding the beginning of the Christian era. Its zenith may perhaps be assigned to the Imperial age of the Guptas—from the fourth to the sixth century A. D. This was the classic period of Sanskrit literature, culminating in the drama of Kālidāsa; and to the same time is assigned the monumental treatise of Bharata on the theory of music and drama.

The art music of the present day is a direct descendant of these ancient schools, whose traditions have been handed down with comment and expansion in the guilds of the hereditary musicians. While the words of a song may have been composed at any date, the musical themes communicated orally from master to disciple are essentially ancient. As in other arts and in life, so here also India presents to us the wonderful spectacle of the still surviving consciousness of the ancient world, with a range of emotional experience rarely accessible to those who are pre-occupied with the activities of over-production, and intimidated by the economic insecurity of a social order based on competition.

The art music of India exists only under cultivated patronage, and in its own intimate environment. It corresponds to all that is most classical in the European tradition. It is the chamber-music of an aristocratic society, where the patron retains musicians for his own entertainment and for the pleasure of the circle of his friends: or it is temple music, where the musician is the servant of God. The public concert is unknown, and the livelihood of the artist does not depend upon his ability and will to amuse the crowd. In other words, the musician is protected. Under these circumstances he is under no temptation to be anything but a musician; his education begins in infancy, and his art remains a vocation. The civilizations of Asia do not afford to the inefficient amateur those opportunities of self-expression

PLATE XV

INDIAN MUSIC.

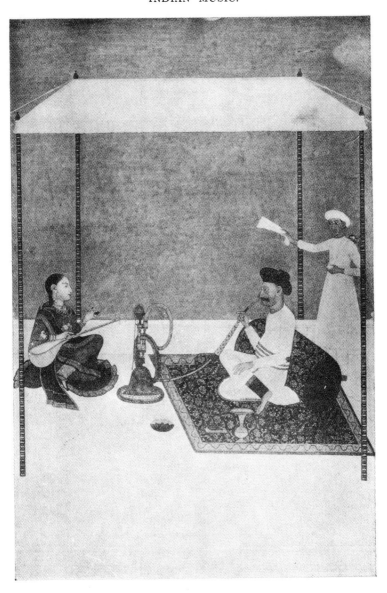

Chamber-music of an aristocratic society.' Late Mughal painting, 18th century.

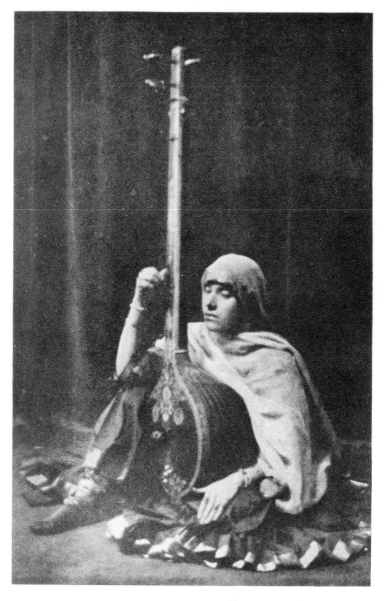

Ratan Devī, singer of Indian songs in America
(Photograph by Arnold Genthe.)

which are so highly appreciated in Europe and America. The arts are nowhere taught as a social accomplishment; on the one hand there is the professional, proficient in a traditional art, and on the other the lay public. The musical cultivation of the public does not consist in "everybody doing it," but in appreciation and reverence.

I have indeed heard the strange objection raised that to sing the music of India one must be an artist; and this objection seems to voice a typically democratic disapproval of superiority. But it would be nearly as true to say that the listener must respond with an art of his own, and this would be entirely in accord with Indian theories of æsthetic. The musician in India finds a model audience—technically critical, but somewhat indifferent to voice production. The Indian audience listens rather to the song than to the singing of the song: those who are musical, perfect the rendering of the song by the force of their own imagination and emotion. Under these conditions the actual music is better heard than where the sensuous perfection of the voice is made a *sine qua non:* precisely as the best sculpture is primitive rather than suave, and we prefer conviction to prettiness—"It is like the outward poverty of God,[1] whereby His glory is nakedly revealed." None the less the Indian singer's voice is sometimes of great intrinsic beauty, and sometimes used with sensitive intelligence as well as skill. It is not, however, the voice that makes the singer, as so often happens in Europe.

Since Indian music is not written, and cannot be learnt from books, except in theory, it will be understood that the only way for a foreigner to learn it must be to establish between himself and his Indian teachers that special relationship of disciple and master which belongs to Indian education in all its phases: he must enter into the inner spirit and must adopt many of the outer conventions of Indian life, and his study must continue until he can improvise the songs under Indian conditions and to the satisfaction of Indian professional listeners. He must possess not only the imagination of an artist, but also a vivid memory and an ear sensitive to microtonal inflections.

The theory of scale is everywhere a generalisation from the

[1] Maheśvara, who wanders through the world a penniless and naked ascetic.

facts of song. The European art scale has been reduced to
twelve fixed notes by merging nearly identical intervals such as
D sharp and E flat, and it is also tempered to facilitate modulation
and free change of key. In other words, the piano is out of
tune by hypothesis. Only this compromise, necessitated in the
development of harmony, has made possible the triumphs of
modern orchestration. A purely melodic art, however, may be
no less intensely cultivated, and retains the advantages of pure
intonation and modal colouring.

Apart from the keyed instruments of modern Europe there
scarcely exists an absolutely fixed scale: at any rate, in India
the thing fixed is a group of intervals, and the precise vibration
value of a note depends on its position in a progression, not on
its relation to a tonic. The scale of twenty-two notes is simply
the sum of all the notes used in all the songs—no musician sings
a chromatic scale from C to C with twenty-two stopping places,
for this would be a mere *tour de force*.

The 'quarter-tone' or *śruti* is the microtonal interval between
two successive scale notes: but as the theme rarely employs
two and never three scale notes in succession, the microtonal
interval is not generally conspicuous except in ornament.

Every Indian song is said to be in a particular *rāga or rāgiṇī*
—rāgiṇī being the feminine of rāga, and indicating an abridge-
ment or modification of the main theme. The rāga, like the old
Greek and the ecclesiastical mode, is a selection of five, six, or
seven notes, distributed along the scale; but the rāga is more
particularized than a mode, for it has certain characteristic pro-
gressions, and a chief note to which the singer constantly returns.
None of the rāgas employs more than seven substantive notes, and
there is no modulation: the strange tonality of the Indian song
is due to the use of unfamiliar intervals, and not to the use of
many successive notes with small divisions.

The rāga may be best defined as a melody-mould or the ground
plan of a song. It is this ground plan which the master first of
all communicates to the pupil; and to sing is to improvise upon
the theme thus defined. The possible number of rāgas is very
large, but the majority of systems recognise thirty-six, that is to
say six rāgas, each with five rāgiṇīs. The origin of the rāgas
is various: some, like Pahārī, are derived from local folk-song,
others, like Jog, from the songs of wandering ascetics, and still

others are the creation of great musicians by whose names they are known. More than sixty are mentioned in a Sanskrit-Tibetan vocabulary of the seventh century, with names such as 'With-a-voice-like-a-thunder-cloud,' 'Like-the-god-Indra,' and 'Delighting-the heart.' Amongst the rāga names in modern use may be cited 'Spring,' Evening beauty,' 'Honey-flower,' 'The swing,' 'Intoxication.'

Psychologically the word rāga, meaning colouring or passion, suggests to Indian ears the idea of mood; that is to say that precisely as in ancient Greece, the musical mode has definite *ethos*. It is not the purpose of the song to repeat the confusion of life, but to express and arouse particular passions of body and soul in man and nature. Each rāga is associated with an hour of the day or night when it may be appropriately sung, and some are associated with particular seasons or have definite magic effects. Thus there is still believed the well-known story of a musician whose royal patron arbitrarily insisted on hearing a song in the Dīpak rāga, which creates fire: the musician obeyed under protest, but as the song proceeded, he burst into flames, which could not be extinguished even though he sprang into the waters of the Jamna. It is just because of this element of magic, and the association of the rāgas with the rhythmic ritual of daily and seasonal life, that their clear outlines must not be blurred by modulation: and this is expressed, when the rāgas are personified as musical genii, by saying that 'to sing out of the rāga' is to break the limbs of these musical angels. A characteristic story is related of the prophet Nārada, when he was still but a learner. He thought that he had mastered the whole art of music; but the all-wise Vishnu, to curb his pride, revealed to him in the world of the gods, a spacious building where there lay men and women weeping over their broken arms and legs. They were the rāgas and rāginīs, and they said that a certain sage of the name of Nārada, ignorant of music and unskillful in performance, had sung them amiss, and therefore their features were distorted and their limbs broken, and until they were sung truly there would be no cure for them. Then Nārada was humbled, and kneeling before Vishnu prayed to be taught the art of music more perfectly: and in due course he became the great musician priest of the gods.

Indian music is a purely melodic art, devoid of any harmonised

accompaniment other than a drone. In modern European art, the meaning of each note of the theme is mainly brought out by the notes of the chord which are heard with it; and even in unaccompanied melody, the musician hears an implied harmony. Unaccompanied folk-song does not satisfy the concert-goer's ear; as pure melody it is the province only of the peasant and the specialist. This is partly because the folk-air played on the piano or written in staff notation is actually falsified; but much more because under the conditions of European art, melody no longer exists in its own right, and music is a compromise between melodic freedom and harmonic necessity. To hear the music of India as Indians hear it one must recover the sense of a pure intonation and must forget all implied harmonies. It is just like the effort which we have to make when for the first time, after being accustomed to modern art, we attempt to read the language of early Italian or Chinese painting, where there is expressed with equal economy of means all that intensity of experience which nowadays we are accustomed to understand only through a more involved technique.

Another feature of Indian song—and so also of the instrumental solo—is the elaborate grace. It is natural that in Europe, where many notes are heard simultaneously, grace should appear as an unnecessary elaboration, added to the note, rather than a structural factor. But in India the note and the microtonal grace compose a closer unity, for the grace fulfils just that function of adding light and shade which in harmonised music is attained by the varying degrees of assonance. The Indian song without grace would seem to Indian ears as bald as the European art song without the accompaniment which it presupposes.

Equally distinctive is the constant portamento, or rather, glissando. In India it is far more the interval than the note that is sung or played, and we recognize accordingly a continuity of sound: by contrast with this, the European song, which is vertically divided by the harmonic interest and the nature of the keyed instruments which are heard with the voice, seems to unaccustomed Indian ears to be "full of holes."

All the songs, except the 'alāps' are in strict rhythms. These are only difficult to follow at a first hearing because the Indian rhythms are founded, as in prosody, on contrasts of long and short duration, while European rhythms are based on stress, as

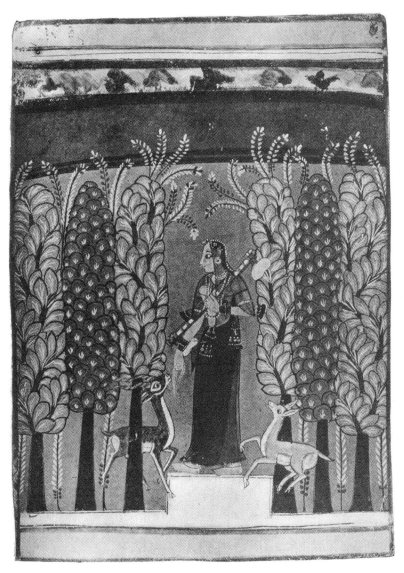

Ṭoḍī Rāgiṇī (a musical mode). Rajput painting, 16th century. Museum of Fine Arts, Boston.

Madhu-mādhavī Rāgiṇī (a musical mode). 'The sweet, sweet rumbling of thunder is heard.' Rajput painting, 16th century, Museum of Fine Arts, Boston.

in dance or marching. The Indian musician does not mark the
beginning of the bar by accent. His fixed unit is a section, or
group of bars which are not necessarily alike, while the Euro-
pean fixed unit is typically the bar, of which a varying number
constitute a section. The European rhythm is counted in mul-
tiples of 2 or 3, the Hindu in sums of 2 or 3. Some of the
countings are very elaborate: Aṭa Tāla, for example, is counted
as 5 plus 5 plus 2 plus 2. The frequent use of cross rhythms
also complicates the form. Indian music is modal in times as
well as melody. For all these reasons it is difficult to grasp
immediately the point at which a rhythm begins and ends, although
this is quite easy for the Indian audience accustomed to quanti-
tative poetic recitation. The best way to approach the Indian
rhythm is to pay attention to the phrasing, and ignore pulsation.

The Indian art-song is accompanied by drums, or by the instru-
ment known as a *tambura,* or by both. The tambura is of the
lute tribe, but without frets: the four very long strings are tuned
to sound the dominant, the upper tonic twice, and the octave
below, which are common to all rāgas: the pitch is adjusted to
suit the singer's voice. The four strings are fitted with simple
resonators—shreds of wool between the string and the bridge—
which are the source of their 'life': and the strings are continu-
ously sounded, making a pedal point background very rich in
overtones, and against this dark ground of infinite potentiality
the song stands out like an elaborate embroidery. The tambura
must not be regarded as a solo instrument, nor as an object of
separate interest like the piano accompaniment of a modern song:
its sound is rather the ambient in which the song lives and moves
and has its being.

India has, besides the tambura, many solo instruments. By
far the most important of these is the *vīṇā.* This classic instru-
ment, which ranks with the violin of Europe and the koto of
Japan, and second only to the voice in sensitive response, differs
chiefly from the tambura in having frets, the notes being made
with the left hand and the strings plucked with the right. The
delicate nuances of microtonal grace are obtained by deflection
of the strings, whole passages being played in this manner solely
by a lateral movement of the left hand, without a fresh plucking.
While the only difficulty in playing the tambura is to maintain
an even rhythm independently of the song, the *vīṇā* presents all

the difficulties of technique that can be imagined, and it is said that at least twelve years are required to attain proficiency.

The Indian singer is a poet, and the poet a singer. The dominant subject matter of the songs is human or divine love in all its aspects, or the direct praise of God, and the words are always sincere and passionate. The more essentially the singer is a musician, however, the more the words are regarded merely as the vehicle of the music: in art-song the words are always brief, voicing a mood rather than telling any story, and they are used to support the music with little regard to their own logic— precisely as the representative element in a modern painting merely serves as the basis for an organisation of pure form or colour. In the musical form called *alāp*—an improvisation on the rāga theme, this preponderance of the music is carried so far that only meaningless syllables are used. The voice itself is a musical instrument, and the song is more than the words of the song. This form is especially favoured by the Indian virtuoso, who naturally feels a certain contempt for those whose first interest in the song is connected with the words. The voice has thus a higher status than in Europe, for the music exists in its own right and not merely to illustrate the words. Rabindranath Tagore has written on this:

When I was very young I heard the song, 'Who dressed you like a foreigner?', and that one line of the song painted such a strange picture in my mind that even now it is sounding in my memory. I once tried to compose a song myself under the spell of that line. As I hummed the tune, I wrote the first line of the song, 'I know thee, thou stranger,' and if there were no tune to it, I cannot tell what meaning would be left in the song. But by the power of the spell of the tune the mysterious figure of that stranger was evoked in my mind. My heart began to say, 'There is a stranger going to and fro in this world of ours — her house is on the further shore of an ocean of mystery—sometimes she is to be seen in the autumn morning, sometimes in the flowery midnight—sometimes we receive an intimation of her in the depths of our heart—sometimes I hear her voice when I turn my ear to the sky.' The tune of my song led me to the very door of that stranger who ensnares the universe and appears in it, and I said:

> 'Wandering over the world
> I come to thy land:
> I am a guest at thy door, thou stranger.'

One day, many days afterwards, there was someone going along the road singing:

'How does that unknown bird go to and away from the cage?
Could I but catch it, I would set the chain of my mind about its feet!'

I saw that that folk-song, too, said the very same thing! Sometimes
the unknown bird comes to the closed cage and speaks a word of the
limitless unknown—the mind would keep it forever, but cannot. What
but the tune of a song could report the coming and going of that
unknown bird? Because of this I always feel a hesitation in publish-
ing a book of songs, for in such a book the main thing is left out.

This Indian music is essentially impersonal: it reflects an
emotion and an experience which are deeper and wider and older
than the emotion or wisdom of any single individual. Its sorrow
is without tears, its joy without exultation and it is passionate
without any loss of serenity. It is in the deepest sense of the
words all-human. But when the Indian prophet speaks of inspira-
tion, it is to say that the Vedas are eternal, and all that the poet
achieves by his devotion is to hear or see: it is then Sarasvatī,
the goddess of speech and learning, or Nārada, whose mission it
is to disseminate occult knowledge in the sound of the strings of
his vīṇā, or Krishna, whose flute is forever calling us to leave the
duties of the world and follow Him—it is these, rather than any
human individual, who speak through the singer's voice, and are
seen in the movements of the dancer.

Or we may say that this is an imitation of the music in heaven.
The master musicians of India are always represented as the
pupils of a god, or as visiting the heavenworld to learn there the
music of the spheres—that is to say, their knowledge springs
from a source far within the surface of the empirical activity
of the waking consciousness. In this connection it is explained
why it is that human art must be studied, and may not be identi-
fied with the imitation of our everyday behaviour.* When Śiva
expounds the technique of the drama to Bharata—the famous
author of the *Nāṭya Śāstra*—he declares that human art must be
subject to law, because in man the inner and outer life are still
in conflict. Man has not yet found Himself, but all his activity
proceeds from a laborious working of the mind, and all his virtue
is self-conscious. What we call our life is uncoördinated, and
far from the harmony of art, which rises above good and evil.
It is otherwise with the gods, whose every gesture immediately
reflects the affections of the inner life. Art is an imitation of
that perfect spontaneity—the identity of intuition and expression
in those who are of the kingdom of heaven, which is within us.

* This is like the principle of 'conscious control' advanced by F. M.
Alexander in *Man's Supreme Inheritance*.

Thus it is that art is nearer to life than any fact can be; and Mr. Yeats has reason when he says that Indian music, though its theory is elaborate and its technique so difficult, is not an art, but life itself.

For it is the inner reality of things, rather than any transient or partial experience that the singer voices. "Those who sing here," says Śankarāchārya, "sing God": and the *Vishnu Purāṇa* adds, "All songs are a part of Him, who wears a form of sound."[1] We could deduce from this a metaphysical interpretation of technique. In all art there are monumental and articulate elements, masculine and feminine factors which are unified in perfect form. We have here the sound of the tambura which is heard before the song, during the song, and continues after it: that is the timeless Absolute, which as it was in the beginning, is now and ever shall be. On the other hand there is the song itself which is the variety of Nature, emerging from its source and returning at the close of its cycle. The harmony of that undivided Ground with this intricate Pattern is the unity of Spirit and Matter. We see from this why this music could not be improved by harmonisation, even if harmonisation were possible without destroying the modal bases: for in breaking up the ground into an articulate accompaniment, we should merely create a second melody, another universe, competing with the freedom of the song itself, and we should destroy the peace on which it rests.

This would defeat the purpose of the singer. Here in this ego-conscious world we are subject to mortality. But this mortality is an illusion, and all its truths are relative: over against this world of change and separation there is a timeless and spaceless Peace which is the source and goal of all our being—"that noble Pearl," in the words of Behmen, "which to the World appears Nothing, but to the Children of Wisdom is All Things." Every religious teacher offers us those living waters. But the way is hard and long: we are called upon to leave houses and lands, fathers and mothers and wives to achieve an end which in our imperfect language we can only speak of as Non-existence. Many of us have great possessions, and the hardest of these to surrender are our own will and identity. What guarantee have we that the reward will be commensurate with the sacrifice?

[1] Cf. the *Granth Sahib* (Japjī xxvii): "How many musicians, how many rāgas and rāginīs and how many singers sing Thee?"

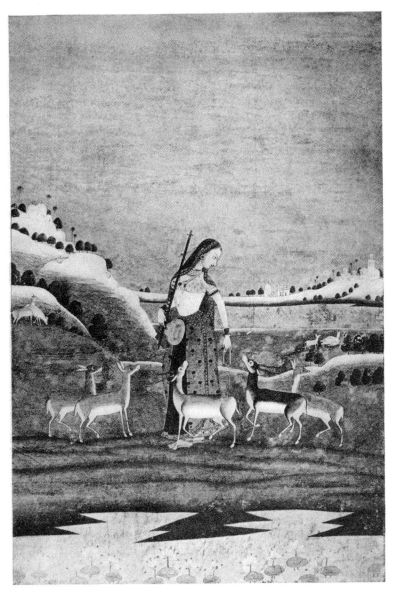

Ṭoḍī Rāginī (a musical mode). Rajput painting, 18th century. Calcutta School
of Art.

Indian theory declares that in the ecstasies of love and art we already receive an intimation of that redemption. This is also the *katharsis* of the Greeks, and it is found in the æsthetic of modern Europe when Goethe says

> For beauty they have sought in every age
> He who perceives it is from himself set free——

aus sich entrückt. We are assured by the experience of æsthetic contemplation that Paradise is a reality.

In other words the magical effects of a song in working mere miracles are far surpassed by its effects upon our inner being. The singer is still a magician, and the song is a ritual, a sacred ceremony, an ordeal which is designed to set at rest that wheel of the imagination and the senses which alone hinder us from contact with reality. But to achieve this ordeal the hearer must coöperate with the musician by the surrender of the will, and by drawing in his restless thought to a single point of concentration: this is not the time or place for curiosity or admiration. Our attitude towards an unknown art should be far from the sentimental or romantic, for it can bring us nothing that we have not already with us in our own hearts: the peace of the Abyss which underlies all art is one and the same, whether we find it in Europe or in Asia.

STATUS OF INDIAN WOMEN

In the *Mahābhārata* there is reported a conversation between Śiva and Umā. The Great God asks her to describe the duties of women, addressing her, in so doing, in terms which acknowledge her perfect attainment of the highest wisdom possible to man or god—terms which it would be hard to parallel anywhere in western literature. He says:

> "Thou that dost know the Self and the not-Self, expert in every work: endowed with self-restraint and perfect same-sightedness towards every creature: free from the sense of I and my—thy power and energy are equal to my own, and thou hast practised the most severe discipline. O Daughter of Himālaya, of fairest eyebrows, and whose hair ends in the fairest curls, expound to me the duties of women in full."

Then She, who is queen of heaven, and yet so sweetly human, answers:

> "The duties of woman are created in the rites of wedding, when in presence of the nuptial fire she becomes the associate of her Lord, for the performance of all righteous deeds. She should be beautiful and gentle, considering her husband as her god and serving him as such in fortune and misfortune, health and sickness, obedient even if commanded to unrighteous deeds or acts that may lead to her own destruction. She should rise early, serving the gods, always keeping her house clean, tending to the domestic sacred fire, eating only after the needs of gods and guests and servants have been satisfied, devoted to her father and mother and the father and mother of her husband. Devotion to her Lord is woman's honour, it is her eternal heaven; and O Maheśvara,"

she adds, with a most touching human cry,

> "I desire not paradise itself if thou are not satisfied with me!"

"She is a true wife who gladdens her husband," says Rājaśekhara in the *Karpura Mañjarī*. The extract following is from the Laws of Manu:

> "Though destitute of virtue, or seeking pleasure elsewhere, or devoid of good qualities, a husband must be constantly worshipped as a god by a faithful wife . . . If a wife obeys her husband, she will for that reason alone be exalted in heaven."

"The production of children, the nurture of those born, and the daily life of men, of these matters woman is visibly the cause."

"She who controlling her thoughts, speech and acts, violates not her duty to her Lord, dwells with him after death in heaven, and in this world is called by the virtuous a faithful wife."

Similar texts from a variety of Indian sources could be indefinitely multiplied.

If such are the duties of women, women are accorded corresponding honour, and exert a corresponding influence upon society. This power and influence do not so much belong to the merely young and beautiful, nor to the wealthy, as to those who have lived—mothers and grandmothers—or who follow a religious discipline—widows or nuns. According to Manu: 'A master exceedeth ten tutors in claim to honour; the father a hundred masters; but the mother a thousand fathers in right to reverence and in the function of teacher.' When Rāma accepted Kaikeyī's decree of banishment, it was because ' a mother should be as much regarded by a son as is a father.' Even at the present day it would be impossible to over-emphasize the influence of Indian mothers not only upon their children and in all household affairs, but upon their grown-up sons to whom their word is law. According to my observation, it is only those sons who have received an 'English' education in India who no longer honour their fathers *and* mothers.

No story is more appropriate than that of Madalasa and her son Vikrānta to illustrate the position of the Indian mother as teacher. As Vikrānta grew up day by day, the *Mārkaṇḍeya Purāṇa* relates, Madalasa 'taught him knowledge of the Self[1] by ministering to him in sickness; and as he grew in strength and there waxed in him his father's heart, he attained to knowledge of the Self by his mother's words.' And these were Madalasa's words, spoken to the baby crying on her lap:

"My child, thou art without a name or form, and it is but in fantasy that thou hast been given a name. This thy body, framed of the five elements, is not thine in sooth, nor art thou of it. Why dost thou weep? Or, maybe, thou weepest not; it is a sound self-born that cometh forth from the king's son....In the body

[1] 'Knowledge of the Self'—the *Adhyātmāvidyā* referred to above, p. 7.

dwells another self, and therewith abideth not the thought that
'This is mine,' which appertaineth to the flesh. Shame that man
is so deceived!"

Even in recent times, in families where the men have received
an English education unrelated to Indian life and thought, the
inheritance of Indian modes of thought and feeling rests in the
main with women; for a definite philosophy of life is bound up
with household ritual and traditional etiquette and finds expres-
sion equally in folk-tale and cradle-song and popular poetry, and
in those pauranic and epic stories which constitute the household
Bible literature of India. Under these conditions it is often
the case that Indian women, with all their faults of sentimentality
and ignorance, have remained the guardians of a spiritual culture
which is of greater worth than the efficiency and information of
the educated.

It is according to the Tāntrik scriptures, devoted to the cult
of the Mother of the World, that women, who partake of her
nature more essentially than other living beings, are especially
honoured; here the woman may be a spiritual teacher (*guru*),
and the initiation of a son by a mother is more fruitful than any
other. One doubts how far this may be of universal application,
believing with Paracelsus that woman is nearer to the world than
man, of which the evidence appears in her always more personal
point of view. But all things are possible to women such as
Madalasa.

The claim of the Buddhist nun—'How should the woman's
nature hinder us?'—has never been systematically denied in
India. It would have been contrary to the spirit of Indian culture
to deny to individual women the opportunity of saintship or
learning in the sense of closing to them the schools of divinity
or science after the fashion of the Western academies in the
nineteenth century. But where the social norm is found in mar-
riage and parenthood for men and women alike, it could only
have been in exceptional cases and under exceptional circum-
stances that the latter specialised, whether in divinity, like Auvvai,
Mīrā Bāī, or the Buddhist nuns, in science, like Līlāvatī, or in war,
like Chānd Bībī or the Rānī of Jhānsī. Those set free to cultivate
expert knowledge of science or to follow with undivided allegi-
ance either religion or any art, could only be the *sannyāsinī* or
devotee, the widow, and the courtesan. A majority of women

PLATE XX

INDIAN WOMEN.

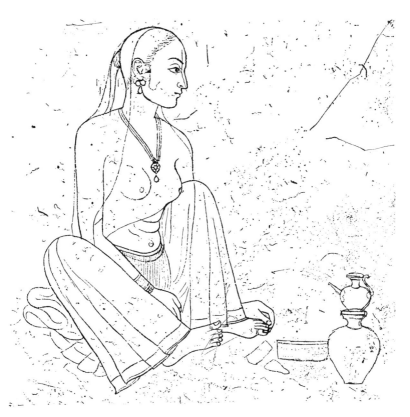

A Hindu lady at her toilet. Rajput drawing, 18th century. Collection of
the author.

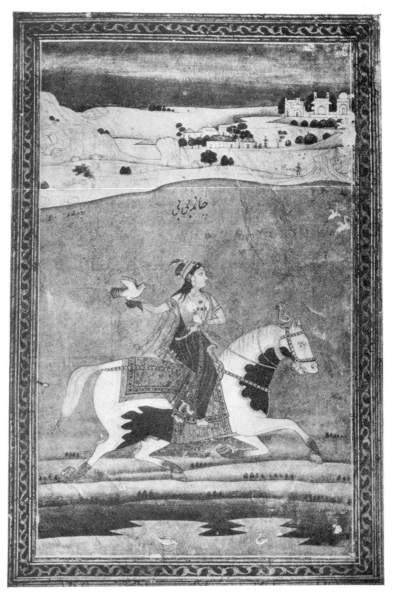

Chānd Bībī, called Chānd Sultān. Defender of Ahmadnagar against Akbar, 1695. Rajput painting, 18th century. Collection of Lady Herringham.

have always, and naturally, preferred marriage and motherhood to either of these conditions. But those who felt the call of religion, those from whom a husband's death removed the central motif of their life, and those trained from childhood as expert artists, have always maintained a great tradition in various branches of cultural activity, such as social service or music. What we have to observe is that Hindu sociologists have always regarded these specializations as more or less incompatible with wifehood and motherhood; life is not long enough for the achievement of many different things.

Hinduism justifies no cult of ego-expression, but aims consistently at spiritual freedom. Those who are conscious of a sufficient inner life become the more indifferent to outward expression of their own or any changing personality. The ultimate purposes of Hindu social discipline are that men should unify their individuality with a wider and deeper than individual life, should fulfil appointed tasks regardless of failure or success, distinguish the timeless from its shifting forms, and escape the all-too-narrow prison of the 'I and mine.'

Anonymity is thus in accordance with the truth; and it is one of the proudest distinctions of the Hindu culture. The names of the 'authors' of the epics are but shadows, and in later ages it was a constant practise of writers to suppress their own names and ascribe their work to a mythical or famous poet, thereby to gain a better attention for the truth that they would rather claim to have 'heard' than to have 'made.' Similarly, scarcely a single Hindu painter or sculptor is known by name; and the entire range of Sanskrit literature cannot exhibit a single autobiography and but little history. Why should women have sought for modes of self-advertisement that held no lure even for men? The governing concept of Hindu ethics is vocation (*dharma*); the highest merit consists in the fulfilment of 'one's own duty,' in other words, in dedication to one's calling. Indian society was highly organized; and where it was considered wrong for a man to fulfil the duties of another man rather than his own, how much more must a confusion of function as between woman and man have seemed wrong, where differentiation is so much more evident. In the words of Manu: 'To be mothers were women created, and to be fathers men;' and he adds significantly 'therefore are religious sacraments ordained in the Veda to be

observed by the husband together with the wife.'[1]

The Asiatic theory of marriage, which would have been perfectly comprehensible in the Middle Ages, before the European woman had become an economic parasite, and which is still very little removed from that of Roman or Greek Christianity, is not readily intelligible to the industrial democratic consciousness of Europe and America, which is so much more concerned for rights than for duties, and desires more than anything else to be released from responsibilities—regarding such release as freedom. It is thus that Western reformers would awaken a divine discontent in the hearts of Oriental women, forgetting that the way of ego-assertion cannot be a royal road to realisation of the Self. The industrial mind is primarily sentimental, and therefore cannot reason clearly upon love and marriage; but the Asiatic analysis is philosophic, religious and practical.

Current Western theory seeks to establish marriage on a basis of romantic love and free choice; marriage thus depends on the accident of 'falling in love.' Those who are 'crossed in love' or do not love are not required to marry. This individualistic position, however, is only logically defensible if at the same time it is recognized that to fall out of love must end the marriage. It is a high and religious ideal which justifies sexual relations only as the outward expression demanded by passionate love and regards an intimacy continued or begun for mere pleasure, or for reasons of prudence, or even as a duty, as essentially immoral; it is an ideal which isolated individuals and groups have constantly upheld; and it may be that the ultimate development of idealistic individualism will tend to a nearer realisation of it. But do not let us deceive ourselves that because the Western marriage is nominally founded upon free choice, it therefore secures a permanent unity of spiritual and physical passion. On the contrary, perhaps in a majority of cases, it holds together those who are no longer 'in love'; habit, considerations of prudence, or, if there are children, a sense of duty often compel the passionless continuance of a marriage for the initiation of which romantic love was felt to be a *sine qua non*. Those who now live side by side upon a basis

[1] Jahangir observes in his 'Memoirs' that the Hindu woman 'is the half of a man, and his companion in religious ceremonies.' Cf. the *Prema Sāgara,* ch. xxiv: 'without a wife a sacrifice is not fruitful.'

of affection and common interest would not have entered upon marriage on this basis alone.

If the home is worth preserving under modern conditions—and in India at any rate, the family is still the central element of social organization, then probably the 'best solution' will always be found in some such compromise as is implied in a more or less permanent marriage; though greater tolerance than is now usual must be accorded to exceptions above and below the norm. What are we going to regard as the constructive basis of the normal marriage?

For Hindu sociologists marriage is a social and ethical relationship, and the begetting of children the payment of a debt. Romantic love is a brief experience of timeless freedom, essentially religious and ecstatic, in itself as purely antisocial as every glimpse of Union is a denial of the Relative; it is the way of Mary. It is true the glamour of this experience may persist for weeks and months, when the whole of life is illumined by the partial merging of the consciousness of the lover and beloved; but sooner or later in almost every case there must follow a return to the world of unreality, and that insight which once endowed the beloved with innumerable perfections fades in the light of commonsense. The lovers are fortunate if there remains to them a basis of common interest and common duty and a mutuality of temperament adequate for friendship, affection and forbearance; upon this chance depends the possibility of happiness during the greater part of almost every married life. The Hindu marriage differs from the marriage of sentiment mainly in putting these considerations first. Here, as elsewhere, happiness will arise from the fulfilment of vocation, far more than when immediate satisfaction is made the primary end. I use the term vocation advisedly; for the Oriental marriage, like the Oriental actor's art, is the fulfilment of a traditional design, and does not depend upon the accidents of sensibility. To be such a man as Rāma, such a wife as Sītā, rather than to express 'oneself,' is the aim. The formula is predetermined ; husband and wife alike have parts to play; and it is from this point of view that we can best understand the meaning of Manu's law, that a wife should look on her husband as a god, regardless of his personal merit or demerits—it would be beneath her dignity to deviate from a woman's norm merely because of the failure of a man. It is for her own sake and for

the sake of the community, rather than for his alone, that life: must be attuned to the eternal unity of Purusha and Prakṛiti.

Whatever the ultimate possibilities of Western individualism, Hindu society was established on a basis of group morality. It is. true that no absolute ethic is held binding on all classes alike; but within a given class the freedom of the individual is subordinated to the interest of the group, the concept of duty is paramount. How far this concept of duty trenches on the liberty of the individual may be seen in Rāma's repudiation of Sītā, subsequent to the victory in Lankā and the coronation at Ayodhyā; although convinced of her perfect fidelity, Rāma, who stands in epic history as the mirror of social ethics, consents to banish his wife, because the people murmur against her. The argument is that if the king should receive back a wife who had been living in another man's house, albeit faithful, popular morality would be endangered, since others might be moved by love and partiality to a like rehabilitation but with less justification. Thus the social order is placed before the happiness of the individual, whether man or woman. This is the explanation of the greater peace which distinguishes the arranged marriage of the East from the self-chosen marriage of the West; where there is no deception there can be no disappointment. And since the conditions on which it is founded do not change, it is logical that Hindu marriage should be indissoluble; only when social duties have been fulfilled and social debts paid, is it permissible for the householder to relinquish simultaneously the duties and the rights of the social individual. It is also logical that when the marriage is childless, it is permissible to take a second wife with the consent—and often at the wish—of the first.

It is sometimes asked, what opportunities are open to the Oriental woman? How can she express herself? The answer is that life is so designed that she is given the opportunity to be a woman—in other words, to realise, rather than to express herself. It is possible that modern Europe errs in the opposite direction. We must also remember that very much which passes for education nowadays is superficial; some of it amounts to little more than parlor tricks, and nothing is gained by communicating this condition to Asia, where I have heard of modern parents who desired that their daughters should be taught 'a little French' or 'a few strokes on the violin.' The arts in India are professional and

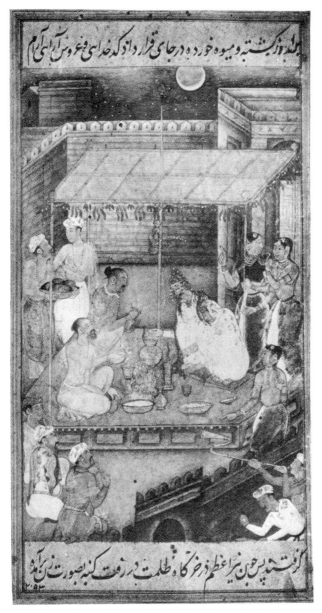

Hindu marriage. From a Mughal painting, about 1600.

PLATE XXIII

INDIAN PAINTING.

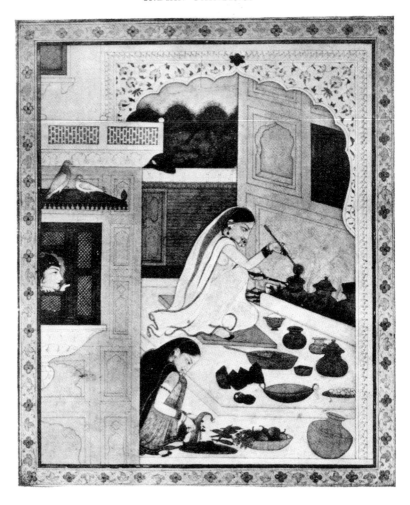

Rādhā in her kitchen : Krishna at the window. Rajput painting. 18th century.
Lahore Museum.

vocational, demanding undivided service; nothing is taught to the amateur by way of social accomplishment or studied superficially. And woman represents the continuity of the racial life, an energy which cannot be divided or diverted without a corresponding loss of racial vitality; she can no more desire to be something other than herself, than the Vaishya could wish to be known as a Kshattriya, or the Kshattriya, as a Brahman.

It has been shown in fact, some seventy-five per cent. of Western graduate women do not marry; and apart from these, if it be true that five-sixths of a child's tendencies and activities are already determined before it reaches school age, and that the habits then deeply rooted cannot be greatly modified, if it be true that so much depends on deliberate training while the instincts of the child are still potential and habits unformed, can we say that women whose social duties or pleasures, or self-elected careers or unavoidable wage slavery draws them into the outer world, are fulfilling their duty to the race, or as we should say, the debt of the ancestors? The modern suffragist declares that the state has no right to demand of woman, whether directly or indirectly, by bribe or pressure of opinion, that she consider herself under any obligation, in return for the protection afforded her, to produce its future citizens. But we are hardly likely to see this point of view accepted in these days when the right of society to conscript the bodies of men is almost universally conceded. It is true that many who do not acquiesce in the existing industrial order are prepared to resist conscription in the military sense, that is to say, conscription for destruction; but we are becoming accustomed to the idea of another kind of conscription, or rather co-operation, based on service, and indeed, according to either of the two dynamic theories of a future society—the syndicalist and the individualistic—it must appear that without the fulfilment of function there can exist no *rights*. From the co-operative point of view society has an absolute right to compel its members to fulfil the functions that are necessary to it; and only those who, like the anchorite, voluntarily and entirely renounce the advantages of society and the protection of law have a right to ignore the claims of society.[1] From the individualist

[1] A vigorous society can well afford to support, and in the interests of spiritual values will gladly support, so far as support is necessary, not only thinkers and artists, whose function is obvious, but also a certain

point of view, on the other hand, the fulfilment of function is regarded as a spontaneous activity, as is even now true in the cases of the thinker and the artist; but even the individualist does not expect to get something for nothing, and the last idea he has is to compel the service of others.

I doubt if anyone will deny that it is the function or nature of women, as a group—not necessarily in every individual case—in general, to be mothers, alike in spiritual and physical senses. What we have to do then, is not to assert the liberty of women to deny the duty or right of motherhood, however we regard it, but to accord this function a higher protection and honour than it now receives. And here, perhaps, there is still something to be learnt in Asia. There the pregnant woman is auspicious, and receives the highest respect; whereas in many industrial and secular Western societies she is an object of more or less open ridicule, she is ashamed to be seen abroad, and tries to conceal her condition, sometimes even by means that are injurious to her own and the child's health. That this was not the case in a more vital period of European civilization may be seen in all the literature and art of the Middle Ages, and particularly in the status of the Virgin Mary, whose motherhood endeared her to the folk so much more nearly than her virginity.

To avoid misunderstanding, let me say in passing, that in depicting the life of Hindu women as fulfilling a great ideal, I do not mean to indicate the Hindu social formula as a thing to be repeated or imitated. This would be a view as futile as that of the Gothic revival in architecture; the reproduction of period furniture does not belong to life. A perfection that has been can never be a perfection for us.

Marriage was made for man, not man for marriage. One would gladly accept for Europe very soon, and for Asia in due time, temporary marriage, the endowment of motherhood, and matriarchal succession, or whatever other forms our own spiritual and economic necessity may determine for us—not because such forms may be absolutely better than the Asiatic or mediaeval European institutions, but because they correspond more nearly

number of thorough-going rebels who to all appearances are mere idlers. But the idler, whether anchorite or courtezan, must not *demand* to be supported in luxury, and must recognize that whatever he or she receives is given in *love,* and not according to *law.*

to *our* inner life. In comparing one social order with another, I have no faith in any millennium past or future, but only in the best attainable adaptation of means to ends; and, 'let the ends determine the means,' should be the evidence of our idealism.

Let us now return to the Indian Satī and try to understand her better. The root meaning of the word is essential being, and we have so far taken it only in the wide sense. But she who refuses to live when her husband is dead is called Satī in a more special sense, and it is only so that the word (suttee) is well-known to Europeans. This last proof of the perfect unity of body and soul, this devotion beyond the grave, has been chosen by many Western critics as our reproach; we differ from them in thinking of our 'suttees' not with pity, but with understanding, respect, and love. So far from being ashamed of our 'suttees' we take a pride in them; that is even true of the most 'progressive' amongst us. It is very much like the tenderness which our children's children may some day feel for those of their race who were willing to throw away their lives for 'their country right or wrong,' though the point of view may seem to us then, as it seems to so many already, evidence rather of generosity than balanced judgment.

The criticism we make on the institution of Satī and woman's blind devotion is similar to the final judgment we are about to pass on patriotism. We do not, as pragmatists may, resent the denial of the ego for the sake of an absolute, or attach an undue importance to mere life; on the contrary we see clearly that the reckless and useless sacrifice of the 'suttee' and the patriot is spiritually significant. And what remains perpetually clear is the superiority of the reckless sacrifice to the calculating assertion of rights. Criticism of the position of the Indian woman from the ground of assertive feminism, therefore, leaves us entirely unmoved: precisely as the patriot must be unmoved by an appeal to self-interest or a merely utilitarian demonstration of futility. We do not object to dying for an idea as 'suttees' and patriots have died; but we see that there may be other and greater ideas we can better serve by living for them.

For some reason it has come to be believed that Satī must have been a man-made institution imposed on women by men for reasons of their own, that it is associated with feminine servility, and that it is peculiar to India. We shall see that these views are historically unsound. It is true that in aristocratic circles Satī

became to some degree a social convention,[1] and pressure was put on unwilling individuals, precisely as conscripts are even now forced to suffer or die for other people's ideas; and from this point of view we cannot but be glad that it was prohibited by law in 1829 on the initiative of Raja Rammohun Roy. But now that nearly a century has passed it should not be difficult to review the history and significance of Satī more dispassionately than was possible in the hour of controversy and the atmosphere of religious prejudice.

It is not surprising that the idea of Satī occupies a considerable place in Indian literature. Pārvatī herself, who could not endure the insults levelled against her husband by her father, is the prototype of all others. In the early Tamil lyrics we read of an earthly bride whom the Brahmans seek to dissuade from the sacrifice; but she answers that since her lord is dead, the cool waters of the the lotus pool and the flames of the funeral pyre are alike to her. Another pleads to share her hero's grave, telling the potter that she has fared with her lord over many a desert plain, and asking him to make the funeral urn large enough for both. Later in history we read of the widowed mother of Harsha that she replied to her son's remonstrances:

"I am the lady of a great house; have you forgotten that I am the lioness-mate of a great spirit, who, like a lion, had his delight in a hundred battles?"

A man of such towering genius and spirituality as Kabīr so takes for granted the authenticity of the impulse to Satī that he constantly uses it as an image of surrender of the ego to God; and indeed, in all Indian mystical literature the love-relation of woman to man is taken unhesitatingly as an immediate reflection of spiritual experience. This is most conspicuous in all the Rādhā-Krishna literature. But here let us notice more particularly the beautiful and very interesting poem of Muhammad Rizā Nau'ī, written in the reign of Akbar upon the 'suttee' of a Hindu girl whose betrothed was killed on the very day of the marriage. This Musulman poet, to whom the Hindus were 'idolaters,' does not relate his story in any spirit of religious intolerance or ethical condescension; he is simply amazed 'that after the death of men, the woman shows forth her marvellous passion.' He

[1] 'Social conventions' are rarely 'man-made laws' alone.

does not wonder at the wickedness of men, but at the generosity of women; how different from the modern critic who can see no motive but self-interest behind a social phenomenon that passes his comprehension!

This Hindu bride refused to be comforted and wished to be burnt on the pyre of her dead betrothed. When Akbar was informed of this, he called the girl before him and offered wealth and protection, but she rejected all his persuasion as well as the counsel of the Brahmans, and would neither speak nor hear of anything but the Fire.

Akbar was forced, though reluctantly, to give his consent to the sacrifice, but sent with her his son Prince Dāniyāl who continued to dissuade her. Even from amidst the flames, she replied to his remonstrances, 'Do not annoy, do not annoy, do not annoy.' 'Ah,' exclaims the poet:

> "Let those whose hearts are ablaze with the Fire of Love learn courage from this pure may!
> Teach me, O God, the Way of Love, and enflame my heart with this maiden's Fire."

Thus he prays for himself; and for her:

> "Do Thou, O God, exalt the head of that rare hidden virgin, whose purity exceeded that of the Houris,
> Do Thou endear her to the first kissing of her King, and graciously accept her sacrifice."

Matter of fact accounts of more modern 'suttees' are given by Englishmen who have witnessed them. One which took place in Baroda in 1825 is described by R. Hartley Kennedy, the widow persisting in her intention in spite of "several fruitless endeavours to dissuade her." A more remarkable case is described by Sir Frederick Halliday. Here also a widow resisted all dissuasion, and finally proved her determination by asking for a lamp, and holding her finger in the flame until it was burnt and twisted like a quill pen held in the flame of a candle; all this time she gave no sign of fear or pain whatever. Sir F. Halliday had therefore to grant her wish, even as Akbar had had to do three centuries earlier.

It is sometimes said by Indian apologists that at certain times or places in India—amongst the Buddhists, or the Marāthās. or in the epics—there was no purdah; or that certain historic or mythic individual women were not secluded. Such statements

ignore the fact that there are other kinds of seclusion than those afforded by palace walls. For example, though Rāma, Lakshman and Sītā had lived together in forest exile for many years in closest affection, it is expressly stated that Lakshman had never raised his eyes above his brother's wife's feet, so that he did not even know her appearance. To speak more generally, it is customary for Hindus, when occasion arises for them to address an unknown woman, to call her 'mother' irrespective of her age or condition. These unseen walls are a seclusion equally absolute with any purdah. One result is that the streets of an Indian city by night are safer for a woman than those of any city in Europe. I have known more than one European woman, acquainted with India, express her strong conviction of this.

Western critics have often asserted that the Oriental woman is a slave, and that we have made her what she is. We can only reply that we do not identify freedom with self-assertion, and that the Oriental woman is what she is, only because our social and religious culture has permitted her to be and to remain essentially feminine. Exquisite as she may be in literature and art, we dare not claim for ourselves as men the whole honour of creating such a type, however persistently the industrious industrial critic would thrust it upon us.

The Eastern woman is not, at least we do not claim that she is, superior to other women in her innermost nature; she is perhaps an older, purer and more specialised type, but certainly an universal type, and it is precisely here that the industrial woman departs from type. Nobility in women does not depend upon race, but upon ideals; it is the outcome of a certain view of life.

Sāvitrī, Padmāvatī, Sītā, Rādhā, Umā, Līlāvatī, Tārā—our divine and human heroines—have an universal fellowship, for everything feminine is of the Mother. Who could have been more wholly devoted than Alcestis, more patient than Griselda, more loving than Deirdre, more soldier than Joan of Arc, more Amazon than Brynhild?

When the Titanic sank, there were many women who refused —perhaps mistakenly, perhaps quite rightly—that was their own affair—to be rescued without their husbands, or were only torn from them by force; dramatic confirmation of the conviction that love-heroism is always and everywhere the same, and not only

in India, nor only in ages past, may be stronger than death.

I do not think that the Indian ideal has ever been the exclusive treasure of any one race or time, but rather, it reappears wherever woman is set free to be truly herself, that is wherever a sufficiently religious, heroic and aesthetic culture has afforded her the necessary protection. Even the freedom which she seeks in modern self-assertion—which I would grant from the standpoint of one who will not govern—is merely an inverted concept of protection, and it may be that the more she is freed the more she will reveal the very type we have most adored in those who seemed to be slaves. Either way would be happier for men than the necessity of protecting women from themselves, and the tyranny of those who are not capable of friendship, being neither bound nor free.

The cry of our Indian Satī, "Do not annoy, do not annoy," and "No one has any right over the life of another; is not that my own affair?" is no cry for protection from a fate she does not seek; it is individualistic, and has been uttered by every woman in the world who has followed love beyond the grave. Deirdre refused every offer of care and protection from Conchubar: "It is not land or earth or food I am wanting," she said, "or gold or silver or horses, but leave to go to the grave where the sons of Usnach are lying." Emer called to Cuchullain slain: "Love of my life, my friend, my sweetheart, my one choice of the men of the world, many is the women, wed or unwed, envied me until to-day, and now I will not stay living after you."

Irish women were free, but we are used even more to look on the old Teutonic type as representative of free and even amazonian womanhood. We do not think of Brynhild, Shield-may and Victory-wafter, as compelled by men to any action against her will, or as weakly submissive. Yet when Sigurd was slain she became 'suttee'; the prayers of Gunnar availed as little as those of Conchubar with Deirdre. He "laid his arms about her neck, and besought her to live and have wealth from him; and all others in like wise letted her from dying; but she thrust them all from her, and said that it was not the part of any to let her in that which was her will." And the second heroic woman figured in the saga, wedded to Sigurd, though she did not die, yet cried when he was betrayed:

> Now am I as little
> As the leaf may be
> Amid wind-swept wood,
> Now when dead he lieth.

"She who is courteous in her mind," says the *Shacktafelsk*, "with shyness shall her face be bright; of all the beauties of the body, none is more shining than shyness." This theory of courtesy, of supreme gentleness—"full sweetly bowing down her head," says the English Merlin, "as she that was shamefast," runs also through all mediæval chivalry. Yet it is about this shy quiet being, a mystery to men, that the whole mediæval world turns; "first reserve the honour to God," says Malory, "and secondly, the quarrel must come of thy lady." Like Umā and Sītā, Virgin Mary is the image of a perfect being—

> For in this rose conteined was
> Heaven and earth in litel space—

and for a little while, in poetry and architecture, we glimpse an idealisation of woman and woman's love akin to the praise of Rādhā in the contemporary songs of Chaṇḍīdās and Vidyāpati.

But for our purpose even more significant than the religious and knightly culture, the product of less quickly changing conditions, and impressive too in its naiveté, is the picture of the woman of the people which we can gather from folk-song and lyric. Here was a being obviously strong and sensible, not without knowledge of life, and by no means economically a parasite. If we study the folk speech anywhere in the world we shall see that it reveals woman, and not the man, as typically the lover; when her shyness allows, it is she who would pray for man's love, and will serve him to the utmost. Industrialism reverses this relation, making man the suppliant and the servant, a condition as unnatural as any other of its characteristic perversions.

The woman of the folk does not bear resentment. Fair Helen, who followed Child Waters on foot, and bore his child in a stable, is overheard singing:

> Lullaby, my owne deere child!
> I wold thy father were a king,
> Thy mother layd on a beere.

Is she not like the Bengali Mālanchamālā, whose husband had

married a second wife, and left her unloved and forgotten—who says, "though I die now, and become a bird or a lesser creature or whatever befall me, I care not, for I have seen my darling happy?"

If woman under industrialism is unsatisfied, it would be difficult to say how much man also loses. For woman is naturally the lover, the bestower of life:

Conjunction with me renders life long.
I give youth when I enter upon amorousness.[1]

Her complaint is not that man demands too much, but that he will accept too little.

Long time have I been waiting for the coming of my dear;
Sometimes I am uneasy and troubled in my mind,
Sometimes I think I'll go to my lover and tell him my mind.
But if I should go to my lover, my lover he will say me nay,
If I show to him my boldness, he'll ne'er love me again.[2]

And it is to serve him, not to seek service from him that she desires:

In the cold stormy weather, when the winds are a-blowing,
My dear, I shall be willing to wait on you then.[3]

The Oriental woman, perhaps is not Oriental at all, but simply woman. If the modern woman could accept this thought, perhaps she would seek a new way of escape, not an escape from love, but a way out of industrialism. Could we not undertake this quest together?

It is true that the modern woman is justified in her discontent. For of what has she not been robbed? The organization of society for competition and exploitation has made possible for the few, and only the very few, more physical comfort and greater security of life; but even these it has robbed of all poise, of the power to walk or to dress or to marry wisely, or to desire children or lovers, or to believe in any power not legally exteriorised. From faith in herself to a belief in votes, what a descent!

Decade after decade since the fourteenth century has seen her

[1] Nizāmī.
[2] Eastern Counties folk-song.
[3] Somerset folksong.

influence reduced. It was paramount in religion, in poetry, in
music, in architecture and in all life. But men, when they
reformed the church and taught you that love was not a sacra-
ment without the seal of clerical approval; when they forced
your music into modes of equal temperament; when they substi-
tuted knowledge for feeling and wisdom in education,[1] when they
asked you to pinch your shoes and your waists, and persuaded you
to think this a refinement, and the language of Elizabethan poetry
coarse; when at last they taught you to become Imperialists, and
went away alone to colonise and civilise the rest of the world,
leaving you in England with nothing particular to do; when, if
you have the chance to marry at all, it is ten or fifteen years too
late— who can wonder that you are dissatisfied, and claim the
right to a career of your own "not merely to earn your livelihood,
but to provide yourself with an object in life?"[2] How many
women have only discovered an object in life since the energies
of men have been employed in activities of pure destruction?
What a confession! To receive the franchise would be but a small
compensation for all you have suffered, if it did not happen that
we have now seen enough of representative government and the
tyranny of majorities to understand their futility. Let women as
well as men, turn away their eyes from the delusions of govern-
ment, and begin to understand direct action, finding enough to
do in solving the problems of their own lives, without attempting
to regulate those of other people. No man of real power has
either time or strength for any other man's work than his own,
and this should be equally true for women. Aside from all
questions of mere lust for power or demand for rights, untold
evils have resulted from the conviction that it is our God-given
duty to regulate other people's lives—the effects of the current
theories of 'uplift,' and of the 'white man's burden' are only single
examples of this; and even if the intentions are good, we need
not overlook the fact that the way to hell is often paved with good
intentions.

Meanwhile there lies an essential weakness in the propaganda
of emancipation, inasmuch as the argument is based on an unques-
tioning acceptance of male values. The so-called feminist is as
much enslaved by masculine ideals as the so-called Indian nation-

[1] Cf. The *Great State,* p. 127.

[2] From an advertisement in the *Englishwoman's Year Book,* 1911.

alist is enslaved by European ideals. Like industrial man, the modern woman values industry more than leisure, she seeks in every way to externalise her life, to achieve success in men's professions, she feigns to be ashamed of her sexual nature, she claims to be as reasonable, as learned, as expert as any man, and her best men friends make the same claims on her behalf. But just in proportion as she lacks a genuine feminine idealism, inasmuch as she wishes to be something other than herself, she lacks power.

The claim of women to share the loaves and fishes with industrial man may be as just as those of Indian politicians. But the argument that women can do what men can do ("we take all labour for our province," says Olive Schreiner) like the argument that Indians can be prepared to govern themselves by a course of studies in democracy, implies a profound self-distrust. The claim to equality with men, or with Englishmen—what an honour! That men, or Englishmen, as the case may be, should grant the claim—what a condescension!

If there is one profound intuition of the non-industrial consciousness, it is that the qualities of men and women are incommensurable. "The sexes are differently entertained," says Novalis, "man demands the sensational in intellectual form, woman the intellectual in sensational form. What is secondary to the man is paramount to the woman. Do they not resemble the Infinite, since it is impossible to square (*quadriren*) them, and they can only be approached through approximation?" Is not the Hindu point of view possibly right; not that men and woman should approach an identity of temperament and function, but that for the greatest abundance of life, there is requisite the greatest possible sexual differentiation?

What is it that great men—poets and creators, not men of analysis—demand of women? It is, surely, the requirements of the prolific, rather than of the devourers, which are of most significance for the human race, which advances under the guidance of leaders, and not by accident. The one thing they have demanded of women is Life.

To one thing at least the greatest men have been always indifferent, that is, the amount of knowledge a woman may possess. It was not by her learning that Beatrice inspired Dante, or the washerwoman Chaṇḍīdās. When Cuchullain chose a wife, it was

Emer, because she had the six gifts of beauty, voice, sweet speech, needlework, wisdom and charity. We know only of Helen that "strangely like she was to some immortal spirit;" in other words, she was radiant. Rādhā's shining made the ground she stood on bright as gold. The old English poet wrote of one like her

> Her luve lumes liht
> As a launterne a nyht.

It is this radiance in women, more than any other quality, that urges men to every sort of heroism, be it martial or poetic.

Everyone understands the heroism of war; we are not surprised at Lady Hamilton's adoration of Nelson. But the activity of war is atavistic, and highly civilised people such as the Chinese regard it with open contempt. What nevertheless we do not yet understand is the heroism of art, that exhausting and perpetual demand which all creative labour makes alike on body and soul. The artist must fight a continual battle for mastery of himself and his environment; his work must usually be achieved in the teeth of violent, ignorant and often well-organised opposition, or against still more wearing apathy, and in any case, even at the best, against the intense resistance which matter opposes to the moulding force of ideas, the tāmasic quality in things. The ardent love of women is not too great a reward for those who are faithful. But it is far more than the reward of action, it is the energy without which action may be impossible. As pure male, the Great God is inert, and his 'power' is always feminine, and it is she who leads the hosts of heaven against the demons.

When man of necessity spent his life in war or in hunting, when women needed a personal physical as well as a spiritual protection, then she could not do enough for him in personal service; we have seen in the record of folk-song and epic how it is part of woman's innermost nature to worship man. In the words of another Indian scripture, her husband is for her a place of pilgrimage, the giving of alms, the performance of vows, and he is her spiritual teacher—this according to the same school which makes the initiation of son by mother eight times more efficacious than any other. What we have not yet learnt is that like relations are needed for the finest quality of life, even under conditions of perpetual peace; the tenderness of women is as

necessary to man now, as ever it was when his first duty was that of physical warfare, and few men can achieve greatness, and then scarcely without the danger of a one-sided development, whose environment lacks this atmosphere of tenderness. Woman possesses the power of perpetually creating in man the qualities she desires, and this is for her an infinitely greater power than the possession of those special qualities could ever confer upon her directly.

Far be it from us, however, to suggest the forcing of any preconceived development upon the modern individualist. We shall accomplish nothing by pressing anything in moulds. What I have tried to explain is that notwithstanding that the formula of woman's status in Oriental society may have ere now crystallised —as the formulae of classic art have become academic—nevertheless this formula represented once, and still essentially represents, although 'unfelt' in realisation, a veritable expression of woman's own nature. If not so, then the formula stands self-condemned. I do not know if through our modern idealistic individualism it may be possible to renounce all forms and formulae for ever—I fear that it is only in heaven that there shall be neither marrying nor giving in marriage—but were that the case, and every creature free to find itself, and to behave according to its own nature, then it is possible, at least, that the 'natural' relation of woman to man would after all involve the same conditions of magic that are implied in the soon-to-be-discarded conventional and calculated forms of mediaeval art and Oriental society. If not, we must accept things as they really are—however they may be.

Meanwhile, it would be worth while to pause before we make haste to emancipate, that is to say, reform and industrialise the Oriental woman. For it is not for Asia alone that she preserves a great tradition, in an age that is otherwise preoccupied. If she too should be persuaded to expend her power upon externals, there might come a time on earth when it could not be believed that such women had ever lived, as the ancient poets describe; it would be forgotten that woman had ever been unselfish, sensuous and shy. Deirdre, Brynhild, Alcestis, Sītā, Rādhā, would then be empty names. And that would be a loss, for already it has been felt in Western schools that we "are not furnished with adequate womanly ideals in history and literature."[1]

[1] Stanley Hall, *Youth*, ed. 1909, p. 286.

The industrial revolution in India is of external and very recent origin; there is no lack of men, and it is the sacred duty of parents to arrange a marriage for every daughter: there is no divergence of what is spiritual and what is sensuous: Indian women do not deform their bodies in the interests of fashion: they are more concerned about service than rights: they consider barrenness the greatest possible misfortune, after widowhood. In a word, it has never happened in India that women have been judged by or have accepted purely male standards. What possible service then, except in a few externals, can the Western world render to Eastern women? Though it may be able to teach us much of the means of life, it has everything yet to relearn about life itself. And what we still remember there, we would not forget before we must.

SAHAJA

Sahaja, sahaja, everyone speaks of sahaja,
But who knows what sahaja means?
——Chandidās.

The last achievement of all thought is a recognition of the identity of spirit and matter, subject and object; and this reunion is the marriage of Heaven and Hell, the reaching out of a contracted universe towards its freedom, in response to the love of Eternity for the productions of time. There is then no sacred or profane, spiritual or sensual, but everything that lives is pure and void. This very world of birth and death is also the great Abyss.

In India we could not escape the conviction that sexual love has a deep and spiritual significance. There is nothing with which we can better compare the 'mystic union' of the finite with its infinite ambient—that one experience which proves itself and is the only ground of faith—than the self-oblivion of earthly lovers locked in each other's arms, where 'each is both.' Physical proximity, contact, and interpenetration are the expressions of love, only because love is the recognition of identity. These two are one flesh, because they have remembered their unity of spirit. This is moreover a fuller identity than the mere sympathy of two individuals; and each as individual has now no more significance for the other than the gates of heaven for one who stands within. It is like an algebraic equation where the equation is the only truth, and the terms may stand for anything. The least intrusion of the ego, however, involves a return to the illusion of duality.

This vision of the beloved has no necessary relation to empirical reality. The beloved may be in every ethical sense of the word unworthy—and the consequences of this may be socially or ethically disastrous: but nevertheless the eye of love perceives her divine perfection and infinity, and is not deceived. That one is chosen by the other is therefore no occasion of pride: for the same perfection and infinity are present in every grain of sand, and in the raindrop as much as in the sea.

To carry through such a relationship, however, and to reach a goal, to really progress and not merely to achieve an intimation—

for this it is necessary that both the lover and the beloved should
be of one and the same spiritual age and of the same moral fibre.
For if not, as Chaṇḍidās says, the woman who loves an unworthy
man will share the fate of a flower that is pierced with thorns,
she will die of a broken heart: and the youth who falls in love
with a woman of lower spiritual degree will be tossed to and
fro in great unrest and will give way to despair.

Because the stages of human love reflect the stations of spiritual
evolution, it is said that the relationship of hero and heroine re-
veals an esoteric meaning, and this truth has been made the basis
of the well known allegories of Rādhā and Krishna, which are
the dominant motif of mediæval Hinduism. Here, illicit love
becomes the very type of salvation: for in India, where social
convention is so strict, such a love involves a surrender of all
that the world values, and sometimes of life itself. When Krishna
receives the milkmaids, and tells them he owes them a debt that
can never be paid, it is because they have come to him "like the
vairāgī who has renounced his home"—neither their duties nor
their great possessions hindered them from taking the way of
Mary. The great seducer makes them his own.

All this is an allegory—the reflection of reality in the mirror of
illusion. This reality is the inner life, where Krishna is the
Lord, the milkmaids are the souls of men, and Brindāban the
field of consciousness. The relation of the milkmaids with the
Divine Herdsman is not in any sense a model intended to be
realised in human relationships, and the literature contains explicit
warnings against any such confusion of planes.

The interpretation of this mystery, however, is so well known
as to need no elaboration. But there is a related cult, which is
called Sahaja,[1] which constitutes a practical discipline, a 'rule,'
and what we have to speak of here concerns this more difficult
and less familiar teaching.

In sahaja, the adoration of young and beautiful girls was made
the path of spiritual evolution and ultimate emancipation. By
this adoration we must understand not merely ritual worship
(the Kumārī Pūjā), but also 'romantic love.'

This doctrine seems to have originated with the later Tāntrik
Buddhists. Kānu Bhatta already in the tenth century wrote
Sahaja love songs in Bengal. The classic exponent, however, is

[1] Root meaning, cognate, or innate, and hence, "spontaneous."

PLATE XXIV

INDIAN SCULPTURE.

"Where each is both." Rock-cut sculpture. Brahmanical. Elūra.
8th century.

Chandidās, who lived in the fourteenth century. Many other poets wrote in the same sense. Chandidās himself was called a madman—a term in Bengālī which signifies a man of eccentric ideas who nevertheless endears himself to everyone. He was Brahman and a priest of the temple of Vāśuli Devī near Bolpur. One day he was walking on the river bank where women were washing clothes. By some chance there was a young girl whose name was Rāmī: she raised her eyes to his. There was a meeting of Dante and Beatrice. From this time on Chandidās was filled with love. Rāmī was very beautiful: but in Hindu society what can a washerwoman be to a Brahman? She could only take the dust of his feet. He, however, openly avowed his love in his songs, and neglected his priestly duties. He would fall into a dream whenever he was reminded of her.

The love songs of Chandidās were more like hymns of devotion: "I have taken refuge at your feet, my beloved. When I do not see you my mind has no rest. You are to me as a parent to a helpless child. You are the goddess herself—the garland about my neck—my very universe. All is darkness without you, you are the meaning of my prayers. I cannot forget your grace and your charm—and yet there is no desire in my heart."

Chandidās was excommunicated, for he had affronted the whole orthodox community. By the good offices of his brother he was once on the point of being taken back into society, on condition of renouncing Rāmī forever, but when she was told of this she went and stood before him at the place of the reunion —never before had she looked upon his face so publicly—then he forgot every promise of reformation, and bowed before her with joined hands as a priest approaches his household goddess.

It is said that a divine vision was vouchsafed to certain of the Brahmans there present—for Rāmī was so transfigured that she seemed to be the Mother of the Universe herself, the Goddess: that is to say that for them, as for Chandidās himself, the doors of perception were cleansed, and they too saw her divine perfection. But the rest of them saw only the washerwoman, and Chandidās remained an outcast.

He has explained in his songs what he means by Sahaja. The lovers must refuse each other nothing, yet never fall. Inwardly, he says of the woman, she will sacrifice all for love, but outwardly she will appear indifferent. This secret love must find

expression in secret: but she must not yield to desire. She must cast herself freely into the sea of contempt, and yet she must never actually drink of forbidden waters: she must not be shaken by pleasure or pain. Of the man he says that to be a true lover he must be able to make a frog dance in the mouth of a snake, or to bind an elephant with a spider's web. That is to say, that although he plays with the most dangerous passions, he must not be carried away. In this restraint, or rather, in the temper that makes it possible, lies his salvation. "Hear me," says Chaṇḍidās, "to attain salvation through the love of woman, make your body like a dry stick—for He that pervades the universe seen of none, can only be found by one who knows the secret of love." It is not surprising if he adds that one such is hardly to be found in a million.

This doctrine of romantic love is by no means unique: we meet with it also at the summit levels of European culture, in the thirteenth century. "And so far as love is concerned," says a modern Russian (Kuprin), "I tell you that even this has its peaks which only one out of millions is able to climb."

Before attempting to understand the practise of Sahaja we must define the significance of the desired salvation—the spiritual freedom (*moksha*) which is called the ultimate purpose, the only true meaning of life, and by hypothesis the highest good and perfection of our nature. It is a release from the ego and from becoming: it is the realisation of self and of entity—when 'nothing of ourself is left in us.' This perfect state must be one without desire, because desire implies a lack: whatever action the *jīvan mukta* or spiritual freeman performs must therefore be of the nature of manifestation, and will be without purpose or intention. Nothing that he does will be praiseworthy or blameworthy, and he will not think in any such terms,— as the *Makābhārata* says, with many like texts, 'He who considers *himself* a doer of good and evil knows not the truth, I trow.' Nothing that the freeman does will be 'selfish,' for he has lost the illusion of the ego. His entire being will be in all he does, and it is this which makes the virtue of his action. This is the innocence of desires.

Then and then only is the lover free—when he is free from willing. He who is free is free to do what he will—but first, as Nietzsche says, he must be such as can will, or as Rūmī expresses it, must have surrendered will. This is by no means the

same as to do what one likes, or avoid what one does not like, for he is very far from free who is subject to the caprices or desires of the ego. Of course, if the doors of perception were cleansed we should know that we are always free ('It is nought indeed but thine own hearing and willing that do hinder thee, so that thou dost not hear and see God')—for the world itself is manifestation and not the handiwork of the Absolute. The most perfect love seeks nothing for itself, requiring nothing, and offers nothing to the beloved, realizing her infinite perfection which cannot be added to: but we do not know this except in moments of perfect experience.

Very surely the love of woman is not the only way to approach this freedom. It is more likely by far the most dangerous way, and perhaps for many an impossible way. We do not however write to condemn or to advocate, but to explain.

In reading of romantic love we are apt to ponder over what is left unsaid. What did the writers really mean? What was the actual physical relation of the Provençal lover to his mistress, of Chaṇḍidās to Rāmī? I have come to see now that even if we knew this to the last detail it would tell us nothing. He who looks upon a woman with desire (be it even his wife) has already committed adultery with her in his heart, for all desire is adultery. We remember that saying, but do not always remember that the converse is also true—that he who embraces a woman without desire has added nothing to the sum of his mortality. Action is then inaction. It is not by non-participation but by non-attachment that we live the spiritual life. So that he in Sahaja who merely *represses* desire, fails. It is easy not to walk, but we have to walk without touching the ground. To refuse the beauty of the earth—which is our birthright—from fear that we may sink to the level of pleasure seekers—*that* inaction would be action, and bind us to the very flesh we seek to evade. The virtue of the action of those who are free beings lies in the complete co-ordination of their being—body, soul and spirit, the inner and outer man, at one.

The mere action, then, reveals nothing. As do the slaves of passion impelled by purpose and poverty, so do the spiritually free, out of the abundance of the bestowing virtue. Only the searcher of hearts can sift the tares from the wheat; it is not for mortal man to judge of another's state of grace.

When we say that the Indian culture is spiritual, we do not mean that it is not sensuous. It is perhaps more sensuous than has ever been realised—because a sensuousness such as this, which can classify three hundred and sixty kinds of the fine emotions of a lover's heart, and pause to count the patterns gentle teeth may leave on the tender skin of the beloved, or to decorate her breasts with painted flowers of sandal paste—and carries perfect sweetness through the most erotic art—is inconceivable to those who are merely sensual or by a superhuman effort are merely self-controlled. The Indian temperament makes it possible to speak of abstract things *même entre les baisers*.

For this to be possible demands a profound culture of the sexual relationship—something altogether different from the "innocence" of Western girlhood and the brutal violence of the "first night" and the married orgy. The mere understanding of what is meant by Sahaja demands at least a racial if not an individual education in love—an education related to athletics and dancing, music and hygiene. The sexual relation in itself must not be so rare or so exciting as to intoxicate: one should enjoy a woman as one enjoys any other living thing, any forest, flower or mountain that reveals itself to those who are patient. One should not be forced to the act of love by a merely physical tension: minutes suffice for that, but hours are needed for the perfect ritual. What the lover seeks should be the full response, and not his mere pleasure: and by this I do not mean anything so sentimental as "forbearance" or "self-sacrifice," but what will please him most. Under these conditions violence has no attractions: in Arabia, Burton tells us, the Musalmans respected even their slaves, and it was "pundonor," a point of culture, that a slave, like any other woman, must be wooed. (There has been no actual slavery in India, or very little).

Lafcadio Hearn has pointed out the enormous degree to which modern European literature is permeated with the idea of love. This is however as nothing compared with what we find in the Vaishṇava literature of Hindustān. There, however, there is always interpretation: in European romantic literature there is rarely anything better than description. That should be only a passing phase, for the real tendency of Western sexual freedom is certainly idealistic, and its forms are destined to be developed until the spiritual significance of love is made clear.

Under the sway of modern hedonism, where nothing is accepted as an end, and everything is a means to something else, the pre-conditions for understanding Sahaja scarcely exist. Sahaja has nothing to do with the cult of pleasure. It is a doctrine of the Tao, and a path of non-pursuit. All that is best for us comes of itself into our hands—but if we strive to overtake it, it perpetually eludes us.

In the passionless spontaneous relation of Sahaja, are we to suppose that children are ever to be begotten? I think not. It is true that in early times it was considered right for the hermit who has renounced the world and the flesh to grant the request of a woman who comes to him of her own will and desires a child. But this is quite another matter—and incidentally a wise eugenic disposition, removing an objection to monasticism which some have found in its sterilisation of the best blood. The Sahaja relation, on the contrary, is an end in itself, and cannot be associated with social and eugenic ideas. Those who are capable of such love must certainly stand on the plane of the 'men of old,' who did not long for descendants, and said 'Why should we long for descendants, we whose self is the universe? For longing for children is longing for possessions, and longing for possessions is longing for the world: one like the' other is merely longing.'[1] We cannot admit such a longing in Sahaja. It is however just possible that such a relation as this might be employed by the Powers for the birth of an avatār: and in such a case we should understand what was meant by immaculate conception and virgin birth—she being virgin who has never been *moved* by desire.

The Sahaja relation is incommensurable with marriage, *categorically regarded as contract,* inasmuch as this relation is undertaken for an end, the definite purpose of 'fulfilling social and religious duties,' and in particular, of paying the 'debt to the ancestors' by begetting children.

Those whose view of life is exclusively ethical will hold that sexual intimacy must be sanctified, justified or expiated by at least the wish to beget and to accept the consequent responsibilities of parenthood. There is, indeed, something inappropriate in the position of those who pursue the pleasures of life and

[1] *Bṛihadāraṇyaka Upaṇishad.*

evade by artificial means their natural fruit. But this point
of view presupposes that the sexual intimacy was a sought pleas-
ure: what we have discussed is something quite other than this,
and without an element of seeking.

It is only by pursuing what is not already ours by divine right
that we go astray and bring upon ourselves and upon others infi-
nite suffering—to those who do not pursue, all things will offer
themselves. What we truly need, we need not strive for.

It will be seen from all this how necessary it is that sexual in-
timacy should not in itself be considered an unduly exciting ex-
perience. It is more than likely also that those who are capable
of this spontaneous control will have been already accustomed
to willed control under other circumstances: and a control of
this kind implies a certain training. We may remark in passing
that in 'birth control' we see an objection to the use of artificial
means—an objection additional to what is obvious on aesthetic
grounds—in the fact that such means remove all incentive to the
practice of *self*-control. Those who have good reason to avoid
procreation at any time, should make it a point of pride to ac-
complish this by their own strength—and in any case, no man
who has not this strength can be sure of his ability to play his
part to perfection, but may at any time meet with a woman whom
he cannot satisfy.

How is one to avoid in such a relation as Sahaja the danger
of self-deception,[1] the pestilence of suppressed desires, and even
of physical overstrain and tension?

For very highly perfected beings it may be true that those
subtle exchanges of nervous energy which are effected in sexual
intercourse—and are necessary to full vitality—can be effected
by mere intimacy, in a relation scarcely passionate in the com-
mon sense. We read, indeed, of other worlds where even gen-
eration may be effected by an exchange of glances. But it is
given to few to function always on such a plane as this. Are we
then to forbid to those who need the consolations of mortal af-
fection—are we to forbid to these the passionless intimacy of
Sahaja? Why should we do so? Even for those who cannot
renounce the sheltered valleys of the personal life for ever, it
is well sometimes to breathe the cold air of the perpetual snows.

[1]"How nicely can doggish lust beg for a piece of spirit, when flesh is
denied it!"—Nietzsche.

We should add that 'to whom chastity is difficult, it is to be dis-
suaded': in order to be sure of our ground we should not at-
tempt the practise of a degree of continence beyond our power.
We should also be careful not to 'mix our planes' or to make
one thing an excuse for another. We must recognize everything
for what it really is—the relative as relative, the absolute as abso-
lute—and render unto Cæsar those things, and only those, which
are lawfully his.

We are now, perhaps, in a better position to know what is
meant by Chandidās when he speaks of the difficulties and the
meaning of Sahaja. What he intends by 'never falling' (satī)
is a perpetual uncalculated life in the present, and the mainte-
nance, not of deliberate control, but of unsought, unshaken seren-
ity in moments of greatest intimacy: he means that under cir-
cumstances of temptation none should be felt—not that tempta-
tion should be merely overcome. And to achieve this he does
not pray to be delivered from temptation, but courts it.

Here nothing is to be done for one another, but all for love.
There is to be no effort to evoke response, and none to withhold
it. All this is far removed from the passion and surrender, the
tricks of seduction, and the shyness, of the spiritual allegory and
of the purely human experience.

INTELLECTUAL FRATERNITY[1]

"To mark by some celebration the intellectual fraternity of mankind."

Alike to those who grieve for Europe in her hour of civil war, and to those who would offer tribute at the shrine of William Shakespeare, it must appear appropriate and significant to publish tokens of the brotherhood of man in art. For it is likely the prestige of Empire may be completely shattered in the present conflict of rival imperialisms: it may appear henceforth a matter for shame to exercise political domination over men of another race: and where until lately it has been the custom to proclaim the conqueror's civilizing purposes, a common civilization of the world will demand of us a mutual understanding carried at least so far that we may substitute for the endeavour to do one another good, an effort based on common needs and human purposes, conceived in intellectual fraternity. None has been more distinguished than William Shakespeare, in his profound appreciation of the common humanity of an infinite variety of man. Civilization must henceforth be human rather than local or national, or it cannot exist. In a world of rapid communications it must be founded in the common purposes and intuitions of humanity, since in the absence of common motives, there cannot be coöperation for agreed ends. In the decades lately passed—in terms of 'real duration,' now so far behind us—it has, indeed, been fashionable to insist upon a supposed fundamental divergence of European and Asiatic character: and those who held this view were not entirely illogical in thinking the wide earth not wide enough for Europe and Asia to live in side by side. For artificial barriers are very frail: and if either white or yellow 'peril' were in truth an essentially inhuman force, then whichever party believed itself to be the only human element, must have desired the extermination, or at least the complete subordination of the other. But the premises were false: the divergences of character are

[1] Contributed to the "Book of Homage to Shakespeare," edited by Israel Gollancz, London 1916.

superficial, and the deeper we penetrate, the more we discover
an identity in the inner life of Europe and Asia. Can we, in
fact, point to any elemental experience or to any ultimate goal
of man which is not equally European and Asiatic? Does one
not see that these are the same for all ages and continents?
Who that has breathed the clear mountain air of Upanishads, of
Gautama, Śankara and Kabīr, of Rūmī, of Laotse and Jesus (I
mention so far Asiatic prophets only) can be alien to those who
have sat at the feet of Plato and Kant, Tauler, Behmen and
Ruysbroeck, Whitman, Nietzsche and Blake? The latter may
well come to be regarded as the supreme prophet of a post-
industrial age, and it is significant that one could not find in
Asiatic scripture a more typically Asiatic purpose than is revealed
in his passionate will to be delivered from the bondage of division:

"I will go down to self-annihilation and Eternal Death,
Lest the Last Judgment come and find me unannihilate,
And I be seized and giv'n into the hands of my own Selfhood."

But it is not only in Philosophy and Religion—Truth and
Love—but also in Art that Europe and Asia are united: and from
this triple likeness we may well infer that all men are alike in
their divinity. Let us only notice here the singular agreement of
Eastern and Western theories of Drama and Poetry, illustrating
what has been said with special reference to the hero of our cele-
bration: for the work of Shakespeare is in close accordance with
Indian canons of Dramatic Art.

" I made this Drama," says Brahmā, " to accord with the movement of
the world, whether at work or play, in peace or laughter, battle, lust or
slaughter—yielding the fruit of righteousness to those who are followers
of a moral law, and pleasures to the followers of pleasure—informed with
the divers moods of the soul—following the order of the world and all its
weal and woe. That which is not to be found herein is neither craft nor
wisdom, nor any art, nor is it Union. That shall be Drama which affords
a place of entertainment in the world, and a place of audience for the
Vedas, for philosophy and for the sequence of events."

And poetry is justified to man inasmuch as it yields the four-
fold Fruit of Life—Virtue, Pleasure, Wealth and Spiritual Free-
dom. The Western reader may inquire, "How Spiritual Free-
dom?" and the answer is to be found in the disinterestedness of
æsthetic contemplation, where the spirit is momentarily freed

from the entanglement of good and evil. We read in the dramatic canon of Dhanamjaya, for example:

"There is no theme, whether delightful or disgusting, cruel or gracious, high or low, obscure or plain, of fact or fancy, that may not be successfully employed to communicate æsthetic emotion."

We may also note the words of Chuang Tzu:

"The mind of the sage being in repose, becomes the mirror of the Universe."

and compare them with those of Whitman, who avows himself not the poet of goodness only, but also the poet of wickedness.

It is sometimes feared that the detachment of the Asiatic vision tends towards inaction. If this be partly true at the present moment, it arises from the fullness of the Asiatic experience, which still contrasts so markedly with European youth. If the everlasting conflict between order and chaos is for the present typically European, it is because spiritual wars no less than physical must be fought by those who are of military age. But the impetuosity of youth cannot completely compensate for the insight of age, and we must demand of a coming race that men should act with European energy, and think with Asiatic calm—the old ideal taught by Krishna upon the field of battle:

"Indifferent to pleasure and pain, to gain and loss, to conquest and defeat, thus make ready for the fight. . . . As do the foolish, attached to works, so should the wise do, but without attachment, seeking to establish order in the world."

Europe, too, in violent reaction from the anarchy of *laissez-faire*, is conscious of a will to the establishment of order in the world. But European progress has long remained in doubt, because of its lack of orientation. It is significant that the discovery of Asia should coincide with the present hour of decision: for Asiatic thought again affirms the unity and interdependence of all life, at the moment when Europe begins to realize that the Fruit of Life is not easily attainable in a society based upon division. In honouring the genius of Shakespeare, then, we do not merely offer homage to the memory of individual, but are witnesses to the intellectual fraternity of mankind: and it is that fraternity which assures us of the possibility of coöperation in a common task, the creation of a social order founded on Union.

COSMOPOLITAN VIEW
OF NIETZSCHE

Certainly, Nietzsche was not a philosopher in the strict sense of the word. He is essentially a poet and sociologist, and above all, a mystic. He stands in the direct line of European mysticism, and though less profound, speaks with the same voice as Blake and Whitman. These three might, indeed, be said to voice the religion of modern Europe—the religion of Idealistic Individualism. If it were realised that his originality does not consist in an incomprehensible and unnatural novelty, but in a poetic restatement of a very old position, it might be less needful to waste our breath in the refutation of theses he never upheld.

It is true that we find in his work a certain violence and exaggeration: but its very nature is that of passionate protest against unworthy values, Pharisaic virtue, and snobisme, and the fact that this protest was received with so much execration suggests that he may be a true prophet. The stone which the builders rejected: Blessed are ye when men shall revile you. Of special significance is the beautiful doctrine of the Superman—so like the Chinese concept of the Superior Man, and the Indian *Mahā Purusha, Bodhisattva* and *Jīvan-mukta.*

Amongst the chief marks of the mystic are a constant sense of the unity and interdependence of all life, and of the interpenetration of the spiritual and material—opposed to Puritanism, which distinguishes the sacred from the secular. So too is the sense of being everywhere at home—unlike the religions of reward and punishment, which speak of a future paradise and hell, and attach an absolute and eternal value to good and evil. "All things," he says, "are enlinked, enlaced and enamoured": "I conjure you, my brethren, remain true to the earth, and believe not those who speak to you of superearthly hopes": "For me—how could there be an outside of me? There is no outside": "Every moment beginneth existence, around every 'Here' rolleth the ball 'There.' The middle is everywhere": "Becoming must appear justified at every instant . . . the present must not under any circumstances be justified by a future, nor the past be justified for the

sake of the present." All these are characteristic mystic intuitions, or logical deductions from monism, in close accord with the Brahmanical formula, "That art thou."

The doctrine of the Superman, whose virtue stands "beyond good and evil," who is at once the flower and the leader and saviour of men, has been put forward again and again in the world's history. A host of names for this ideal occur in Indian literature: he is the *Arhat* (adept), *Buddha* (enlightened), *Jina* (conqueror), *Tīrthakara* (finder of the ford), the *Bodhisattva* (incarnation of the bestowing virtue), and above all *Jīvan-mukta* (freed in this life), whose actions are no longer good or bad, but proceed from his freed nature.

Let us see what Nietzsche himself has to say of the Superman. "Upward goeth our course onward from genera to super-genera. But a horror to me is the degenerating sense, which saith 'All for myself'." Is that the doctrine of selfishness? As well accuse the Upanishad, where it declares that all things are dear to us for the sake of the Self. For the monist there is no true distinction of selfish and unselfish, for all interests are identical. Self-realisation is perfect service, and our supreme and only duty is to become what we are (*That* art thou). This is idealistic individualism, and this doctrine of inner harmony is valid on all planes,[1] for we are not saved by what we do, only by what we are. "Ye constrain," he says, "all things to flow towards you and into you, so that they shall flow back again out of your fountain as the gifts of your love. Verily, an appropriator of all values must such a bestowing love become: but healthy and holy call I this selfishness . . . But another selfishness there is, an all-too-poor and hungry kind, which would always steal—with the eye of the thief it looketh upon all that is lustrous: with the craving of hunger it measureth him who hath abundance: and ever doth it prowl round the table of bestowers." It is the author of a supposed apotheosis of the "Blonde Beast," who exclaims: "Better to perish than to fear and hate: far better to perish than to be feared and hated!"

Nietzsche has certainly a contempt for pity—that is, for senti-

[1] See, for example, Artzibashef's *Sanine,* where the one man who is at peace with himself, though far from a highly spiritual type, is still the most lovable.

mentalizing over one's own sufferings or those of others. Naturally, life is hard: for the higher man it should be ever harder by choice. "My suffering and my fellow-suffering—what matter about them!" "Ye tell me 'Life is hard to bear.' But for what purpose should ye have your pride in the morning and your resignation in the evening?" This is certainly different from the "greatest happiness of the greatest number," which Western democracies have made their aim.

It is hardly worth while to refer to those who bracket our poet-philosopher and mystic with the Treitschkes and Crambs, and would make him one of the prime instigators of a "Euro-Nietzschean" war. It would be easy to show by quotation how he scorned alike the mediocrity of Germany and England, and how he regarded France as "still the seat of the most intelligent and refined culture of Europe," and contrasted the French esprit with "our German infirmity of taste." Better than this, however, will be to show how well he understood the fundamental unity of Europe—a unity of suffering now, but then as now a unity of movement, by the side of which the present hatreds assume the proportions of a mere episode—and how little he could ever have associated patriotism with greatness:

"Owing," he says, "to the morbid estrangement which the nationality-craze has induced and still induces amongst the nations of Europe, owing also to the short-sighted and hasty-handed politicians, who with the help of this craze, are at present in power, and do not suspect to what extent the disintegrating policy they pursue must necessarily be only an interlude policy—owing to all this, and much more that is altogether unmentionable at present, the most unmistakable signs that *Europe wishes to be one,* are now overlooked, or arbitrarily and falsely misinterpreted. With all the more profound and large-minded men of this century, the real general tendency of the mysterious labour of their souls was to prepare the way for that new *synthesis* and tentatively to anticipate the European of the future; only in their simulations, or in their weaker moments, in old age, perhaps, did they belong to the 'fatherlands'—they only rested from themselves when they became 'patriots'." And what may be said to prove the truth of this sense of European unity, which even ten years ago might have seemed a too brilliant generalization, is the fact that we see now, that not only Europe, but the whole world, and in precisely the

same way, through the mysterious labours of great men, has long
striven to be one, and is now, perhaps for the first time in history,
within a measurable distance of realising its unconscious purpose.

The "Will to Power" has nothing to do with tyranny—it is
opposed alike to the tyranny of the autocrat and the tyranny of
the majority. The Will to Power asserts that our life is not to
be swayed by motives of pleasure or pain, the "pairs of opposites,"
but is to be directed towards its goal, and that goal is the free-
dom and spontaneity of the *Jīvan-mukta*. And this is beyond
good and evil. This also set out in the *Bhagavad Gītā:* the hero
must be superior to pity (*aśocyānanvaśocastvam*); resolute for
the fray, but unattached to the result, for, as Whitman expresses
it, "battles are lost in the same spirit in which they are won." If he
be wounded, he will urge his comrades onward, rather than ask
them to delay to condole with him: and he will not insult them by
supposing that they in their turn would do otherwise. "Let your
love be stronger than your pity": but that is not self-love, it is
not even neighbour-love or patriotism—"Higher than love to your
neighbour is love to the furthest and future ones; higher still than
love to men is love to things and phantoms . . . 'Myself do I
offer unto my love, and my neighbour as myself'—such is the
language of all creators." "Ah! that ye understood my word,"
he says: "do ever what ye will—but first be such as can will
 He who cannot command himself shall obey." This
is infinitely remote from the doctrine of "getting our own way"
or "doing what we like"—"a horror to us," as he says, "is the
degenerating sense, which saith 'All for myself'."

The teaching of Nietzsche is a pure *nishkāma dharma:* "Do I
then strive after *happiness?* I strive after my *work!*" and "All
those modes of thinking," he says, "which measure the worth of
things according to *pleasure* and *pain,* are plausible modes of
thought and naivetés, which everyone conscious of creative
powers and an artist's conscience will look down upon with
scorn." For the Superman, as we should say, is not swayed by
the pairs of opposites. 'Do what ye will': this doctrine is neither
egotistic nor altruistic. Not egotistic, for to yield to all the
promptings of the senses, to be the slave of caprice, is to be
moulded by our environment, and the very reverse of far-willing:
it is precisely himself the Superman may not spare. It is not
altruistic, for where there is naught external to myself, there

can be no altruism. The highest duty is that of self-realisation. "Physician, heal thyself," exclaims Nietzsche: "then wilt thou also heal thy patient. Let it be his best cure to see with his eyes him who maketh himself whole." This is nothing but the old doctrine of Chuang Tzu: "The sages of old first got *Tao* for themselves, and then got it for others. Before you possess this yourself, what leisure have you to attend to the doings of wicked men? Cherish and preserve your own self, and all the rest will prosper of itself." It reminds us also of Jesus: "First cast out the mote from thine own eye."

The leaders of humanity have never been such as have acted from a sense of duty, in the ordinary sense of the word. Duty is but a means of playing safe for those who lack the Bestowing Virtue. The activity of genius is not an obedience to rules, but dedication of life to what is commanded from within, even though it should appear to all others as evil.

Was Jesus humble, or did He
Give any proofs of humility?
When but a child He ran away,
And left His parents in dismay:
These were the words upon His tongue
"I am doing My Father's business."

What constitutes the virtue of any action is the complete co-ordination of the actor. We should act according to our own nature: and when that nature has developed to its fullest stature, then what is divine attains complete manifestation. It is with preoccupations such as this that Nietzsche exclaims with such profound conviction:

"That ye might become weary of saying: 'that an action is good because it is unselfish.' Ah! my friends! That your very self be in your action, as the mother is in the child: let that be your formula of virtue."

This is the very prayer of Socrates, "and may the outward and inward man be at one"—all else is hypocrisy. The inferior man regulates his life by externals: inasmuch as he is constrained by desire for long life, reputation, riches, rank or offspring, he is not free. The superior man is of another sort, and of him it

may be said, with Chuang Tzu, "that they live in accordance with
their own nature. In the whole world they have no equal, They
regulate their life by inward things."

"What are not the powerful doing?" says the *Prema Sāgara*
"Who knows their course of action? They, indeed, do nothing
for themselves; but to those that do them honour and seek their
aid, they grant their prayers. Such is their path, that they appear
united to all; but upon reflection thou shalt perceive that they
stand aloof from all, as the lotus leaf from water." "The man
of perfect virtue" (Superman), says Chuang Tzu again, "in
repose has no thoughts, in action no anxiety. He recognizes no
right, nor wrong, nor good, nor bad. Within the Four Seas, when
all profit—that is his pleasure; when all share—that is his repose.
Men cling to him as children who have lost their mothers; they
rally round him as wayfarers who have missed their road." For
his is the Bestowing Virtue.

According to Aśvaghosha, too, "it is said that we attain to Nir-
vāna and that various *spontaneous* displays of activity are accom-
plished." The Bodhisattvas do not consider the ethics of their
behaviour: "they have attained to spontaneity of action, because
their discipline is in unison with the wisdom and activity of all
Tathāgatas." "Jesus was all virtue, because he acted from im-
pulse and not from rules." When Nietzsche says that the Super-
man is the meaning of the earth he means what we mean when
we speak of a Bodhisattva, or of a *Jīvan-mukta*. This type which
represents the highest attainment and purpose of humanity is the
most difficult thing for self-assertive minds to grasp. A being
"beyond good and evil," a law unto himself. "How wicked!"
exclaims the ordinary man: "for even *I* feel it my duty to con-
form to the rules of morality and to restrain *my* selfish desires."

Thus we shall never comprehend the selfishness which Nietzsche
and other mystics praise, if we interpret it according to the lights
of those who believe that all actions should be *praiseworthy.*
The pattern of man's behaviour is not to be found in any code,
but in the principles of the universe, which is continually reveal-
ing to us *its own nature.* Consider the lilies . . .

There exists a voluptuousness that is not sensuality, a passion
for power that is not self-assertion, and a selfishness that is more
generous than any altruism. These are distinctions which Nietz-
sche himself is careful to insist upon, and only wilful misunder-

standing ignores it. It is precisely of the great man who fails
that he says: "Once they thought of becoming heroes; but sen-
sualists are they now." "Art thou the victorious one (*jina*)," he
says, "the self-conqueror, the ruler of thy passions, the master of
thy virtues? Thus do I ask thee. Or does the animal speak in
thy wish, and necessity? or isolation? or discord in thee?" "What
I warn people against . . . confounding debauchery, and the
principle '*laisser aller*' (i. e. 'never mind') with the Will to
Power—the latter is the exact reverse of the former." "And
verily, it is no commandment for to-day and to-morrow to learn
to love oneself. Rather is it of all arts the finest, subtlest, last
and patientest." "True and ideal selfishness consists in always
watching over and restraining the soul, so that our productiveness
may come to a beautiful termination."

So far, then, from a doctrine of self-indulgence, it is a form of
asceticism or ardor (*tapas*) which Nietzsche would have us im-
pose on ourselves, if we are strong enough. This was precisely
the view of Manu when he established a severe rule of life for
the Brahman, and one far easier for the Śūdra. And understand-
ing this, Nietzsche has praised the institution of caste, for he
thought it right that life should grow colder towards the summit.
As the *Mārkaṇḍeya Purāṇa* pronounces, a Brahman should do
nothing for the sake of enjoyment.

Those who have comprehended the decline and fall of Western
civilization will recognize in Nietzsche the reawakening of the
conscience of Europe.

YOUNG INDIA

In order to understand Young India, one must understand the world. What is the meaning of youth or age in cycles of civilization, as well as in individuals? In terms of reality, this is not a question of dates or years, but of experience. India is at once unbelievably old and incredibly young, utterly sophisticated and pathetically naive. Her great achievements of the past—in philosophy, art and social organization—possess an indestructible value, and there can be no true citizenship of the world of which the roots do not reach back into this ground, at least as far as they reach back into the classic culture of the Mediterranean. There is no point at which the speculation, experiment, success or failure which constitute Indian civilization do not touch the vital problems of the present day. And yet we cannot say that modern India has created anything.

We stand in the West at the close of the great cycle of Christian civilization which attained its zenith, let us say, in the twelfth or thirteenth century, when the creative will of man swept far beyond its personal boundaries, striving to establish an order in the outer world to correspond with the universal order of the world of imagination or eternity. From the thirteenth to the twentieth century one can follow the progressive decay of life—the ever fainter expression of the creative will, loosening social integration, the substitution of contract for status, the advancement of material and moral to the exclusion of spiritual values, the decline of vision, up to this present hour of pure chaos, when life and art are evidence of centuries of aimlessness.

The war in Europe is no unfortunate accident, but the inevitable outcome of European civilization. How clearly this was already apparent towards the close of the nineteenth century is to be seen in the remarkable words of Viscount Torio, published in 1890: "Occidental civilization . . . must ultimately end in disappointment and demoralization. . . . Peaceful equality can never be attained until built up among the ruins of annihilated Western States and the ashes of extinct Western peoples." And, indeed, we cannot be surprised that the philosophy of internecine

peace should have been transferred at last to the visible field of battle.

We feel that the intention of this war has been to make the world safe for exploitation; this might have been accomplished by a decisive victory on either side. And "Victory breeds hatred: because the conquered are unhappy."[1] The best one could hope for was that the struggle would go on long enough and be sufficiently inconclusive to destroy the prestige of Imperialism and exploitation for many centuries. Nevertheless, democracy understood politically as the tyranny of a majority is no more congenial to liberty than an autocracy, for it implants or assumes in every one the desire to govern. But those only are worthy to govern, as the Chinese say, who would rather be excused. Representative government has everywhere been found to involve no more than the victory of the most powerful interests. And even revolts have not created liberty—

> The Iron hand crushed the tyrant's head
> And became a tyrant in his stead.

Every oppressed nationality oppresses some other or embraces the oppression of class by class. Our sympathies are then not only with the oppressed, but with the oppressor, for both alike are in need of salvation from the same group of false values. The liberty that we concede is of far greater significance to us than any liberty we can take by force or receive by gift.

Perhaps we ought not to include the Russians in these criticisms. In Russia more clearly than anywhere else, the religion of Europe—the idealistic individualism of Blake and Whitman and Nietzsche—has found expression in art and action. It is a tragic reflection that those who laid down their arms were not wrong, but only too right. Yet we cannot collectively abandon the use of force in a day or establish the kingdom of heaven in a week: to find the Paradise still upon earth is possible only for the individual, never for the race . . . If we cannot see our way to the end of all government, however, we can see that the least amount of government it is possible to live with is the best, and the less we are mixed up with it the better for us: or, rather,

[1] *Dhammapada.*

the better we are, the less we shall wish to be involved in it. Needless to say, in refusing to govern, we do not refuse to coöperate: but to accomplish this, we must serve, not one another, but ends beyond ourselves.

Let us pause now to see what has been going on in India, and first to consider the past as it survives side by side with the Young India that is the final subject of our argument. Broadly contrasted with the opportunist industrial order of today ("a desperately precarious institutional situation"),[1] where the whole energy of man is used up in making sure of mere existence, the civilization of India presents to us the spectacle of something stable and leisurely: and this not merely by virtue of some kind of inertia, but as the result of deliberate organization based on a definite view (definite, whether right or wrong) of the meaning and purpose of life. The principles of government are defined, not by the interested, but by the disinterested; that is to say, by the philosopher who has no personal ends to serve and no "stake in the country"; he is the law-giver, and the status of the executive power is inferior. In a stable coöperative society the achievement of mere life, the solution of the bare economic problem, is taken for granted, and there remains abundant energy for the pursuit of the real ends of life. These were defined in India in the famous formula of "Human Aim" (*purushārtha*), on the one hand temporarily as vocational activity (function, or duty), winning wealth and enjoying pleasure; and on the other hand eternally as spiritual freedom. Obviously the latter object is the main concern of all higher men.

Here are the criteria of ethical judgment. That is a *priori* right, which tends to the achievement of one or all of these ends (all being good in their degree or kind), and that is wrong, which involves the attainment of any end not appropriate to the individual concerned, or involves a failure to attain what is appropriate. We speak of right or wrong accordingly as purely relative to individuality and circumstance; and since all men are really unlike, it requires but a slight development of the doctrine of "own-morality" of the vocational groups, which is the basis of organized ethics, to reach the pure individualism which is the ultimate religion alike of Asia and modern Europe. The indi-

[1] Veblen, *The Instinct of Workmanship.*

vidual who attains this ground of liberty is called in India "jivan-mukta," free in this life, since nothing of himself is left in him. This is the concept of superman; but it demands also the entirety of man at every stage of development. There can be no doubt that this latter end of spiritual freedom—to become what we are—dominated in India all others; so that the connotation of success in India has but little in common with its connotation in America.

Let us speak of two conspicuous features of the Hindu social order. First, the caste system. This system, of which the lines are drawn at once ethnically and culturally (not pecuniarily), represents an integration (not a division) of society in vocational groups internally democratic, and outwardly answerable to other groups only for the fulfillment of their 'own function.' It is somewhat as if, for example, the farmers of the whole United States should be answerable to the community at large only for the production of good and sufficient food, in return for the means of production guaranteed to them, while as a group they should remain completely autonomous in all other respects, e. g., in matters of marriage and divorce, education, wages and hours of labor, etc., while none could be called on for any other public service than their own. In place of States, then, we should have nation-wide, someday perhaps world-wide, vocational groups directly founded on the instinct of workmanship and the inheritance of aptitude.

It was assumed in India that heredity determined birth in the appropriate environment. This may have been true of an ordered society like that of ancient India, but it could not apply to the melting pot, and we may expect that the coming development of syndicalism will differ chiefly from the caste system in permitting intermarriage and choice or change of occupation under certain conditions, though still recognizing the general desirability of marriage within the group and of following one's parent's calling. In such a reinstatement of the instinct of workmanship in the West, and a certain relaxation of caste rule in the East, it is possible to foresee a common sociological agreement of the workers of the world.

Secondly, marriage. In India the home is still the foundation of all social thought; in Europe and America the home as determined by existing tradition is already a lost cause—a profound

distinction, and yet, under the same influences the same result is bound to succeed even in India, though the ancient order may be long in dying. The Indian marriage is an impersonal contract, undertaken as a social debt, by men and women alike, not for happiness, but for the fulfillment of social and religious duties. It is not based on romantic love or passion, and it is indissoluble, just because it is undertaken for ends that are realizable apart from individual interest. To be perfect wife or husband is not so much a question of personal adaptation as of education, since ethical culture is achieved through hero-worship and the general knowledge of epic literature. The end is a perfect harmony based on self-forgetfulness—an order exquisite in form, and possibly superior to the romantic concept of the harmony of selves which underlies the modern theory of marriage or liaison based on love, but incongruous with our necessity to prove for ourselves the spiritual and dynamic value of passion.

One further observation on the past: it was from beginning to end an era of proficiency in handicraft, rather than of ingenious mechanism. The industrial arts attained an unsurpassed perfection with great economy of means. Sculpture had already declined, but painting and architecture were still at a very high level at the end of the eighteenth century. Music, poetry and dancing survive today, however, precariously.

In the nineteenth century we have to remark two special conditions beside the survival of the past in the present. First, that the Indian culture was already decadent, that is to say, suffering from the inevitable consequences of all formulation. The formula, however admirable, is inherited rather than earned, it becomes an end instead of a means, and its meaning is forgotten, so that it is insecure. Secondly, political subjection coincided with the impact of the industrial revolution and of the dead weight of empirical science apprehended simply as the basis of economic success. All this implied a transvaluation of all values, in an arbitrary rather than a constructive sense—in the main a degradation of values and a diversion of energy compressing into half a century a process that has occupied five hundred years in Europe.

Let us emphasize again that the war is merely the evidence and not the cause of European chaos: there is immediate hope for Europe since he that is down need fear no fall. Western

civilization stands at the beginning of a new movement, and is not without renewed religious motivation. But India affords the most tragic spectacle of the world, since we see there a living and magnificent organization, akin to, but infinitely more complete than that of mediæval Europe, still in the process of destruction. Inheriting incalculable treasure, she is still incalculably poor, and most of all in the naiveté with which she boasts of the poverty that she regards as progress. One questions sometimes whether it would not be wiser to accelerate the process of destruction than to attempt to preserve the broken fragments of the great tradition.

It is hard to realize how completely the continuity of Indian life has been severed. A single generation of English education suffices to break the threads of tradition and to create a nondescript and superficial being deprived of all roots—a sort of intellectual pariah who does not belong to the East or the West, the past or the future. The greatest danger for India is the loss of her spiritual integrity. Of all Indian problems the educational is the most difficult and most tragic. As things now stand it is dominated by political considerations in the sense that loyalty is more essential than personality in a teacher—even university professors are subject to espionage and their activity to censorship: it is dominated by economic considerations, too, for the present system is really a vested interest in the hands of Macmillans and Longmans and the younger graduates of English universities, while the power of the missionary school is derived from the contributions of those who are interested much more in proselytizing than in education. In all government and missionary institutions there is the widest possible divergence between the ideals of the school and the ideals of the home: the teachers do not in one case in a hundred effect any real contact with their pupils, whatever they may believe to the contrary.

Modern pedagogic theory teaches us that the aim of education should be not so much the levelling up of faculties and the production of uniform types as the intensive cultivation of the faculties we have. Ruskin was never more right than when he said that education means finding out what people have tried to do, and helping them to do it better. There has been no "finding out" in India, but only a complete inversion of values. And what does this imply? From the home to the world, from the freedom of

the spirit it was the aim of every great Hindu to attain, from the great example of Bhīshma and Rāma, from the pursuit and acquisition of Yoga, from the celestial songs of Rādhā and Krishna, from the knowledge which is in unity to the knowledge of manifold things, this was a descent from the Himalayas to the plains.[1] It is true that this was inevitable. The English, in spite of Macaulay and Cramb, are not entirely to blame for it. A renunciation of what appears to be obsolete is justified; political and economic problems cannot be ignored; man and man's world are still to be explored: but with all that there has been too little love, too much of snobism, too indiscriminate a taste, and too little distaste, and now only the greatest souls by a supreme effort can achieve a synthesis of the past and the future.

In the midst of all these conditions we have seen the rise of Indian Nationalism, the growth of Young India. Fundamentally this has been a political movement covering a wide range of purposes, from those of the Moderates who desire to see a gradual progress towards colonial self-government, to those of the Extremists who would like to see the last Englishmen driven out of India at the earliest opportunity.

There is no question but that India has had and still has many just grievances, some inseparable from any foreign domination and some peculiar to the present situation. For example, Indians are excluded to a very large extent from the higher paid posts of the civil and educational service: while India is freely open to British economic exploitation, Indian settlers are arbitrarily excluded from other parts of the Empire. The system of police espionage and the searching of private houses, the censorship of private correspondence, the law against the possession of arms, the not infrequent imprisonment and even deportation of influential men without charge or trial, and particular measures such as the partition of Bengal are constant provocatives of a very natural resentment. The color prejudice is such that educated Indians are often insulted by Englishmen in railway trains and to all intents and purposes are excluded from English society. Many of these grievances depend immediately on the fact that India is never regarded by the Englishman as his home: a conquest resulting in the establishment of an English dynasty related

[1] Dinesh Chandra Sen. *History of Bengali Language and Literature.*

by marriage to the Indian aristocracy (however the latter might
have resented it), and identified with Indian interests, would
have involved far more vital integrations than now exist. This
was what happened in the case of the Mughals. As it is, the
sympathy between rulers and ruled and the common understand-
ing are admittedly less than was the case fifty years ago.

A large part of the Indian unrest is, of course, economic, and
due to the disturbance of settled conditions by industrial compe-
tition, and the impact of the era of technology upon an era of
handicraft. Conditions of this kind are not so much traceable
to foreign domination as to world-wide economic disorder. As
for the war, it can only be said to concern the Indians indirectly,
or rather, they are directly concerned only because of the political
association with Britain. It is interesting to note that two particu-
lar grievances have been remedied since the outbreak of the war:
the excise duty on cotton has been removed, and very recently,
Indians have been allowed to qualify as commissioned officers.
It is certain that far-reaching changes in the direction of self-
government will be made immediately after the war, and this
must result equally from the actual situation and from the prin-
ciples of freedom to which the Allies have declared their alle-
giance. It is, however, with a certain distaste that one is com-
pelled to enumerate these various grievances and to refer to the
inevitable resentments they must evoke: for Indian national
idealism has a wider significance than the redress of grievances.

Moderate nationalism has found expression not only in polit-
ical, but also in economic, social and educational activities. Eco-
nomically in the Swadeshi ('own-country') movement, which,
despite the heroic idealism of communities and individuals, in the
main represents a rather pathetic endeavour to 'get back' at
European trade, without much reference to the quality or desir-
ability of particular industries or the conditions of manufacture.
Indian economists are still or have remained until very recently
in the early Victorian stage, enthusiastic believers in factory pro-
duction and laissez-faire. Even in Western universities the
student is rarely brought in touch with current thought, and this
is still more true of universities in India. The Indian student has
little opportunity to realise that the accepted forms of European
thought are necessarily far behind its real development. Western
society is in process of such rapid change that it must be regarded

as tragic or ridiculous that the prestige of power should have provoked imitation: and this at the best implies provincialism, for sociological, like sartorial fashions, travel round the world at second hand long after they have been forgotten at their source. Creation or death.

Social endeavor has been in the nature of what is here known as "uplift," and has been especially directed to the elevation of the depressed classes, the reduction of caste institutionalism, and the "emancipation" of women. A recrudescence of puritanism, like a return to the early Buddhist fear of the world, but really of Christian missionary and bourgeois origin, and no better reasoned than similar movements in modern America, leads to the condemnation of exquisite national costumes as "indecent" and to absurd apologies for classic literature and art: and the dancer has been driven from the temple to the streets. We must class here also as Moderate activities such movements as are represented by the Bengal National College, the Fergusson College, Poona, the diffusion of popular education in Baroda, and part of the work of the Arya Samāj, and the Servants of India. The effects are meritorious rather than inspiring. Sometimes the genuine English educationalist, seeking to restore the Indian classics or vernaculars to their real place in Indian curricula, is met by the determined opposition of the Nationalists: and it is not without reason that Professor Patrick Geddes, who, I am glad to say, has been entrusted with the organization of the Hindu University at Benares[1] has remarked that it would be a mistake to allow the Europeanized Indian graduates to have their way with Indian education: "that would be continuing our mistake," as he says, "not correcting it."

There have been somewhat parallel developments in religion, typified in the eclecticism of the Brahmo Samāj—a sort of Unitarianism combining Hindu philosophy with Nonconformist ethics.

The keynote of most of these activities, as of the political programme of the National Congress and the Moderate press, is to be recognized in a complete acceptance of European models, and, indeed, of European sources of inspiration: they represent the just wish of Indians to do for themselves what is now done or left undone by others. But this is a somewhat uninspiring and

[1] Since writing this I learn with regret that this is no longer the case.

PLATE XXV

INDIAN PAINTING.

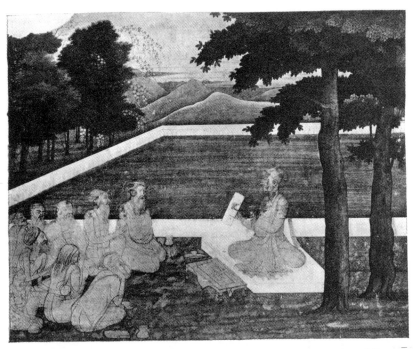

A School of Philosophy. Rajput painting, 18th century, Collection of the
author.

PLATE XXVI

"MERELY AN INHERITANCE."

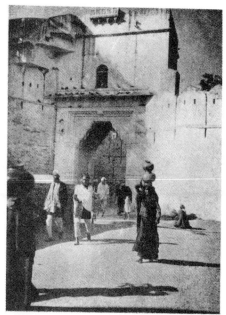

Figure a. One of the gates of Jaipur.
(Photograph by Mr. Thornton Oakley.)

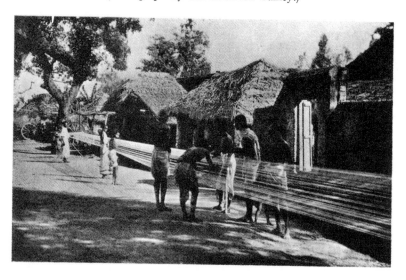

Figure b. Laying a warp in Madura.

insufficient programme, regarded from the standpoint of futurist Europeans, who expect from the East, not a repetition of their own mistakes, but a positive contribution to the solution of problems that face the whole world, and no longer merely a single race or continent.

The beauty and logic of Indian life belong to a dying past: the nineteenth century has degraded much and created nothing. If any blame for this is to be laid on alien shoulders, it should be only in the sense that if it must be that offences come, woe unto them through whom they come. It is an ungrateful and unromantic task to govern a subject race. England could not in any case have inspired a new life: the best she could have done would have been to understand and conserve through patronage and education the surviving categories of Indian civilization—architecture, music, handicrafts, popular and classic literature, and schools of philosophy—and that she failed here is to have been found wanting in imagination and sympathy. It should not have been regarded as the highest ideal of Empire "to give to all men an English mind."

If I speak now of the Idealists as distinguished from the Moderates, it is because they alone possess a genuine sense of the future. Needless to say, it is not the idealist who is "impatient": it is the opportunist who has not the patience to pursue a distant end. It should also be emphasized that there is never a hard and fast line separating the Idealist from the Moderate; these are types that may be combined in a single individual, and are almost always represented in any group. I also dismiss the questions of disloyalty and sedition as irrelevant for the present discussion: and as I have said elsewhere, loyalty is too often sentimentality or interest and disloyalty no more than irritation—if loyalty were always friendship and disloyalty detachment one could welcome either.

The first reaction of the idealist is recognizable in disillusion. He begins to see that people are not inspired or made happy by government but by themselves—he loses faith in politics, and turns to direct action, more often than otherwise, educational. He is no longer deceived by the prestige of European power—very often he has lived for many years in Europe or America, and has learnt to regard both "progress" and "civilization" with distaste and distrust. He begins to see things as they really are

and regards his Indian life no longer with disparagement, but
with a new understanding and affection. He begins to see that
life is an art, and is rather a means than an end.

The first expression of national idealism is then a rehabilita-
tion of the past. We have turned from the imitation of European
formulae to follow the historical development of our own beliefs,
our architecture, sculpture, music and literature, and of all the
institutions, social and religious, with which they are inseparably
intertwined; and to preserve and defend the Prolific against the
Devourers. This is fundamentally a process of creative intro-
spection preparatory to renewed activity.

It does not matter that the realization of what we have lost has
come too late: this was inevitable. For a moment, perhaps, we
desired to turn back the hands of the clock, but that was only
sentimentality, and it was not long before we remembered that
fresh waters are ever flowing in upon us. We have learnt that we
are exiled; but we would not and cannot return. In India, as in
Europe, the vestiges of ancient civilization must be renounced:
we are called from the past and must make our home in the future.
But to understand, to endorse with passionate conviction, and to
love what we have left behind us is the only possible foundation
for power. If the time has hardly yet come for the creation of
new values—and it cannot long be delayed—let us remember
that time and suffering are essential to all creation.

We see now springing up all over India societies of literary
or historical research or sociological experiment, and schools of
national education. In Bengal, for example, the Sāhitya Parishad
(library, MSS. and research), in the United Provinces the Nā-
garī Prachārinī Sabhā (Hindu texts and a great dictionary), in
Poona the Gayan Samāj (study and encouragement of pure
music), in Madura the Tamil Sangam (modelled after the old
Tamil literary academies), religious organizations such as the
Ārya Samāj (in part), the Rāmakrishna order, the Vivekānanda
societies, and the Theosophical society (in part): and the Bud-
dhist revival in Ceylon. There are signs of life even in the uni-
versities, though the most interesting development in this direc-
tion is the newly established Hindu University in Benares, which
gives at least an equal place to indigenous and to foreign learning.
A time must come and will come when Indian universities will
be once more places of pilgrimage for foreign students. Beside

this there are many individual Indian scholars publishing their results in association with European savants, with the Archæological Survey of India or through the various Asiatic societies or in separate volumes. Private collections of ancient works of art are being made and interest is taken in museums and the preservation of ancient monuments.

The inner meaning of most of these activities is to be found in the concept of National Education: a return to the aims of Oriental education in general, the development of personality rather than the mere acquisition of knowledge, and above all, a reunion of those links of understanding which have been so roughly broken: and to the end that we may see the last of those "educated" Indians who are Indian only in name. Up till now the sterility of higher education in India has been far more unfortunate than the absence of elementary literary education for the masses and for women. The latter have always possessed and have not yet lost, what the progressive amongst the men have lost, the incalculable advantage of familiarity through oral tradition with an epic literature vast in amount and saturated with a great philosophy. To some extent, indeed, India may be said to be now a land of cultivated peasants and uncultivated leaders —"Their ordinary Plowmen and Husbandmen," said Knox without exaggeration, "do speak elegantly and are full of compliment. And there is no difference between the ability and speech of a Countryman and a Courtier"—a fact which affords us a good deal of food for reflection.

Amongst the schools of national education two or three are of special importance: Sir Rabindranath Tagore's school at Bolpur, the Kālasāla at Masulipatam, and the Gurukula of the Ārya Samāj at Hardwar. In all these the mother-tongue is made the medium of instruction, and English takes a second though still very important place: there had been danger of creating an educated class unable to express itself perfectly in any language. The Gurukula, it has been said very truly, is perhaps the most fascinating educational experiment in the world. It is for boys of all castes, from the highest to the lowest, and no distinctions are made. Tuition is free and the teachers are unpaid. The first seven years are devoted entirely to Sanskrit, religion and physical culture, and the twelve years following to Western literature, science and laboratory work: at the age of twenty-five the man

is ready to go out into the world. During the whole of this time the pupils remain in charge of their teacher, without returning home, nor are they permitted to meet any women except their mothers. There are institutions for the education of girls on somewhat similar but less severe lines: since the marriage of spiritual equals is taken for granted in the foundations of Hindu society. The most conspicuous feature of the system is its return to the impersonal and philosophic concepts of culture which have always been characteristic of the East, and the combination of this ancient wisdom with modern and practical knowledge.

At the same time the return of idealism has brought with it a renewed appreciation of indigenous art and popular mythology, and has sought expression in creative activity. These matters have been closed books to the politicians and social reformers: even now there is perhaps no country in the world so completely lacking in cultivated and conscious taste as modern India, for as we have said, all that is so beautiful in the life that we see by riverside, in temples or homes, and in the streets, is merely an inheritance, and those who have been mis-educated would gladly exchange it all for the cheapest commercial art of Western stores and music halls and for the villa architecture of a London suburb.

There has been a revival of painting in Bengal, inspired by Abanindronath Tagore and his brother, nephews of the well known poet. But important as this movement has been, its main significance belongs to appreciation rather than production. It may be compared rather to the work of the pre-Raphaelites than to that of the great post-Impressionists—the time for these has not yet arrived. It has proved impossible for those who have not seen the ancient gods to represent them: and the powers to be are not yet seen or heard, only the movement of their dance is faintly felt.

But for the great idealists of younger India, nationalism is not enough. Patriotism is parochial, and even banal, and there are finer parts great souls may play. Certainly not as missionaries or propagandists—the day has gone by for sectarian groupings and for invitations to be "one of us": but as equally concerned with all others in the exploration of the thousand paths that have never yet been trodden. It is life, and not merely Indian life that claims our loyalty. The pursuit of mere liberty is not enough: it is not

PLATE XXVII

"MERELY AN INHERITANCE."

The Bathing Ghat at Benares.

his happiness, but his task that concerns the idealist.' For those who pursue a distant end there is no time to devote to what is momentary.

Freedom is always open to those who are free. And free for what? For the very same ends that are foreseen by the idealists of Europe: how could there be a divergence of idealism from idealism? The chosen people of the future cannot be any nation or race, but an aristocracy of the earth uniting the virility of European youth to the serenity of Asiatic age. Already the leaders of thought in every nation understand each other very well, and all significant movements are international and world-wide—as has always been the case to a greater extent than we are apt to realize. We only await the declaration of peace to renew our camaraderie with the other idealists, and meanwhile we will not betray our common cause. The flowering of humanity is more to us than the victory of any party. The only condition of a renewal of life in India, or elsewhere, should be a spiritual, not merely an economic and political awakening, and it is on this ground alone that it will ever be possible to bridge the gulf which has been supposed to divide the East from the West.

To the idealist all interests are identical because all life is one. The only and real significance of Young India for the world will be revealed in the great men who are given to the common life: one great philosopher, poet, painter, scientist or singer shall be accounted in the last judgment more than all the concessions won by all the Congresses in a hundred years.

And so while India is occupied with national education and social reconstruction at home, she must also throw in her lot with the world: what we need for the creation of a common civilization is the recognition of common problems, and to coöperate in their solution.

Meanwhile it is not sufficient for the Western world to stand aside from the development of Asia, with idle curiosity or apprehension wondering what will happen next. There is serious danger that the degradation of Asia will ultimately menace the security of European social idealism, for the standing of idealism is even more precarious in modern Asia than in modern Europe: and that would be a strange nemesis if European post-Industrialists should utimately be defeated by an Industrialism or Imperialism of European origin established in the East!

Asia is like the artist in the modern city—doing nothing great, mainly because nothing heroic is demanded of him: it is enough if he pleases and amuses us, we do not take him seriously. It is with something of this romantic attitude that Europe and America have regarded India. The merely philological studies of the universities have been conducted in such an arid fashion as to be comparatively inaccessible to artistic spirits: on the other hand, Indian thought has been popularized and perverted in many forms that are vague, mysterious, and feminine, and so brought into disrepute. What is really needed is a point of view which is practical, rather than scholastic or sentimental: some power to grasp what is essential, disentangled by clear thinking from a mass of incorrect assumptions. The challenge of the East is very precise: To what end is your life? Without an answer to this question there may indeed be change, but progress is impossible; for without a sense of direction, who knows if we do not return upon our footsteps in everlasting circles? I conclude then with this reminder: that the future of India depends as much upon what is asked of her as upon what she is.

INDIVIDUALITY, AUTONOMY
AND FUNCTION[1]

The object of government is to make the governed behave as
the governors wish. This is true of 'good' and 'bad' govern-
ment alike, and alike of the rule of a conqueror, of a hereditary
monarchy and of majority government by representation.

The repudiation of tyranny must ultimately involve a repudia-
tion of majority rule. Consider a community of five. It is im-
possible to deny that the rule of three, in so far as it affects the
other two, is as much an arbitrary constraint as the rule of one
affecting the other four. It is very liable to be less intelligent.
In any case, however, the rule of three becomes, on the basis
of votes, a rule of two: and a majority government will mean
the rule of two over three.

Inasmuch, however, as each of the five is unique, and 'one
law for the lion and the ox is oppression,' there can be no
entirely just solution outside the autonomy of each. This, which is
widely admitted to be true for nations, is no less true for
individuals.

From an existing tyranny it is possible to arrive at an indi-
vidual autonomy in two ways. In the first place four of the five
may revolt against the arbitrary rule of the one, setting up in
place of it the rule of the majority. The remaining two may
then assert their 'right' of self-determination as against the major-
ity. Ultimately each of the five will become autonomous: each, as
it were, sitting armed in his own house, prepared to repel the
intruder. This may be described as a disintegration sanctioned
by the presumed diversity of interests which a pluralistic philoso-
phy must assert.

Since, however, each still desires to govern (to feel it one's
'duty' to govern is only the same thing in other words), and
nothing prevents the exercise of governing powers but fear of
resistance, the desire will be translated into action as soon as
opportunity affords: and one, or a group of two, three, or four
of the five must be regarded as merely awaiting (consciously or

[1] *Sva-bhāva, sva-rājya, sva-dharma.*

unconsciously) the favorable moment. In the meantime co-operation for common ends is excluded by mutual suspicion: each of the five will have to exercise all of the functions necessary to the existence of an individual, and only a fraction of the activity of each will be vocational. This is the inevitable conse-quence of resistance, and of that sort of desire to take part in government which finds expression in the demand for votes.

The anarchy approached by self-assertion, however justified, is therefore the anarchy of chaos: resistance, however inevitable, can of itself only create an unstable equilibrium, which must tend to reconstitute the *status quo ante*.

The second approach to individual autonomy is through renun-ciation—a repudiation of the will to govern. As we are speaking in terms of time, we must conceive of this idea as originating with one of the five, and spreading to the others. Let us, how-ever, ignore the transition period, and suppose that the idea of government has become, for each of the five, even more distaste-ful than the idea of being governed.

In this situation there is nothing to prevent a recognition of common interests, or co-operation to achieve them (co-operation is not government). This will be an integration founded on the presumed identity of all interests which a monistic philosophy must assert. Neither of the five will expect to receive from any of the others something for nothing: but the principle of mutual aid or co-operation will permit each one to fulfil his own function. Activity will be vocational, that is to say, willing.

The anarchy approached by renunciation is thus an anarchy of spontaneity: only a renunciation of the will to govern could create a stable equilibrium. Everyone who believes in the self-determination of national groups is to that extent an anarchist. And while we must acknowledge that a state of entire liberty can never be attained, because the will to govern can never be totally eradicated, nevertheless it can be shown that activity based on anarchic principles may be and often is far more immediately and practically effective than an activity of control. Contrast, for example, the result of granting a large measure of autonomy to the Boers with the consequences of withholding it in Ireland.

"The last ideal of a future state," says Dmitri Merezhkovski, "can only consist in the creation of new religious forms of thought and affairs; a new religious synthesis between the in-

dividual and society, composed of unending love and unending liberty." Far be it from me to assert that such a millennium could ever be realised. But *he who knows not whither he saileth knows not which is a fair or a foul wind for him.* It cannot be unwise to shape our course towards the desired haven. So much, at least, is possible to every individual: and only he is an individualist in truth, who does not will to govern any other than himself.

The 'will to govern' must not be confused with the 'will to power.' The will to govern is the will to govern others: the will to power is the will to govern oneself.

Those who would be free should have the will to power without the will to govern. If such as these are chosen to advise the executive, which cannot be entirely dispensed with, this should tend to the greatest degree of freedom and justice practically possible.

A CATALOG OF SELECTED

DOVER BOOKS

IN ALL FIELDS OF INTEREST

A CATALOG OF SELECTED DOVER

BOOKS IN ALL FIELDS OF INTEREST

DRAWINGS OF REMBRANDT, edited by Seymour Slive. Updated Lippmann, Hofstede de Groot edition, with definitive scholarly apparatus. All portraits, biblical sketches, landscapes, nudes. Oriental figures, classical studies, together with selection of work by followers. 550 illustrations. Total of 630pp. 9⅛ × 12¼.
21485-0, 21486-9 Pa., Two-vol. set $25.00

GHOST AND HORROR STORIES OF AMBROSE BIERCE, Ambrose Bierce. 24 tales vividly imagined, strangely prophetic, and decades ahead of their time in technical skill: "The Damned Thing," "An Inhabitant of Carcosa," "The Eyes of the Panther," "Moxon's Master," and 20 more. 199pp. 5⅜ × 8½. 20767-6 Pa. $3.95

ETHICAL WRITINGS OF MAIMONIDES, Maimonides. Most significant ethical works of great medieval sage, newly translated for utmost precision, readability. Laws Concerning Character Traits, Eight Chapters, more. 192pp. 5⅜ × 8½.
24522-5 Pa. $4.50

THE EXPLORATION OF THE COLORADO RIVER AND ITS CANYONS, J. W. Powell. Full text of Powell's 1,000-mile expedition down the fabled Colorado in 1869. Superb account of terrain, geology, vegetation, Indians, famine, mutiny, treacherous rapids, mighty canyons, during exploration of last unknown part of continental U.S. 400pp. 5⅜ × 8½. 20094-9 Pa. $6.95

HISTORY OF PHILOSOPHY, Julián Marías. Clearest one-volume history on the market. Every major philosopher and dozens of others, to Existentialism and later. 505pp. 5⅜ × 8½. 21739-6 Pa. $8.50

ALL ABOUT LIGHTNING, Martin A. Uman. Highly readable non-technical survey of nature and causes of lightning, thunderstorms, ball lightning, St. Elmo's Fire, much more. Illustrated. 192pp. 5⅜ × 8½. 25237-X Pa. $5.95

SAILING ALONE AROUND THE WORLD, Captain Joshua Slocum. First man to sail around the world, alone, in small boat. One of great feats of seamanship told in delightful manner. 67 illustrations. 294pp. 5⅜ × 8½. 20326-3 Pa. $4.95

LETTERS AND NOTES ON THE MANNERS, CUSTOMS AND CONDITIONS OF THE NORTH AMERICAN INDIANS, George Catlin. Classic account of life among Plains Indians: ceremonies, hunt, warfare, etc. 312 plates. 572pp. of text. 6⅛ × 9¼. 22118-0, 22119-9 Pa. Two-vol. set $15.90

ALASKA: The Harriman Expedition, 1899, John Burroughs, John Muir, et al. Informative, engrossing accounts of two-month, 9,000-mile expedition. Native peoples, wildlife, forests, geography, salmon industry, glaciers, more. Profusely illustrated. 240 black-and-white line drawings. 124 black-and-white photographs. 3 maps. Index. 576pp. 5⅜ × 8½. 25109-8 Pa. $11.95

CATALOG OF DOVER BOOKS

THE BOOK OF BEASTS: Being a Translation from a Latin Bestiary of the Twelfth Century, T. H. White. Wonderful catalog real and fanciful beasts: manticore, griffin, phoenix, amphivius, jaculus, many more. White's witty erudite commentary on scientific, historical aspects. Fascinating glimpse of medieval mind. Illustrated. 296pp. 5⅜ × 8¼. (Available in U.S. only) 24609-4 Pa. $5.95

FRANK LLOYD WRIGHT: ARCHITECTURE AND NATURE With 160 Illustrations, Donald Hoffmann. Profusely illustrated study of influence of nature—especially prairie—on Wright's designs for Fallingwater, Robie House, Guggenheim Museum, other masterpieces. 96pp. 9¼ × 10¾. 25098-9 Pa. $7.95

FRANK LLOYD WRIGHT'S FALLINGWATER, Donald Hoffmann. Wright's famous waterfall house: planning and construction of organic idea. History of site, owners, Wright's personal involvement. Photographs of various stages of building. Preface by Edgar Kaufmann, Jr. 100 illustrations. 112pp. 9¼ × 10.
23671-4 Pa. $7.95

YEARS WITH FRANK LLOYD WRIGHT: Apprentice to Genius, Edgar Tafel. Insightful memoir by a former apprentice presents a revealing portrait of Wright the man, the inspired teacher, the greatest American architect. 372 black-and-white illustrations. Preface. Index. vi + 228pp. 8¼ × 11. 24801-1 Pa. $9.95

THE STORY OF KING ARTHUR AND HIS KNIGHTS, Howard Pyle. Enchanting version of King Arthur fable has delighted generations with imaginative narratives of exciting adventures and unforgettable illustrations by the author. 41 illustrations. xviii + 313pp. 6⅛ × 9¼. 21445-1 Pa. $6.50

THE GODS OF THE EGYPTIANS, E. A. Wallis Budge. Thorough coverage of numerous gods of ancient Egypt by foremost Egyptologist. Information on evolution of cults, rites and gods; the cult of Osiris; the Book of the Dead and its rites; the sacred animals and birds; Heaven and Hell; and more. 956pp. 6⅛ × 9¼.
22055-9, 22056-7 Pa., Two-vol. set $20.00

A THEOLOGICO-POLITICAL TREATISE, Benedict Spinoza. Also contains unfinished *Political Treatise*. Great classic on religious liberty, theory of government on common consent. R. Elwes translation. Total of 421pp. 5⅜ × 8½.
20249-6 Pa. $6.95

INCIDENTS OF TRAVEL IN CENTRAL AMERICA, CHIAPAS, AND YUCATAN, John L. Stephens. Almost single-handed discovery of Maya culture; exploration of ruined cities, monuments, temples; customs of Indians. 115 drawings. 892pp. 5⅜ × 8½. 22404-X, 22405-8 Pa., Two-vol. set $15.90

LOS CAPRICHOS, Francisco Goya. 80 plates of wild, grotesque monsters and caricatures. Prado manuscript included. 183pp. 6⅜ × 9⅜. 22384-1 Pa. $4.95

AUTOBIOGRAPHY: The Story of My Experiments with Truth, Mohandas K. Gandhi. Not hagiography, but Gandhi in his own words. Boyhood, legal studies, purification, the growth of the Satyagraha (nonviolent protest) movement. Critical, inspiring work of the man who freed India. 480pp. 5⅜ × 8½. (Available in U.S. only)
24593-4 Pa. $6.95

ILLUSTRATED DICTIONARY OF HISTORIC ARCHITECTURE, edited by Cyril M. Harris. Extraordinary compendium of clear, concise definitions for over 5,000 important architectural terms complemented by over 2,000 line drawings. Covers full spectrum of architecture from ancient ruins to 20th-century Modernism. Preface. 592pp. 7½ × 9⅝. 24444-X Pa. $14.95

THE NIGHT BEFORE CHRISTMAS, Clement Moore. Full text, and woodcuts from original 1848 book. Also critical, historical material. 19 illustrations. 40pp. 4⅝ × 6. 22797-9 Pa. $2.25

THE LESSON OF JAPANESE ARCHITECTURE: 165 Photographs, Jiro Harada. Memorable gallery of 165 photographs taken in the 1930's of exquisite Japanese homes of the well-to-do and historic buildings. 13 line diagrams. 192pp. 8⅞ × 11¼. 24778-3 Pa. $8.95

THE AUTOBIOGRAPHY OF CHARLES DARWIN AND SELECTED LETTERS, edited by Francis Darwin. The fascinating life of eccentric genius composed of an intimate memoir by Darwin (intended for his children); commentary by his son, Francis; hundreds of fragments from notebooks, journals, papers; and letters to and from Lyell, Hooker, Huxley, Wallace and Henslow. xi + 365pp. 5⅜ × 8. 20479-0 Pa. $6.95

WONDERS OF THE SKY: Observing Rainbows, Comets, Eclipses, the Stars and Other Phenomena, Fred Schaaf. Charming, easy-to-read poetic guide to all manner of celestial events visible to the naked eye. Mock suns, glories, Belt of Venus, more. Illustrated. 299pp. 5¼ × 8¼. 24402-4 Pa. $7.95

BURNHAM'S CELESTIAL HANDBOOK, Robert Burnham, Jr. Thorough guide to the stars beyond our solar system. Exhaustive treatment. Alphabetical by constellation: Andromeda to Cetus in Vol. 1; Chamaeleon to Orion in Vol. 2; and Pavo to Vulpecula in Vol. 3. Hundreds of illustrations. Index in Vol. 3. 2,000pp. 6⅛ × 9¼. 23567-X, 23568-8, 23673-0 Pa., Three-vol. set $38.85

STAR NAMES: Their Lore and Meaning, Richard Hinckley Allen. Fascinating history of names various cultures have given to constellations and literary and folkloristic uses that have been made of stars. Indexes to subjects. Arabic and Greek names. Biblical references. Bibliography. 563pp. 5⅜ × 8½. 21079-0 Pa. $7.95

THIRTY YEARS THAT SHOOK PHYSICS: The Story of Quantum Theory, George Gamow. Lucid, accessible introduction to influential theory of energy and matter. Careful explanations of Dirac's anti-particles, Bohr's model of the atom, much more. 12 plates. Numerous drawings. 240pp. 5⅜ × 8½. 24895-X Pa. $4.95

CHINESE DOMESTIC FURNITURE IN PHOTOGRAPHS AND MEASURED DRAWINGS, Gustav Ecke. A rare volume, now affordably priced for antique collectors, furniture buffs and art historians. Detailed review of styles ranging from early Shang to late Ming. Unabridged republication. 161 black-and-white drawings, photos. Total of 224pp. 8⅞ × 11¼. (Available in U.S. only) 25171-3 Pa. $12.95

VINCENT VAN GOGH: A Biography, Julius Meier-Graefe. Dynamic, penetrating study of artist's life, relationship with brother, Theo, painting techniques, travels, more. Readable, engrossing. 160pp. 5⅜ × 8½. (Available in U.S. only) 25253-1 Pa. $3.95

HOW TO WRITE, Gertrude Stein. Gertrude Stein claimed anyone could understand her unconventional writing—here are clues to help. Fascinating improvisations, language experiments, explanations illuminate Stein's craft and the art of writing. Total of 414pp. 4⅝ × 6⅜. 23144-5 Pa. $5.95

ADVENTURES AT SEA IN THE GREAT AGE OF SAIL: Five Firsthand Narratives, edited by Elliot Snow. Rare true accounts of exploration, whaling, shipwreck, fierce natives, trade, shipboard life, more. 33 illustrations. Introduction. 353pp. 5⅜ × 8½. 25177-2 Pa. $7.95

THE HERBAL OR GENERAL HISTORY OF PLANTS, John Gerard. Classic descriptions of about 2,850 plants—with over 2,700 illustrations—includes Latin and English names, physical descriptions, varieties, time and place of growth, more. 2,706 illustrations. xlv + 1,678pp. 8½ × 12¼. 23147-X Cloth. $75.00

DOROTHY AND THE WIZARD IN OZ, L. Frank Baum. Dorothy and the Wizard visit the center of the Earth, where people are vegetables, glass houses grow and Oz characters reappear. Classic sequel to *Wizard of Oz*. 256pp. 5⅜ × 8. 24714-7 Pa. $4.95

SONGS OF EXPERIENCE: Facsimile Reproduction with 26 Plates in Full Color, William Blake. This facsimile of Blake's original "Illuminated Book" reproduces 26 full-color plates from a rare 1826 edition. Includes "The Tyger," "London," "Holy Thursday," and other immortal poems. 26 color plates. Printed text of poems. 48pp. 5¼ × 7. 24636-1 Pa. $3.50

SONGS OF INNOCENCE, William Blake. The first and most popular of Blake's famous "Illuminated Books," in a facsimile edition reproducing all 31 brightly colored plates. Additional printed text of each poem. 64pp. 5¼ × 7. 22764-2 Pa. $3.50

PRECIOUS STONES, Max Bauer. Classic, thorough study of diamonds, rubies, emeralds, garnets, etc.: physical character, occurrence, properties, use, similar topics. 20 plates, 8 in color. 94 figures. 659pp. 6⅛ × 9¼. 21910-0, 21911-9 Pa., Two-vol. set $15.90

ENCYCLOPEDIA OF VICTORIAN NEEDLEWORK, S. F. A. Caulfeild and Blanche Saward. Full, precise descriptions of stitches, techniques for dozens of needlecrafts—most exhaustive reference of its kind. Over 800 figures. Total of 679pp. 8⅛ × 11. Two volumes. Vol. 1 22800-2 Pa. $11.95
Vol. 2 22801-0 Pa. $11.95

THE MARVELOUS LAND OF OZ, L. Frank Baum. Second Oz book, the Scarecrow and Tin Woodman are back with hero named Tip, Oz magic. 136 illustrations. 287pp. 5⅜ × 8½. 20692-0 Pa. $5.95

WILD FOWL DECOYS, Joel Barber. Basic book on the subject, by foremost authority and collector. Reveals history of decoy making and rigging, place in American culture, different kinds of decoys, how to make them, and how to use them. 140 plates. 156pp. 7⅞ × 10¾. 20011-6 Pa. $8.95

HISTORY OF LACE, Mrs. Bury Palliser. Definitive, profusely illustrated chronicle of lace from earliest times to late 19th century. Laces of Italy, Greece, England, France, Belgium, etc. Landmark of needlework scholarship. 266 illustrations. 672pp. 6⅛ × 9¼. 24742-2 Pa. $14.95

ILLUSTRATED GUIDE TO SHAKER FURNITURE, Robert Meader. All furniture and appurtenances, with much on unknown local styles. 235 photos. 146pp. 9 × 12. 22819-3 Pa. $7.95

WHALE SHIPS AND WHALING: A Pictorial Survey, George Francis Dow. Over 200 vintage engravings, drawings, photographs of barks, brigs, cutters, other vessels. Also harpoons, lances, whaling guns, many other artifacts. Comprehensive text by foremost authority. 207 black-and-white illustrations. 288pp. 6 × 9. 24808-9 Pa. $8.95

THE BERTRAMS, Anthony Trollope. Powerful portrayal of blind self-will and thwarted ambition includes one of Trollope's most heartrending love stories. 497pp. 5⅜ × 8½. 25119-5 Pa. $8.95

ADVENTURES WITH A HAND LENS, Richard Headstrom. Clearly written guide to observing and studying flowers and grasses, fish scales, moth and insect wings, egg cases, buds, feathers, seeds, leaf scars, moss, molds, ferns, common crystals, etc.—all with an ordinary, inexpensive magnifying glass. 209 exact line drawings aid in your discoveries. 220pp. 5⅜ × 8½. 23330-8 Pa. $3.95

RODIN ON ART AND ARTISTS, Auguste Rodin. Great sculptor's candid, wide-ranging comments on meaning of art; great artists; relation of sculpture to poetry, painting, music; philosophy of life, more. 76 superb black-and-white illustrations of Rodin's sculpture, drawings and prints. 119pp. 8⅜ × 11¼. 24487-3 Pa. $6.95

FIFTY CLASSIC FRENCH FILMS, 1912–1982: A Pictorial Record, Anthony Slide. Memorable stills from Grand Illusion, Beauty and the Beast, Hiroshima, Mon Amour, many more. Credits, plot synopses, reviews, etc. 160pp. 8¼ × 11. 25256-6 Pa. $11.95

THE PRINCIPLES OF PSYCHOLOGY, William James. Famous long course complete, unabridged. Stream of thought, time perception, memory, experimental methods; great work decades ahead of its time. 94 figures. 1,391pp. 5⅜ × 8½. 20381-6, 20382-4 Pa., Two-vol. set $19.90

BODIES IN A BOOKSHOP, R. T. Campbell. Challenging mystery of blackmail and murder with ingenious plot and superbly drawn characters. In the best tradition of British suspense fiction. 192pp. 5⅜ × 8½. 24720-1 Pa. $3.95

CALLAS: PORTRAIT OF A PRIMA DONNA, George Jellinek. Renowned commentator on the musical scene chronicles incredible career and life of the most controversial, fascinating, influential operatic personality of our time. 64 black-and-white photographs. 416pp. 5⅜ × 8¼. 25047-4 Pa. $7.95

GEOMETRY, RELATIVITY AND THE FOURTH DIMENSION, Rudolph Rucker. Exposition of fourth dimension, concepts of relativity as Flatland characters continue adventures. Popular, easily followed yet accurate, profound. 141 illustrations. 133pp. 5⅜ × 8½. 23400-2 Pa. $3.95

HOUSEHOLD STORIES BY THE BROTHERS GRIMM, with pictures by Walter Crane. 53 classic stories—Rumpelstiltskin, Rapunzel, Hansel and Gretel, the Fisherman and his Wife, Snow White, Tom Thumb, Sleeping Beauty, Cinderella, and so much more—lavishly illustrated with original 19th century drawings. 114 illustrations. x + 269pp. 5⅜ × 8½. 21080-4 Pa. $4.50

SUNDIALS, Albert Waugh. Far and away the best, most thorough coverage of ideas, mathematics concerned, types, construction, adjusting anywhere. Over 100 illustrations. 230pp. 5⅜ × 8½. 22947-5 Pa. $4.50

PICTURE HISTORY OF THE NORMANDIE: With 190 Illustrations, Frank O. Braynard. Full story of legendary French ocean liner: Art Deco interiors, design innovations, furnishings, celebrities, maiden voyage, tragic fire, much more. Extensive text. 144pp. 8⅞ × 11¾. 25257-4 Pa. $9.95

THE FIRST AMERICAN COOKBOOK: A Facsimile of "American Cookery," 1796, Amelia Simmons. Facsimile of the first American-written cookbook published in the United States contains authentic recipes for colonial favorites—pumpkin pudding, winter squash pudding, spruce beer, Indian slapjacks, and more. Introductory Essay and Glossary of colonial cooking terms. 80pp. 5⅜ × 8½. 24710-4 Pa. $3.50

101 PUZZLES IN THOUGHT AND LOGIC, C. R. Wylie, Jr. Solve murders and robberies, find out which fishermen are liars, how a blind man could possibly identify a color—purely by your own reasoning! 107pp. 5⅜ × 8½. 20367-0 Pa. $2.50

THE BOOK OF WORLD-FAMOUS MUSIC—CLASSICAL, POPULAR AND FOLK, James J. Fuld. Revised and enlarged republication of landmark work in musico-bibliography. Full information about nearly 1,000 songs and compositions including first lines of music and lyrics. New supplement. Index. 800pp. 5⅜ × 8¼. 24857-7 Pa. $14.95

ANTHROPOLOGY AND MODERN LIFE, Franz Boas. Great anthropologist's classic treatise on race and culture. Introduction by Ruth Bunzel. Only inexpensive paperback edition. 255pp. 5⅜ × 8½. 25245-0 Pa. $5.95

THE TALE OF PETER RABBIT, Beatrix Potter. The inimitable Peter's terrifying adventure in Mr. McGregor's garden, with all 27 wonderful, full-color Potter illustrations. 55pp. 4¼ × 5½. (Available in U.S. only) 22827-4 Pa. $1.75

THREE PROPHETIC SCIENCE FICTION NOVELS, H. G. Wells. *When the Sleeper Wakes, A Story of the Days to Come* and *The Time Machine* (full version). 335pp. 5⅜ × 8½. (Available in U.S. only) 20605-X Pa. $5.95

APICIUS COOKERY AND DINING IN IMPERIAL ROME, edited and translated by Joseph Dommers Vehling. Oldest known cookbook in existence offers readers a clear picture of what foods Romans ate, how they prepared them, etc. 49 illustrations. 301pp. 6⅛ × 9¼. 23563-7 Pa. $6.50

SHAKESPEARE LEXICON AND QUOTATION DICTIONARY, Alexander Schmidt. Full definitions, locations, shades of meaning of every word in plays and poems. More than 50,000 exact quotations. 1,485pp. 6½ × 9¼. 22726-X, 22727-8 Pa., Two-vol. set $27.90

THE WORLD'S GREAT SPEECHES, edited by Lewis Copeland and Lawrence W. Lamm. Vast collection of 278 speeches from Greeks to 1970. Powerful and effective models; unique look at history. 842pp. 5⅜ × 8½. 20468-5 Pa. $11.95

THE BLUE FAIRY BOOK, Andrew Lang. The first, most famous collection, with many familiar tales: Little Red Riding Hood, Aladdin and the Wonderful Lamp, Puss in Boots, Sleeping Beauty, Hansel and Gretel, Rumpelstiltskin; 37 in all. 138 illustrations. 390pp. 5⅜ × 8½. 21437-0 Pa. $5.95

THE STORY OF THE CHAMPIONS OF THE ROUND TABLE, Howard Pyle. Sir Launcelot, Sir Tristram and Sir Percival in spirited adventures of love and triumph retold in Pyle's inimitable style. 50 drawings, 31 full-page. xviii + 329pp. 6½ × 9¼. 21883-X Pa. $6.95

AUDUBON AND HIS JOURNALS, Maria Audubon. Unmatched two-volume portrait of the great artist, naturalist and author contains his journals, an excellent biography by his granddaughter, expert annotations by the noted ornithologist, Dr. Elliott Coues, and 37 superb illustrations. Total of 1,200pp. 5⅜ × 8.
Vol. I 25143-8 Pa. $8.95
Vol. II 25144-6 Pa. $8.95

GREAT DINOSAUR HUNTERS AND THEIR DISCOVERIES, Edwin H. Colbert. Fascinating, lavishly illustrated chronicle of dinosaur research, 1820's to 1960. Achievements of Cope, Marsh, Brown, Buckland, Mantell, Huxley, many others. 384pp. 5¼ × 8¼. 24701-5 Pa. $6.95

THE TASTEMAKERS, Russell Lynes. Informal, illustrated social history of American taste 1850's–1950's. First popularized categories Highbrow, Lowbrow, Middlebrow. 129 illustrations. New (1979) afterword. 384pp. 6 × 9. 23993-4 Pa. $6.95

DOUBLE CROSS PURPOSES, Ronald A. Knox. A treasure hunt in the Scottish Highlands, an old map, unidentified corpse, surprise discoveries keep reader guessing in this cleverly intricate tale of financial skullduggery. 2 black-and-white maps. 320pp. 5⅜ × 8½. (Available in U.S. only) 25032-6 Pa. $5.95

AUTHENTIC VICTORIAN DECORATION AND ORNAMENTATION IN FULL COLOR: 46 Plates from "Studies in Design," Christopher Dresser. Superb full-color lithographs reproduced from rare original portfolio of a major Victorian designer. 48pp. 9¼ × 12¼. 25083-0 Pa. $7.95

PRIMITIVE ART, Franz Boas. Remains the best text ever prepared on subject, thoroughly discussing Indian, African, Asian, Australian, and, especially, Northern American primitive art. Over 950 illustrations show ceramics, masks, totem poles, weapons, textiles, paintings, much more. 376pp. 5⅜ × 8. 20025-6 Pa. $6.95

SIDELIGHTS ON RELATIVITY, Albert Einstein. Unabridged republication of two lectures delivered by the great physicist in 1920–21. *Ether and Relativity* and *Geometry and Experience*. Elegant ideas in non-mathematical form, accessible to intelligent layman. vi + 56pp. 5⅜ × 8½. 24511-X Pa. $2.95

THE WIT AND HUMOR OF OSCAR WILDE, edited by Alvin Redman. More than 1,000 ripostes, paradoxes, wisecracks: Work is the curse of the drinking classes, I can resist everything except temptation, etc. 258pp. 5⅜ × 8½. 20602-5 Pa. $4.50

ADVENTURES WITH A MICROSCOPE, Richard Headstrom. 59 adventures with clothing fibers, protozoa, ferns and lichens, roots and leaves, much more. 142 illustrations. 232pp. 5⅜ × 8½. 23471-1 Pa. $3.95

PLANTS OF THE BIBLE, Harold N. Moldenke and Alma L. Moldenke. Standard reference to all 230 plants mentioned in Scriptures. Latin name, biblical reference, uses, modern identity, much more. Unsurpassed encyclopedic resource for scholars, botanists, nature lovers, students of Bible. Bibliography. Indexes. 123 black-and-white illustrations. 384pp. 6 × 9. 25069-5 Pa. $8.95

FAMOUS AMERICAN WOMEN: A Biographical Dictionary from Colonial Times to the Present, Robert McHenry, ed. From Pocahontas to Rosa Parks, 1,035 distinguished American women documented in separate biographical entries. Accurate, up-to-date data, numerous categories, spans 400 years. Indices. 493pp. 6½ × 9¼. 24523-3 Pa. $9.95

THE FABULOUS INTERIORS OF THE GREAT OCEAN LINERS IN HISTORIC PHOTOGRAPHS, William H. Miller, Jr. Some 200 superb photographs capture exquisite interiors of world's great "floating palaces"—1890's to 1980's: *Titanic, Ile de France, Queen Elizabeth, United States, Europa,* more. Approx. 200 black-and-white photographs. Captions. Text. Introduction. 160pp. 8⅜ × 11¼. 24756-2 Pa. $9.95

THE GREAT LUXURY LINERS, 1927-1954: A Photographic Record, William H. Miller, Jr. Nostalgic tribute to heyday of ocean liners. 186 photos of Ile de France, Normandie, Leviathan, Queen Elizabeth, United States, many others. Interior and exterior views. Introduction. Captions. 160pp. 9 × 12. 24056-8 Pa. $9.95

A NATURAL HISTORY OF THE DUCKS, John Charles Phillips. Great landmark of ornithology offers complete detailed coverage of nearly 200 species and subspecies of ducks: gadwall, sheldrake, merganser, pintail, many more. 74 full-color plates, 102 black-and-white. Bibliography. Total of 1,920pp. 8⅜ × 11¼. 25141-1, 25142-X Cloth. Two-vol. set $100.00

THE SEAWEED HANDBOOK: An Illustrated Guide to Seaweeds from North Carolina to Canada, Thomas F. Lee. Concise reference covers 78 species. Scientific and common names, habitat, distribution, more. Finding keys for easy identification. 224pp. 5⅜ × 8½. 25215-9 Pa. $5.95

THE TEN BOOKS OF ARCHITECTURE: The 1755 Leoni Edition, Leon Battista Alberti. Rare classic helped introduce the glories of ancient architecture to the Renaissance. 68 black-and-white plates. 336pp. 8⅜ × 11¼. 25239-6 Pa. $14.95

MISS MACKENZIE, Anthony Trollope. Minor masterpieces by Victorian master unmasks many truths about life in 19th-century England. First inexpensive edition in years. 392pp. 5⅜ × 8½. 25201-9 Pa. $7.95

THE RIME OF THE ANCIENT MARINER, Gustave Doré, Samuel Taylor Coleridge. Dramatic engravings considered by many to be his greatest work. The terrifying space of the open sea, the storms and whirlpools of an unknown ocean, the ice of Antarctica, more—all rendered in a powerful, chilling manner. Full text. 38 plates. 77pp. 9¼ × 12. 22305-1 Pa. $4.95

THE EXPEDITIONS OF ZEBULON MONTGOMERY PIKE, Zebulon Montgomery Pike. Fascinating first-hand accounts (1805-6) of exploration of Mississippi River, Indian wars, capture by Spanish dragoons, much more. 1,088pp. 5⅜ × 8½. 25254-X, 25255-8 Pa. Two-vol. set $23.90

A CONCISE HISTORY OF PHOTOGRAPHY: Third Revised Edition, Helmut Gernsheim. Best one-volume history—camera obscura, photochemistry, daguerreotypes, evolution of cameras, film, more. Also artistic aspects—landscape, portraits, fine art, etc. 281 black-and-white photographs. 26 in color. 176pp. 8⅜ × 11¼. 25128-4 Pa. $12.95

THE DORÉ BIBLE ILLUSTRATIONS, Gustave Doré. 241 detailed plates from the Bible: the Creation scenes, Adam and Eve, Flood, Babylon, battle sequences, life of Jesus, etc. Each plate is accompanied by the verses from the King James version of the Bible. 241pp. 9 × 12. 23004-X Pa. $8.95

HUGGER-MUGGER IN THE LOUVRE, Elliot Paul. Second Homer Evans mystery-comedy. Theft at the Louvre involves sleuth in hilarious, madcap caper. "A knockout."—Books. 336pp. 5⅜ × 8½. 25185-3 Pa. $5.95

FLATLAND, E. A. Abbott. Intriguing and enormously popular science-fiction classic explores the complexities of trying to survive as a two-dimensional being in a three-dimensional world. Amusingly illustrated by the author. 16 illustrations. 103pp. 5⅜ × 8½. 20001-9 Pa. $2.25

THE HISTORY OF THE LEWIS AND CLARK EXPEDITION, Meriwether Lewis and William Clark, edited by Elliott Coues. Classic edition of Lewis and Clark's day-by-day journals that later became the basis for U.S. claims to Oregon and the West. Accurate and invaluable geographical, botanical, biological, meteorological and anthropological material. Total of 1,508pp. 5⅜ × 8½. 21268-8, 21269-6, 21270-X Pa. Three-vol. set $25.50

LANGUAGE, TRUTH AND LOGIC, Alfred J. Ayer. Famous, clear introduction to Vienna, Cambridge schools of Logical Positivism. Role of philosophy, elimination of metaphysics, nature of analysis, etc. 160pp. 5⅜ × 8½. (Available in U.S. and Canada only) 20010-8 Pa. $2.95

MATHEMATICS FOR THE NONMATHEMATICIAN, Morris Kline. Detailed, college-level treatment of mathematics in cultural and historical context, with numerous exercises. For liberal arts students. Preface. Recommended Reading Lists. Tables. Index. Numerous black-and-white figures. xvi + 641pp. 5⅜ × 8½. 24823-2 Pa. $11.95

28 SCIENCE FICTION STORIES, H. G. Wells. Novels, *Star Begotten* and *Men Like Gods*, plus 26 short stories: "Empire of the Ants," "A Story of the Stone Age," "The Stolen Bacillus," "In the Abyss," etc. 915pp. 5⅜ × 8½. (Available in U.S. only) 20265-8 Cloth. $10.95

HANDBOOK OF PICTORIAL SYMBOLS, Rudolph Modley. 3,250 signs and symbols, many systems in full; official or heavy commercial use. Arranged by subject. Most in Pictorial Archive series. 143pp. 8⅜ × 11. 23357-X Pa. $5.95

INCIDENTS OF TRAVEL IN YUCATAN, John L. Stephens. Classic (1843) exploration of jungles of Yucatan, looking for evidences of Maya civilization. Travel adventures, Mexican and Indian culture, etc. Total of 669pp. 5⅜ × 8½. 20926-1, 20927-X Pa., Two-vol. set $9.90

DEGAS: An Intimate Portrait, Ambroise Vollard. Charming, anecdotal memoir by famous art dealer of one of the greatest 19th-century French painters. 14 black-and-white illustrations. Introduction by Harold L. Van Doren. 96pp. 5⅜ × 8½.
25131-4 Pa. $3.95

PERSONAL NARRATIVE OF A PILGRIMAGE TO ALMANDINAH AND MECCAH, Richard Burton. Great travel classic by remarkably colorful personality. Burton, disguised as a Moroccan, visited sacred shrines of Islam, narrowly escaping death. 47 illustrations. 959pp. 5⅜ × 8½. 21217-3, 21218-1 Pa., Two-vol. set $19.90

PHRASE AND WORD ORIGINS, A. H. Holt. Entertaining, reliable, modern study of more than 1,200 colorful words, phrases, origins and histories. Much unexpected information. 254pp. 5⅜ × 8½. 20758-7 Pa. $4.95

THE RED THUMB MARK, R. Austin Freeman. In this first Dr. Thorndyke case, the great scientific detective draws fascinating conclusions from the nature of a single fingerprint. Exciting story, authentic science. 320pp. 5⅜ × 8½. (Available in U.S. only) 25210-8 Pa. $5.95

AN EGYPTIAN HIEROGLYPHIC DICTIONARY, E. A. Wallis Budge. Monumental work containing about 25,000 words or terms that occur in texts ranging from 3000 B.C. to 600 A.D. Each entry consists of a transliteration of the word, the word in hieroglyphs, and the meaning in English. 1,314pp. 6⅜ × 10.
23615-3, 23616-1 Pa., Two-vol. set $27.90

THE COMPLEAT STRATEGYST: Being a Primer on the Theory of Games of Strategy, J. D. Williams. Highly entertaining classic describes, with many illustrated examples, how to select best strategies in conflict situations. Prefaces. Appendices. xvi + 268pp. 5⅜ × 8½. 25101-2 Pa. $5.95

THE ROAD TO OZ, L. Frank Baum. Dorothy meets the Shaggy Man, little Button-Bright and the Rainbow's beautiful daughter in this delightful trip to the magical Land of Oz. 272pp. 5⅜ × 8. 25208-6 Pa. $4.95

POINT AND LINE TO PLANE, Wassily Kandinsky. Seminal exposition of role of point, line, other elements in non-objective painting. Essential to understanding 20th-century art. 127 illustrations. 192pp. 6½ × 9¼. 23808-3 Pa. $4.50

LADY ANNA, Anthony Trollope. Moving chronicle of Countess Lovel's bitter struggle to win for herself and daughter Anna their rightful rank and fortune—perhaps at cost of sanity itself. 384pp. 5⅜ × 8½. 24669-8 Pa. $6.95

EGYPTIAN MAGIC, E. A. Wallis Budge. Sums up all that is known about magic in Ancient Egypt: the role of magic in controlling the gods, powerful amulets that warded off evil spirits, scarabs of immortality, use of wax images, formulas and spells, the secret name, much more. 253pp. 5⅜ × 8½. 22681-6 Pa. $4.00

THE DANCE OF SIVA, Ananda Coomaraswamy. Preeminent authority unfolds the vast metaphysic of India: the revelation of her art, conception of the universe, social organization, etc. 27 reproductions of art masterpieces. 192pp. 5⅜ × 8½.
24817-8 Pa. $5.95

CHRISTMAS CUSTOMS AND TRADITIONS, Clement A. Miles. Origin, evolution, significance of religious, secular practices. Caroling, gifts, yule logs, much more. Full, scholarly yet fascinating; non-sectarian. 400pp. 5⅜ × 8½.
23354-5 Pa. $6.50

THE HUMAN FIGURE IN MOTION, Eadweard Muybridge. More than 4,500 stopped-action photos, in action series, showing undraped men, women, children jumping, lying down, throwing, sitting, wrestling, carrying, etc. 390pp. 7⅞ × 10⅝.
20204-6 Cloth. $21.95

THE MAN WHO WAS THURSDAY, Gilbert Keith Chesterton. Witty, fast-paced novel about a club of anarchists in turn-of-the-century London. Brilliant social, religious, philosophical speculations. 128pp. 5⅜ × 8½.
25121-7 Pa. $3.95

A CEZANNE SKETCHBOOK: Figures, Portraits, Landscapes and Still Lifes, Paul Cezanne. Great artist experiments with tonal effects, light, mass, other qualities in over 100 drawings. A revealing view of developing master painter, precursor of Cubism. 102 black-and-white illustrations. 144pp. 8¾ × 6⅝.
24790-2 Pa. $5.95

AN ENCYCLOPEDIA OF BATTLES: Accounts of Over 1,560 Battles from 1479 B.C. to the Present, David Eggenberger. Presents essential details of every major battle in recorded history, from the first battle of Megiddo in 1479 B.C. to Grenada in 1984. List of Battle Maps. New Appendix covering the years 1967–1984. Index. 99 illustrations. 544pp. 6½ × 9¼.
24913-1 Pa. $14.95

AN ETYMOLOGICAL DICTIONARY OF MODERN ENGLISH, Ernest Weekley. Richest, fullest work, by foremost British lexicographer. Detailed word histories. Inexhaustible. Total of 856pp. 6½ × 9¼.
21873-2, 21874-0 Pa., Two-vol. set $17.00

WEBSTER'S AMERICAN MILITARY BIOGRAPHIES, edited by Robert McHenry. Over 1,000 figures who shaped 3 centuries of American military history. Detailed biographies of Nathan Hale, Douglas MacArthur, Mary Hallaren, others. Chronologies of engagements, more. Introduction. Addenda. 1,033 entries in alphabetical order. xi + 548pp. 6½ × 9¼. (Available in U.S. only)
24758-9 Pa. $11.95

LIFE IN ANCIENT EGYPT, Adolf Erman. Detailed older account, with much not in more recent books: domestic life, religion, magic, medicine, commerce, and whatever else needed for complete picture. Many illustrations. 597pp. 5⅜ × 8½.
22632-8 Pa. $8.50

HISTORIC COSTUME IN PICTURES, Braun & Schneider. Over 1,450 costumed figures shown, covering a wide variety of peoples: kings, emperors, nobles, priests, servants, soldiers, scholars, townsfolk, peasants, merchants, courtiers, cavaliers, and more. 256pp. 8⅜ × 11¼.
23150-X Pa. $7.95

THE NOTEBOOKS OF LEONARDO DA VINCI, edited by J. P. Richter. Extracts from manuscripts reveal great genius; on painting, sculpture, anatomy, sciences, geography, etc. Both Italian and English. 186 ms. pages reproduced, plus 500 additional drawings, including studies for *Last Supper, Sforza* monument, etc. 860pp. 7⅞ × 10¾. (Available in U.S. only) 22572-0, 22573-9 Pa., Two-vol. set $25.90

CATALOG OF DOVER BOOKS

THE ART NOUVEAU STYLE BOOK OF ALPHONSE MUCHA: All 72 Plates from "Documents Decoratifs" in Original Color, Alphonse Mucha. Rare copyright-free design portfolio by high priest of Art Nouveau. Jewelry, wallpaper, stained glass, furniture, figure studies, plant and animal motifs, etc. Only complete one-volume edition. 80pp. 9⅜ × 12¼. 24044-4 Pa. $8.95

ANIMALS: 1,419 COPYRIGHT-FREE ILLUSTRATIONS OF MAMMALS, BIRDS, FISH, INSECTS, ETC., edited by Jim Harter. Clear wood engravings present, in extremely lifelike poses, over 1,000 species of animals. One of the most extensive pictorial sourcebooks of its kind. Captions. Index. 284pp. 9 × 12.
23766-4 Pa. $9.95

OBELISTS FLY HIGH, C. Daly King. Masterpiece of American detective fiction, long out of print, involves murder on a 1935 transcontinental flight—"a very thrilling story"—NY Times. Unabridged and unaltered republication of the edition published by William Collins Sons & Co. Ltd., London, 1935. 288pp. 5⅜ × 8½. (Available in U.S. only) 25036-9 Pa. $4.95

VICTORIAN AND EDWARDIAN FASHION: A Photographic Survey, Alison Gernsheim. First fashion history completely illustrated by contemporary photographs. Full text plus 235 photos, 1840-1914, in which many celebrities appear. 240pp. 6½ × 9¼. 24205-6 Pa. $6.00

THE ART OF THE FRENCH ILLUSTRATED BOOK, 1700-1914, Gordon N. Ray. Over 630 superb book illustrations by Fragonard, Delacroix, Daumier, Doré, Grandville, Manet, Mucha, Steinlen, Toulouse-Lautrec and many others. Preface. Introduction. 633 halftones. Indices of artists, authors & titles, binders and provenances. Appendices. Bibliography. 608pp. 8⅜ × 11¼. 25086-5 Pa. $24.95

THE WONDERFUL WIZARD OF OZ, L. Frank Baum. Facsimile in full color of America's finest children's classic. 143 illustrations by W. W. Denslow. 267pp. 5⅜ × 8½. 20691-2 Pa. $5.95

FRONTIERS OF MODERN PHYSICS: New Perspectives on Cosmology, Relativity, Black Holes and Extraterrestrial Intelligence, Tony Rothman, et al. For the intelligent layman. Subjects include: cosmological models of the universe; black holes; the neutrino; the search for extraterrestrial intelligence. Introduction. 46 black-and-white illustrations. 192pp. 5⅜ × 8½. 24587-X Pa. $6.95

THE FRIENDLY STARS, Martha Evans Martin & Donald Howard Menzel. Classic text marshalls the stars together in an engaging, non-technical survey, presenting them as sources of beauty in night sky. 23 illustrations. Foreword. 2 star charts. Index. 147pp. 5⅜ × 8½. 21099-5 Pa. $3.50

FADS AND FALLACIES IN THE NAME OF SCIENCE, Martin Gardner. Fair, witty appraisal of cranks, quacks, and quackeries of science and pseudoscience: hollow earth, Velikovsky, orgone energy, Dianetics, flying saucers, Bridey Murphy, food and medical fads, etc. Revised, expanded In the Name of Science. "A very able and even-tempered presentation."—The New Yorker. 363pp. 5⅜ × 8.
20394-8 Pa. $6.50

ANCIENT EGYPT: ITS CULTURE AND HISTORY, J. E Manchip White. From pre-dynastics through Ptolemies: society, history, political structure, religion, daily life, literature, cultural heritage. 48 plates. 217pp. 5⅜ × 8½. 22548-8 Pa. $4.95

SIR HARRY HOTSPUR OF HUMBLETHWAITE, Anthony Trollope. Incisive, unconventional psychological study of a conflict between a wealthy baronet, his idealistic daughter, and their scapegrace cousin. The 1870 novel in its first inexpensive edition in years. 250pp. 5⅜ × 8½. 24953-0 Pa. $5.95

LASERS AND HOLOGRAPHY, Winston E. Kock. Sound introduction to burgeoning field, expanded (1981) for second edition. Wave patterns, coherence, lasers, diffraction, zone plates, properties of holograms, recent advances. 84 illustrations. 160pp. 5⅜ × 8¼. (Except in United Kingdom) 24041-X Pa. $3.50

INTRODUCTION TO ARTIFICIAL INTELLIGENCE: SECOND, EN-LARGED EDITION, Philip C. Jackson, Jr. Comprehensive survey of artificial intelligence—the study of how machines (computers) can be made to act intelligently. Includes introductory and advanced material. Extensive notes updating the main text. 132 black-and-white illustrations. 512pp. 5⅜ × 8½. 24864-X Pa. $8.95

HISTORY OF INDIAN AND INDONESIAN ART, Ananda K. Coomaraswamy. Over 400 illustrations illuminate classic study of Indian art from earliest Harappa finds to early 20th century. Provides philosophical, religious and social insights. 304pp. 6⅝ × 9⅜. 25005-9 Pa. $8.95

THE GOLEM, Gustav Meyrink. Most famous supernatural novel in modern European literature, set in Ghetto of Old Prague around 1890. Compelling story of mystical experiences, strange transformations, profound terror. 13 black-and-white illustrations. 224pp. 5⅜ × 8½. (Available in U.S. only) 25025-3 Pa. $5.95

ARMADALE, Wilkie Collins. Third great mystery novel by the author of *The Woman in White* and *The Moonstone*. Original magazine version with 40 illustrations. 597pp. 5⅜ × 8½. 23429-0 Pa. $9.95

PICTORIAL ENCYCLOPEDIA OF HISTORIC ARCHITECTURAL PLANS, DETAILS AND ELEMENTS: With 1,880 Line Drawings of Arches, Domes, Doorways, Facades, Gables, Windows, etc., John Theodore Haneman. Sourcebook of inspiration for architects, designers, others. Bibliography. Captions. 141pp. 9 × 12. 24605-1 Pa. $6.95

BENCHLEY LOST AND FOUND, Robert Benchley. Finest humor from early 30's, about pet peeves, child psychologists, post office and others. Mostly unavailable elsewhere. 73 illustrations by Peter Arno and others. 183pp. 5⅜ × 8½. 22410-4 Pa. $3.95

ERTÉ GRAPHICS, Erté. Collection of striking color graphics: *Seasons, Alphabet, Numerals, Aces* and *Precious Stones*. 50 plates, including 4 on covers. 48pp. 9⅜ × 12¼. 23580-7 Pa. $6.95

THE JOURNAL OF HENRY D. THOREAU, edited by Bradford Torrey, F. H. Allen. Complete reprinting of 14 volumes, 1837–61, over two million words; the sourcebooks for *Walden*, etc. Definitive. All original sketches, plus 75 photographs. 1,804pp. 8½ × 12¼. 20312-3, 20313-1 Cloth., Two-vol. set $80.00

CASTLES: THEIR CONSTRUCTION AND HISTORY, Sidney Toy. Traces castle development from ancient roots. Nearly 200 photographs and drawings illustrate moats, keeps, baileys, many other features. Caernarvon, Dover Castles, Hadrian's Wall, Tower of London, dozens more. 256pp. 5⅜ × 8¼. 24898-4 Pa. $5.95

AMERICAN CLIPPER SHIPS: 1833–1858, Octavius T. Howe & Frederick C. Matthews. Fully-illustrated, encyclopedic review of 352 clipper ships from the period of America's greatest maritime supremacy. Introduction. 109 halftones. 5 black-and-white line illustrations. Index. Total of 928pp. 5⅜ × 8½.
25115-2, 25116-0 Pa., Two vol. set $17.90

TOWARDS A NEW ARCHITECTURE, Le Corbusier. Pioneering manifesto by great architect, near legendary founder of "International School." Technical and aesthetic theories, views on industry, economics, relation of form to function, "mass-production spirit," much more. Profusely illustrated. Unabridged translation of 13th French edition. Introduction by Frederick Etchells. 320pp. 6⅛ × 9¼. (Available in U.S. only)
25023-7 Pa. $8.95

THE BOOK OF KELLS, edited by Blanche Cirker. Inexpensive collection of 32 full-color, full-page plates from the greatest illuminated manuscript of the Middle Ages, painstakingly reproduced from rare facsimile edition. Publisher's Note. Captions. 32pp. 9⅜ × 12¼.
24345-1 Pa. $4.95

BEST SCIENCE FICTION STORIES OF H. G. WELLS, H. G. Wells. Full novel *The Invisible Man*, plus 17 short stories: "The Crystal Egg," "Aepyornis Island," "The Strange Orchid," etc. 303pp. 5⅜ × 8½. (Available in U.S. only)
21531-8 Pa. $4.95

AMERICAN SAILING SHIPS: Their Plans and History, Charles G. Davis. Photos, construction details of schooners, frigates, clippers, other sailcraft of 18th to early 20th centuries—plus entertaining discourse on design, rigging, nautical lore, much more. 137 black-and-white illustrations. 240pp. 6⅛ × 9¼.
24658-2 Pa. $5.95

ENTERTAINING MATHEMATICAL PUZZLES, Martin Gardner. Selection of author's favorite conundrums involving arithmetic, money, speed, etc., with lively commentary. Complete solutions. 112pp. 5⅜ × 8½.
25211-6 Pa. $2.95

THE WILL TO BELIEVE, HUMAN IMMORTALITY, William James. Two books bound together. Effect of irrational on logical, and arguments for human immortality. 402pp. 5⅜ × 8½.
20291-7 Pa. $7.50

THE HAUNTED MONASTERY and THE CHINESE MAZE MURDERS, Robert Van Gulik. 2 full novels by Van Gulik continue adventures of Judge Dee and his companions. An evil Taoist monastery, seemingly supernatural events; overgrown topiary maze that hides strange crimes. Set in 7th-century China. 27 illustrations. 328pp. 5⅜ × 8½.
23502-5 Pa. $5.95

CELEBRATED CASES OF JUDGE DEE (DEE GOONG AN), translated by Robert Van Gulik. Authentic 18th-century Chinese detective novel; Dee and associates solve three interlocked cases. Led to Van Gulik's own stories with same characters. Extensive introduction. 9 illustrations. 237pp. 5⅜ × 8½.
23337-5 Pa. $4.95

Prices subject to change without notice.

Available at your book dealer or write for free catalog to Dept. GI, Dover Publications, Inc., 31 East 2nd St., Mineola, N.Y. 11501. Dover publishes more than 175 books each year on science, elementary and advanced mathematics, biology, music, art, literary history, social sciences and other areas.